minimalist houses

Author
Linda Parker

Publishing Director
Nacho Asensio

Texts
Patricia Bueno
Martha Torres
Marta Eiriz

Design
David Maynar
Mar Nieto

Cover Design and Layout
Carlos Gamboa Permanyer

Production
Juanjo Rodriguez Novel

Copyright © 2002 Atrium Group
C/ Ganduxer 112; 1º
08022 Barcelona (Spain)
Tel: + 34 93 254 00 99
Fax:+ 34 93 211 81 39
e-mail: atrium@atriumgroup.org
www.atriumbooks.com

First published in 2002 by HBI, an imprint
of HarperCollins International
10 East 53rd Street. New York, NY 10022-5299

Internationally distributed by HBI, an imprint
of HarperCollins International
10 East 53rd Street. New York, NY 10022-5299
Fax: (212) 207.7654

ISBN: 0-06-053994-1
Dep.Leg: B-37.864-2002

Editorial Project
Books Factory, S.L.
books@booksfactory.org

Printed in Anman Gràfiques del Vallès
Sabadell, Barcelona, Spain.

minimalist houses

Minimalism seeks purity as an expression of aesthetic beauty as well as functionality. This objective is reached in architecture by reducing form and color to their most basic level. Mies van der Rohe´s celebrated phrase "less is more" encapsulates the principles of a movement that turns its back on artifice in the search for the simplest way to design a structure, always keeping in mind the goal of achieving the highest functionality with the most basic elements. Minimalism also embraces the concept of simplicity. Its austere and serene spatial designs seek to transmit an atmosphere of calm and tranquility.

Summary

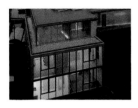
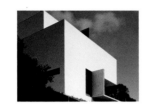
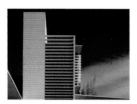
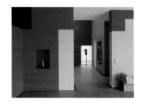
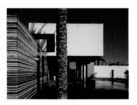
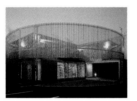
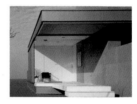

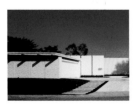
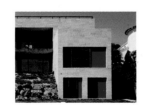
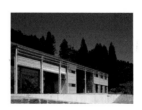
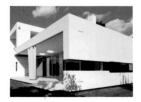

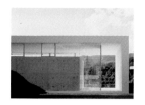
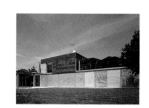

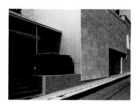
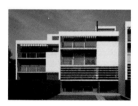
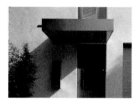
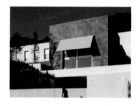

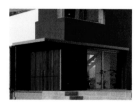
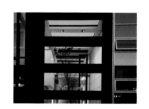
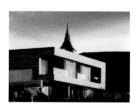

Introduction

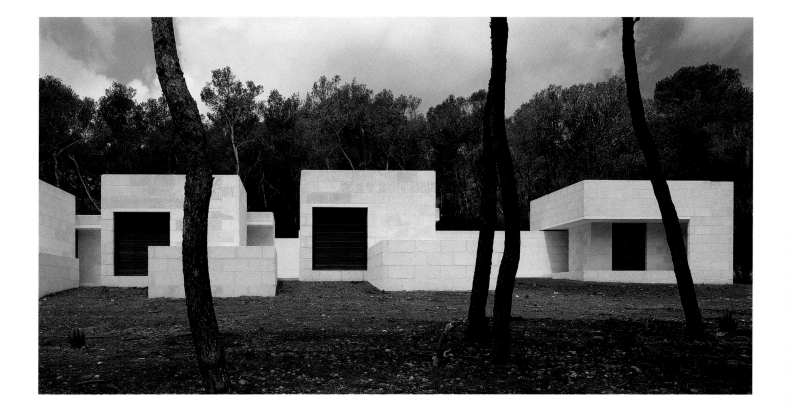

This book does not intend to be an exhaustive account of all the houses in the world conceived and designed along the lines of architectural minimalism, a style that weds beauty and functionality of design with the simplicity of the finished work.

The twenty-four selections of Minimalist-based homes that follow exemplify different composite schemes. They show us how a multitude of original architectural works can result from ideas inspired by the principles of Minimalism. The reader will also find a wide range of solutions to design questions regarding his or her own home.

Representations of homes in countries as diverse as Japan, The United States, Germany, Mexico and Spain may be found in the book. Some are located in the center of the city, while others are situated on a mountain or next to the sea. The diverse locations of the selected works demonstrate how the architects have adapted their designs to specific climates and environments. They also serve to present some of the distinct forms that Minimalism takes around the world.

Y.S House

Architect: Itsuko Hasegawa | **Location:** Tokyo, Japan. 2000-2001 | **Photos:** Tomio Ohashi

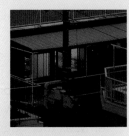

Well-known Japanese architect Itsuko Hasegawa creates architecture with a personal atmosphere. While this quality is carefully guarded as if it were an alternative reality, Hasegawa does not allow his buildings to become disassociated from their context. In the case of "Y.S. House", located on a storefront street, this personal atmosphere aims at the preservation of intimate space in the heart of Tokyo. The home is part of 336 m² (1,100 sq. ft) complex, consisting of a pharmacy and three clinics that occupy

the first two floors of the building. This leaves the top floor for the house of a mother and son. The situation of the house within the complex possesses such virtues as panoramic views of the Tokyo skyline. The use of the lower floor and top floor differs greatly. Space is completely occupied on the lower floors, while on the top floor there are terraces that guard the intimacy of the inhabitants and offer privileged views of the city. The formal volumetric design benefits from the material virtues of the blue-glass block of the façades, which projects the image of a luminous, suspended box. More than perimeter elements of the volume, the glass walls are treated as two independent planes. The planes not only span volumetric limits, thus separating exterior from interior, but on two occasions enter the house, creating three principal spaces as well as enclosing the rooms. In this way, three spaces are generated with very few elements. Sparse furnishing completes the rooms' functional requirements.

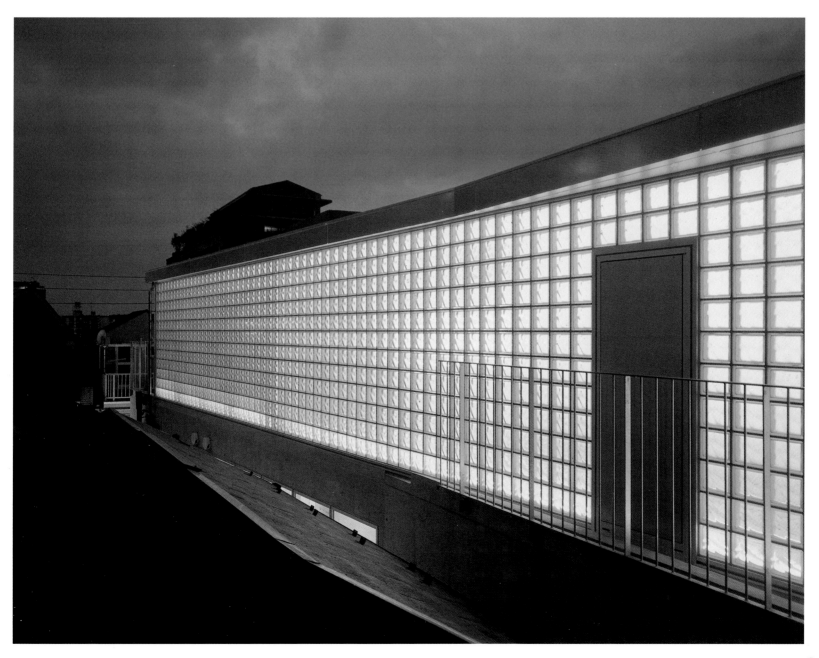

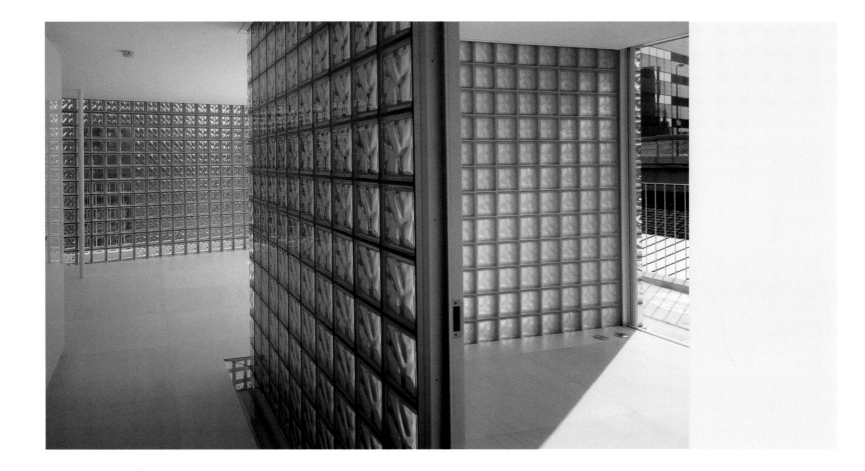

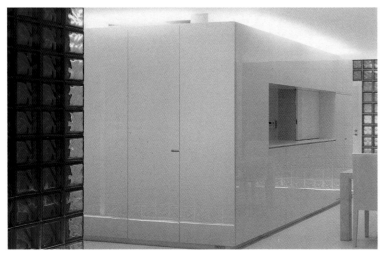
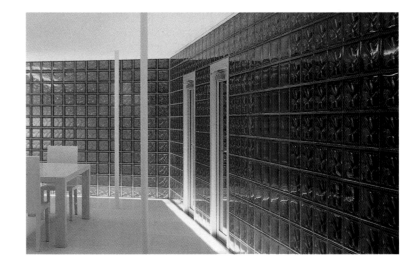

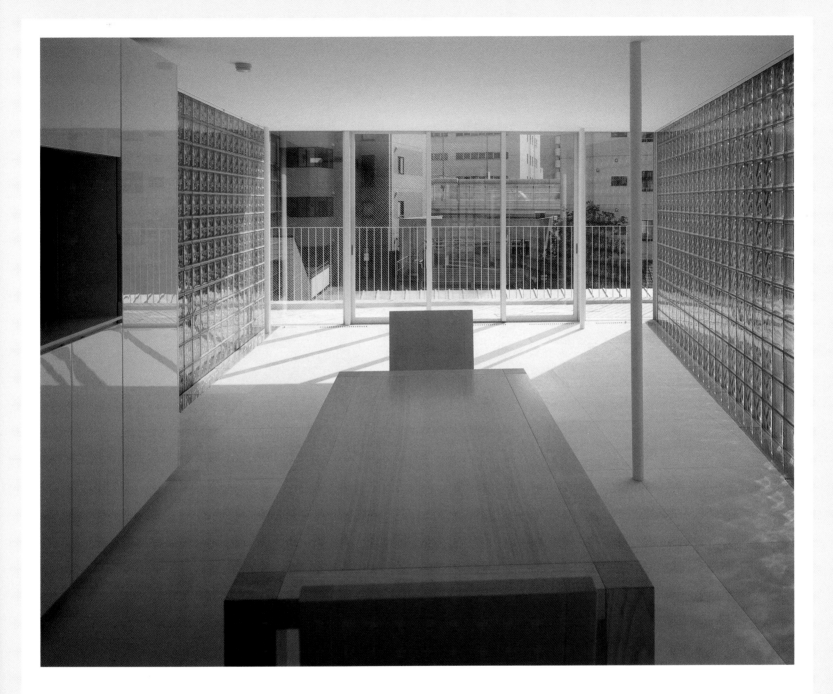

Few elements serve to define the main areas of the house: glass planes that form part of the ex-terior enclosure and volumes that hold installations. The spaces communicate with a terrace that stretches the entirety of the home.

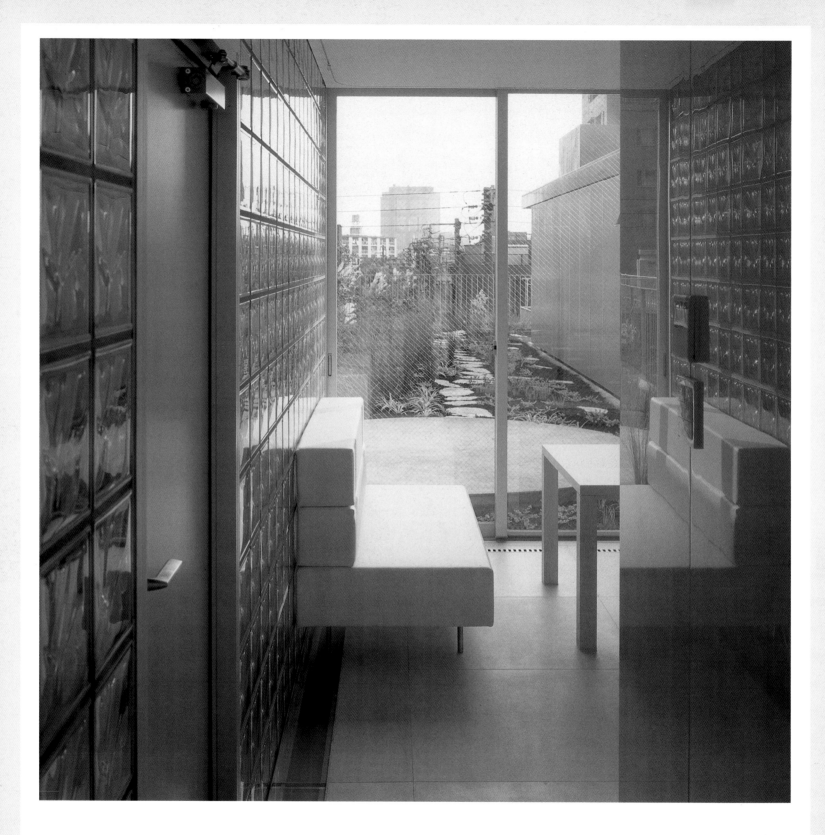

Blue-glass planes make the home look as if it were floating above the complex. These independent façade planes enter the house and articulate three main spaces: two rooms and a living room-dining room. In this way, and with few resources, an attractive residential environment is achieved.

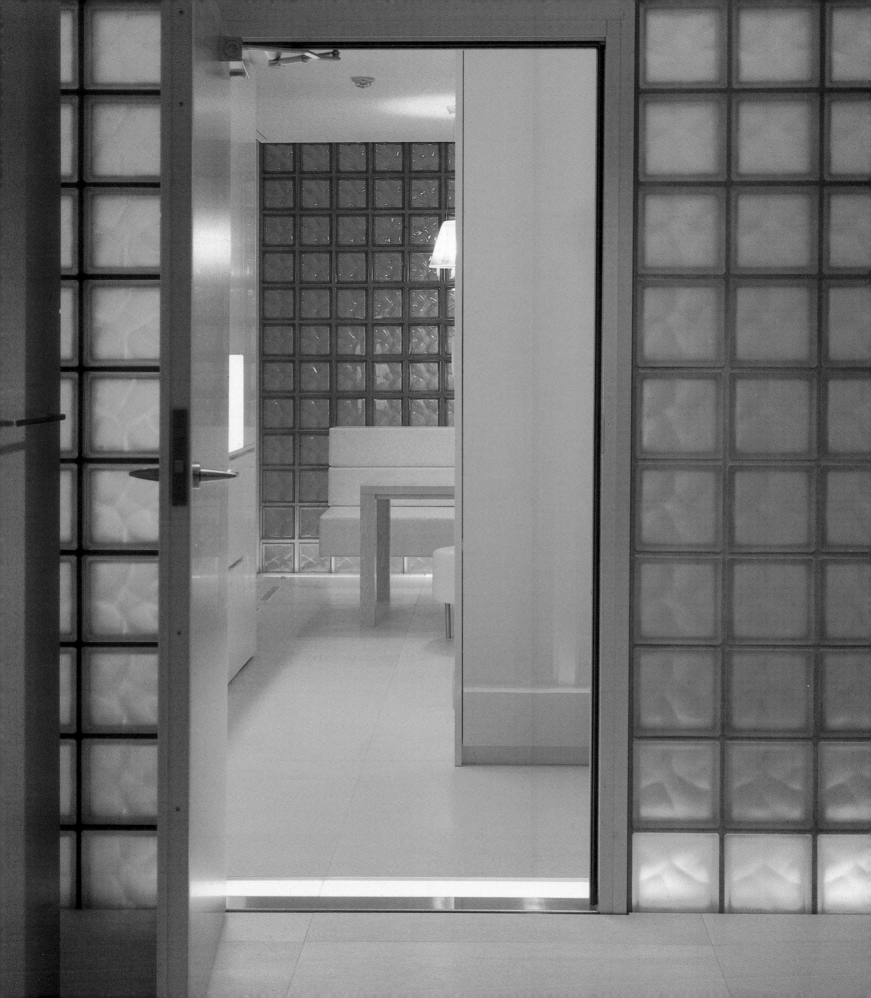

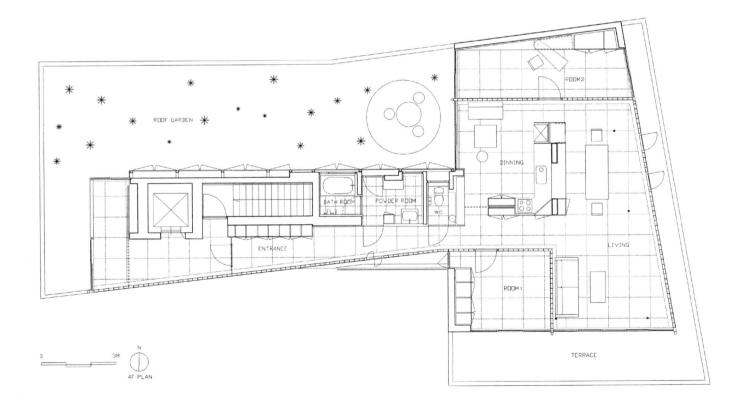

ROOM2

ROOF GARDEN

DINNING

BATH ROOM

POWDER ROOM

W.C

LIVING

ENTRANCE

ROOM1

TERRACE

0 3M

N

4F PLAN

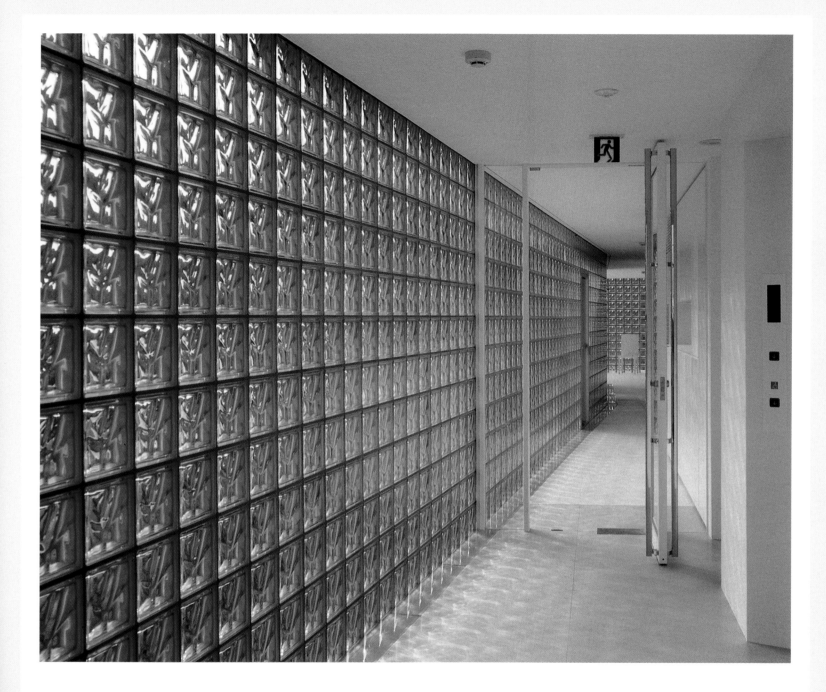

The location of the house on the upper floor of the complex calls for a design that considers all the possibilities suggested by such a positioning. The spatial organization allows for the possibility of designing terraces and gardens to enjoy views of the city. The skyline of the city thus takes on a more dynamic role, granting the "penthouse" a greater visual diversity.

A-M House

Architect: Elena Mateu | **Location:** Barcelona, Spain. 2001| **Photos:** Alejo Bagué

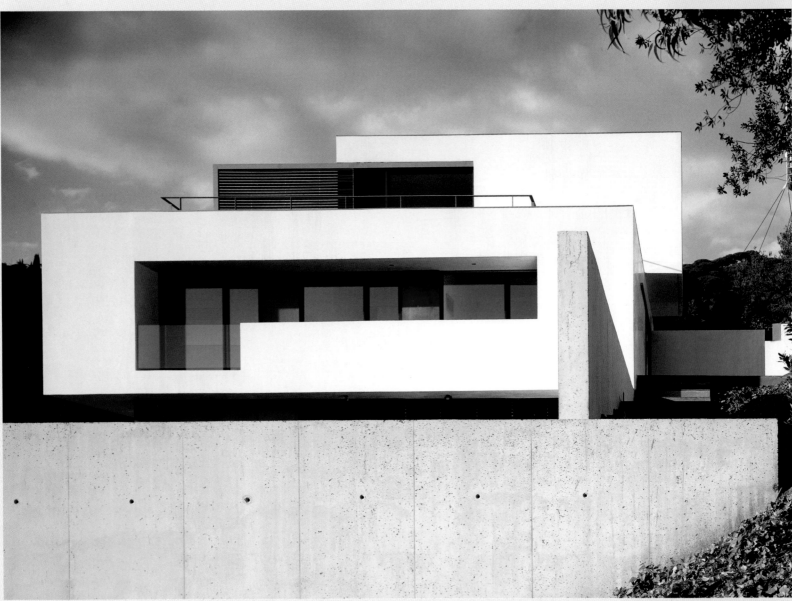

This one-family home consists of three superimposed cubes, one atop the other. The arrangement gives rise to a combination of forms that may be fully appreciated only from the façade opening up to the garden. The other three façades are closed to block the view of abutting homes from the interior of the house. Light enters these sections through horizontal windows and an interior patio. The façade facing the garden, on the other hand, is completely open. Each cube corresponds to a different approach with respect

to the design of the enclosures. The smaller, upper section of the home sits in the center of the second floor roof, offering a generous terrace space. A sliding wood-slat shutter blocks the entrance of direct light into the interior. Fully opened, the shutter rests in a lightweight aluminum frame and seems to hang in the air. One edge of the cube overhangs the front façade, making for a canopy above the front door.

The second cube contains a singular opening formed by the structure itself, which serves as a kind of protective framework for the interior spaces. The framework appears to envelop the windows, creating an independent space with privileged overviews of the city. The base of the second floor overhangs the structural center of the home, projecting above the terrace. On the side of the slope, the terrace extends beyond the foundations. Suspended in the air, it transmits a sense of weightlessness.

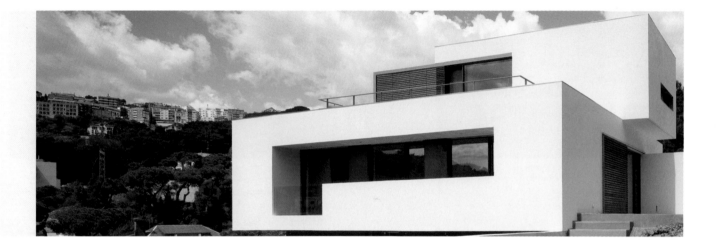

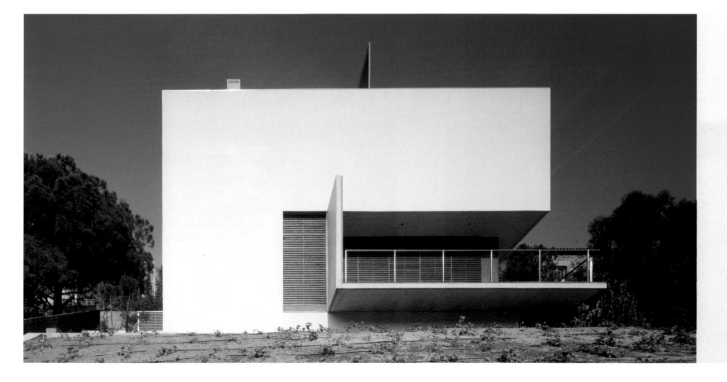

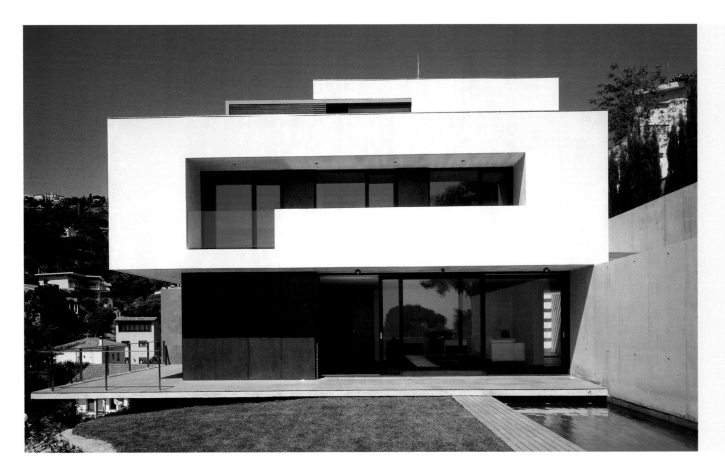

The building design of the home is based on the concept of the "cube" and the interplay of super-imposed volumes. The result is a dynamic exterior in which the three parts of the home seem to arrange themselves asymmetrically, given their different dimensions and forms.

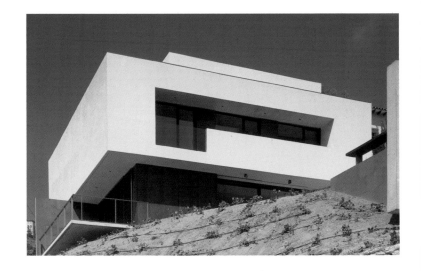

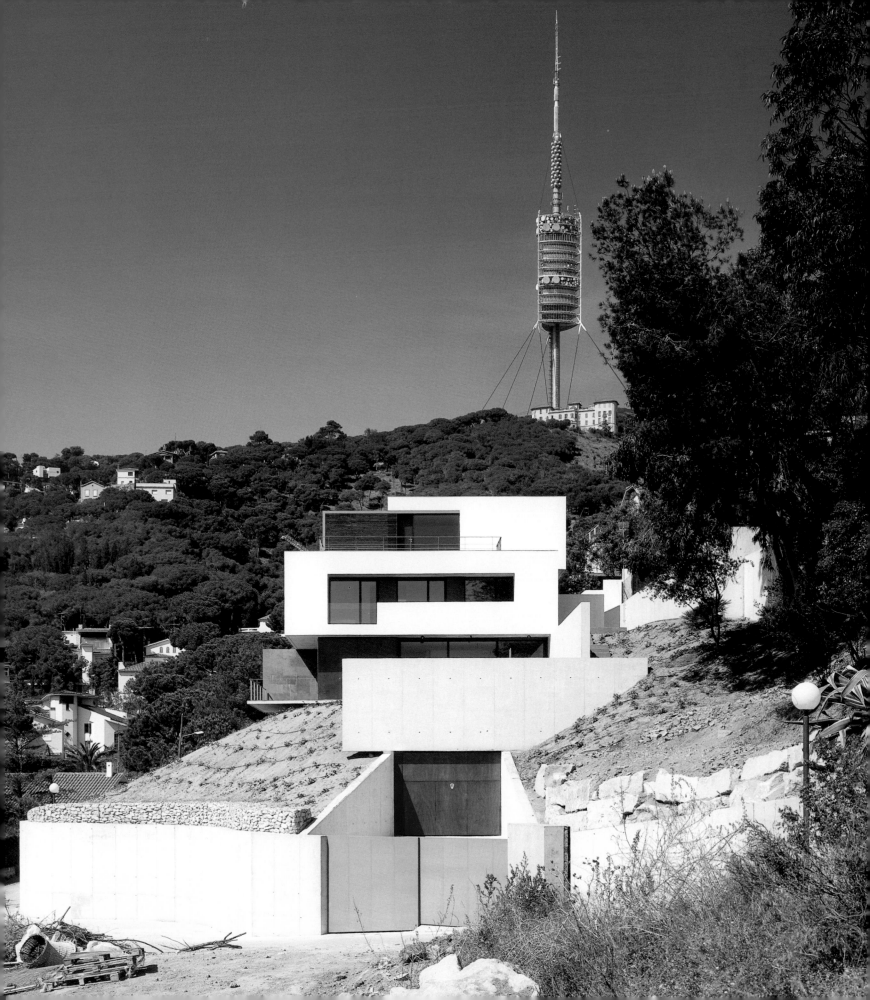

Alonso House

Architect: Carlos Ferrater | **Location:** Barcelona, Spain. 1999 | **Photos:** Lluís Casals

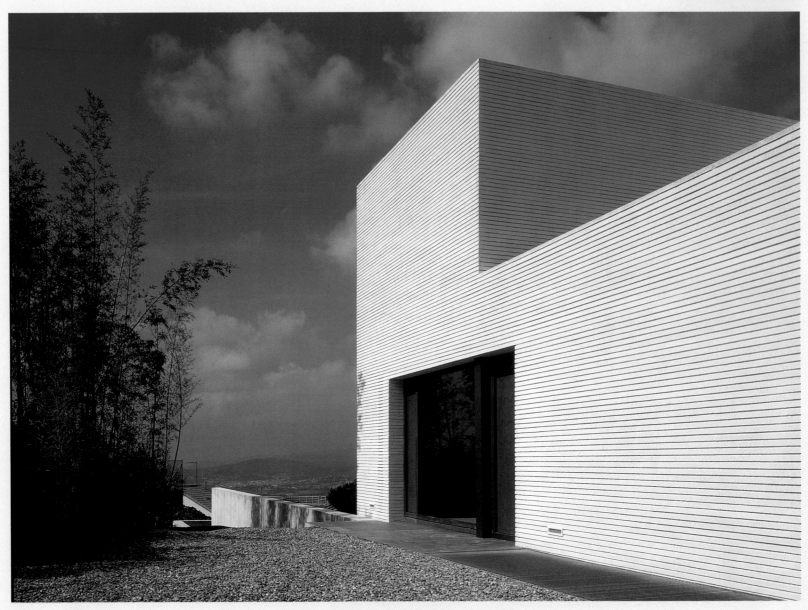

errater´s designs are characterized by the search for plasticity. This translates into works that stand out for their purity of line, giving rise to sculpture-like forms. In this one-family home, other formal constants typical of the architect's work find expression (vertically fragmented volumes particularized through the diversification of façades, use of horizontal elements –e.g., pergolas and bris-soleils– to dislocate building scale, use of tinted, white brick).

The façade and constructive details of the home interact in a remarkable play of light and shadow. Circles and rectangles interrupt the façade's uniformity. These meticulously placed openings in the exterior also provoke intriguing light refractions. From the highest point of the property, shaped like a trapezoid with a sixteen-meter (about 52 ft) slope, there is a view of two valleys and the city of Barcelona. The design situates the main part of the home at the top of the lot, perpendicular to the leveling curves. This creates horizontal spaces in the front and back with perfect southerly orientations, allowing for optimum enjoyment of the views over the two valleys. The body of the structure, narrow and long, is arranged in three floors. The levels interrelate with a square in front –where the pool and solarium are located– and landscaped strips in back with access from the intermediate level. The building rests on a substructure excavated out of the mountain. Within are located the accesses to the home, parking spaces, installation rooms, the shell of the pool, and a painting and sculpture workshop.

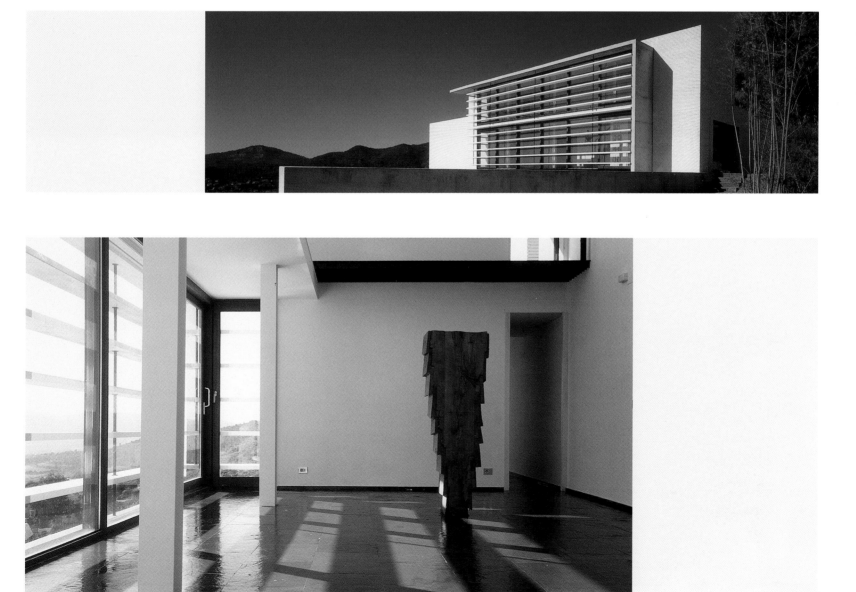

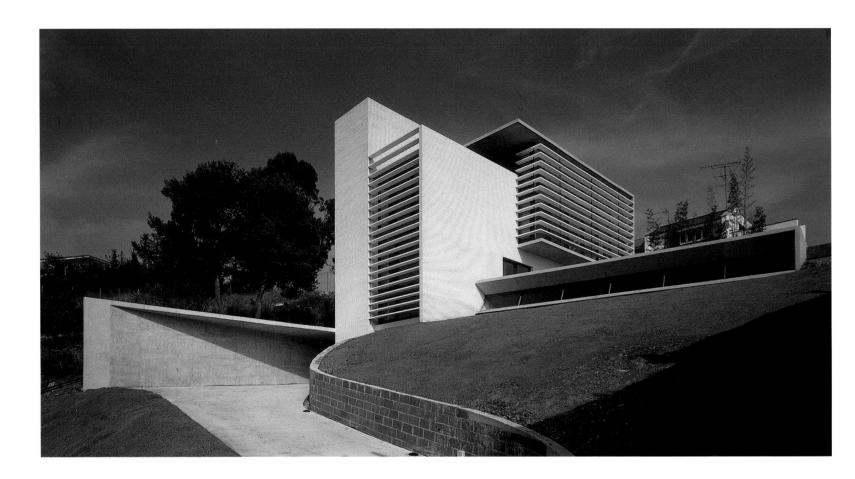

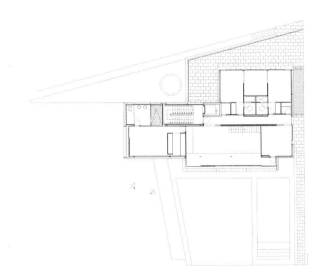

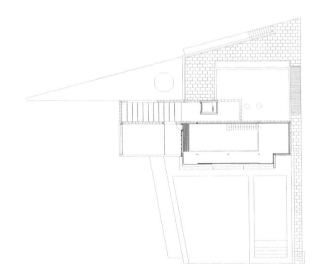

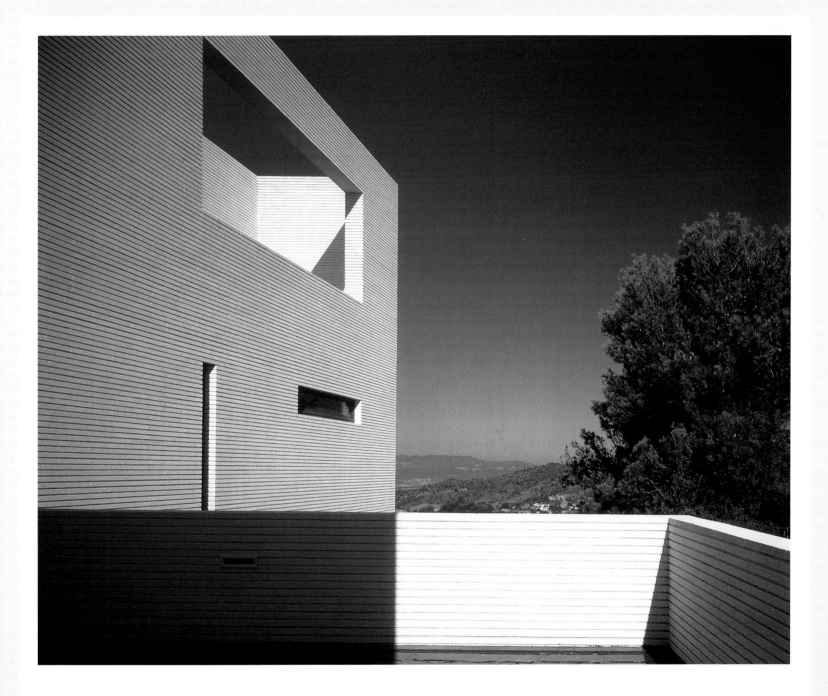

Carlos Ferrater´s constant concern for the appropriate presentation of volumes, spaces, light and shadow, and constructive finishing details finds perfect expression in this design, where the architect allows certain elements of sculpture to come through.

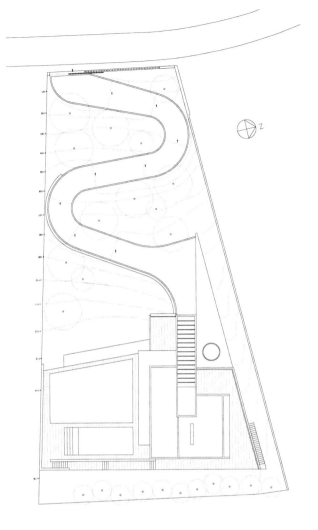

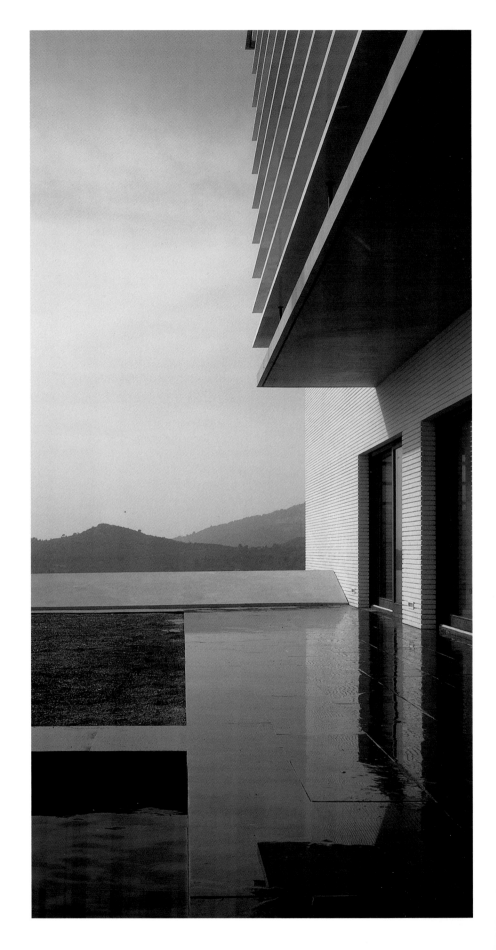

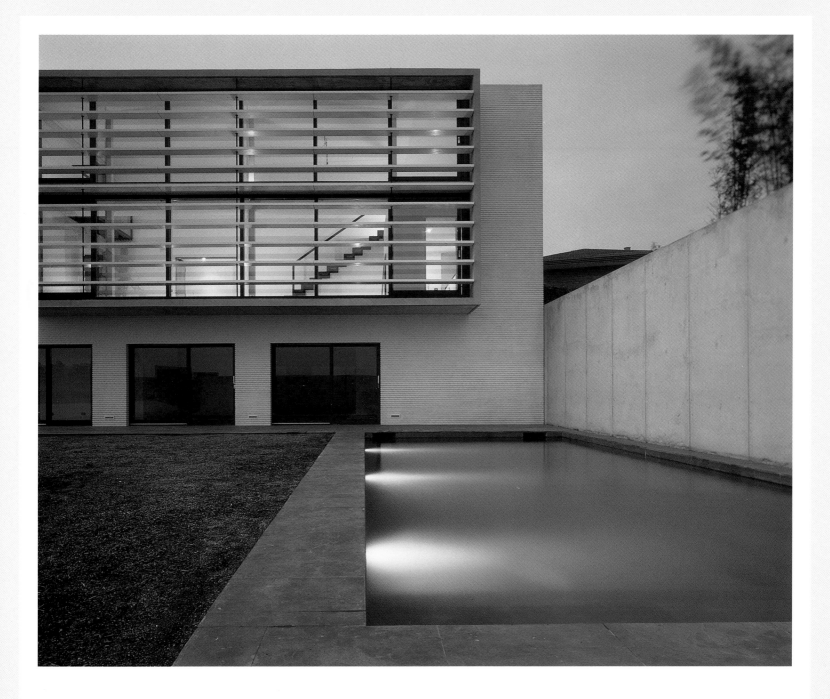

Access to the home is obtained by a driveway beginning at the bottom of the lot and ascending in serpentine fashion between local vegetation. The drive continues until a walled entrance, a sort of sky-lit tunnel, and enters the foyer and workshops.

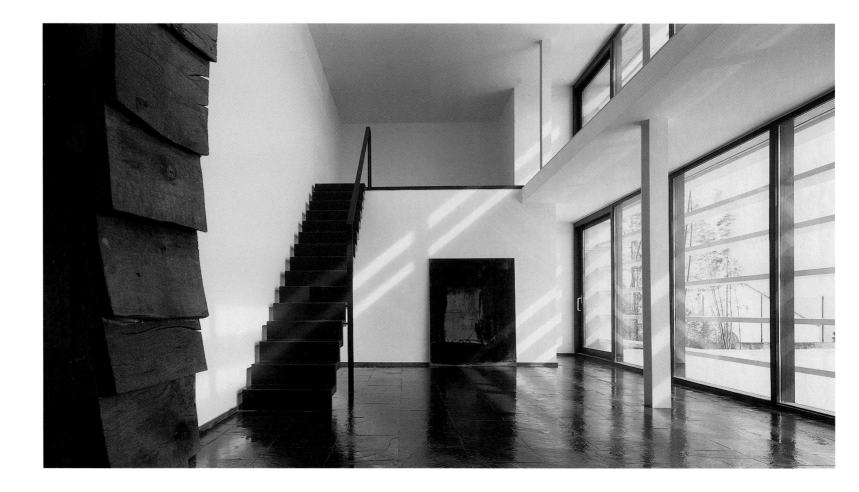

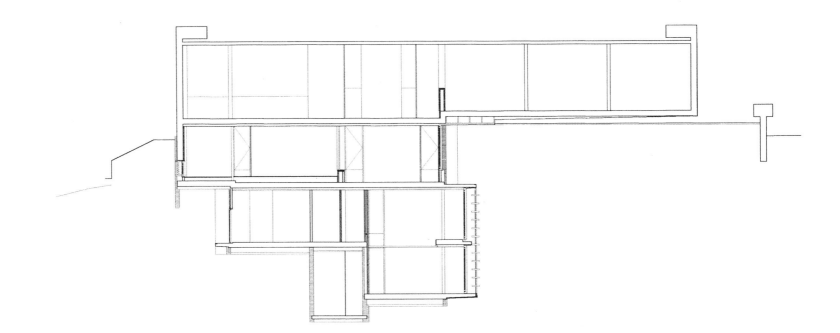

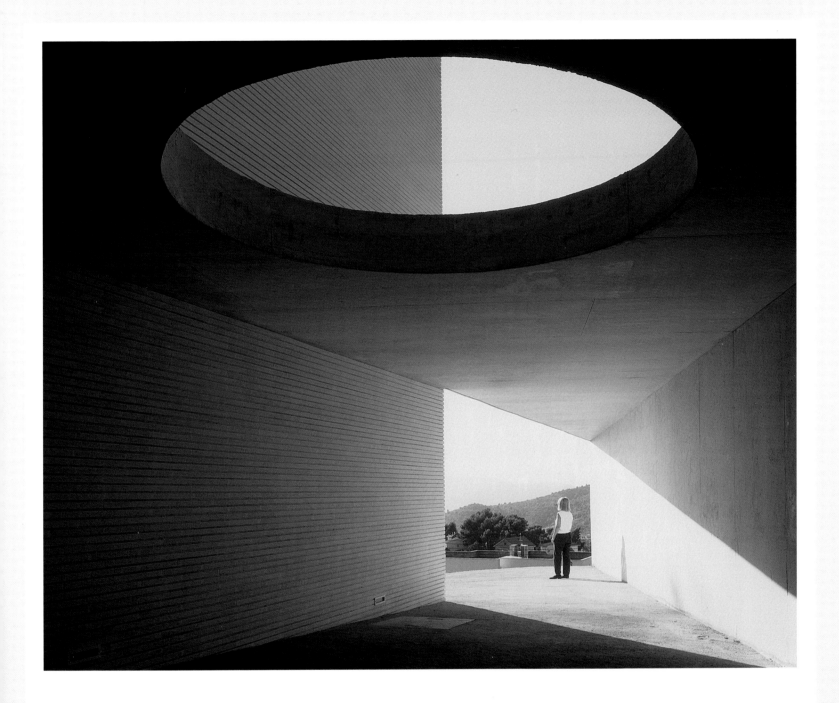

The walls, flagstones, and eaves of the home are made of concrete, while the enclosures are pressed, white brick. The woodwork is teak, and mechanically controlled hanging slats protect the openings.

K in K House

Architects: Heinz & Nikolaus Bienefeld | **Photos:** Lukas Roth Architekturfotograffie.

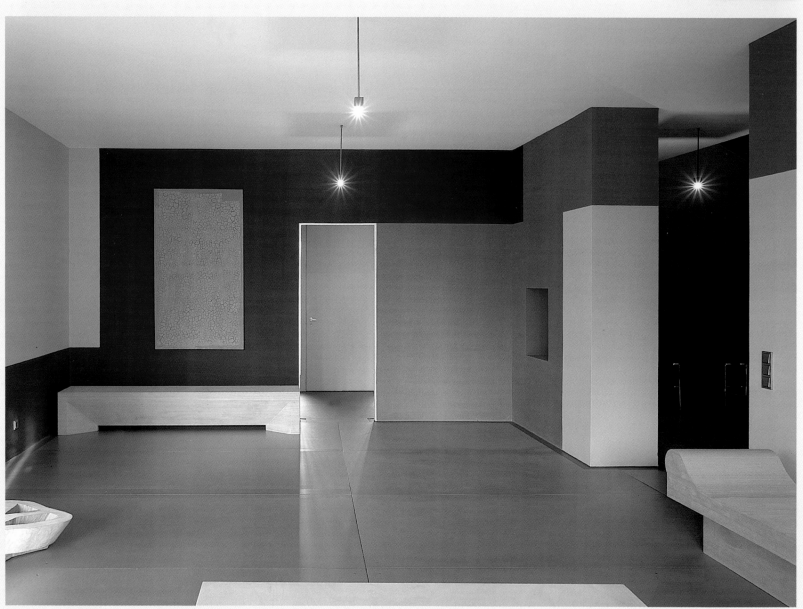

The design of K in K House centered around the remodeling of original spaces. The result is better spatial organization and the modernization of surfaces. The stairway leading to the upper floor underwent a complete structural and image transformation. Originally, four rectangular columns that supported the large skylight dominated this space. The first step was to eliminate the columns in order to create a greater sense of width and allow the stairway to be the focal center of the access space. In

addition to getting rid of the columns, the entrance was renovated to improve the stairwell's natural lighting. A silver-plated metallic structure supports the skylight from above, thus freeing up the entire space.

The diverse areas of the house are characterized by the bold use of color. Color stands out as an element of contrast, graphically defining the different rooms and enriching the visual experience of these interiors. The architect fuses the boldness of abstract painting to architecture, enhancing the effect of color in a domestic setting while, at the same time, underscoring its use as means of expression. The collaboration of the architect's son Nikolaus, a painter and sculptor whose work is inspired by Minimalism, assured the appropriate application of color.

Other renovations include the elimination and replacement of the dining room wall that faced the neighboring house. A large window now allows light to enter a relatively dark space, while also establishing spatial continuity with the exterior.

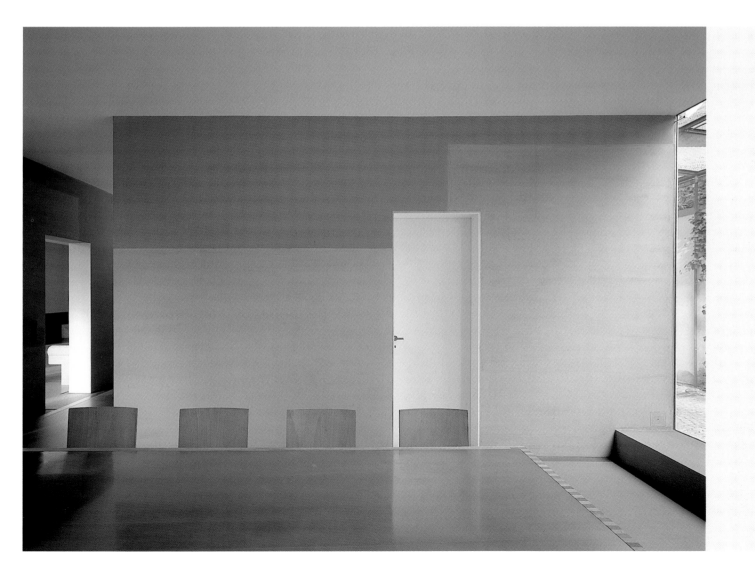

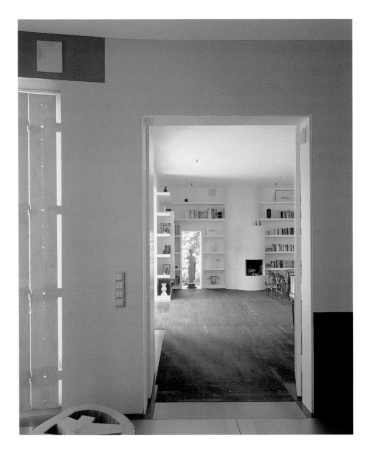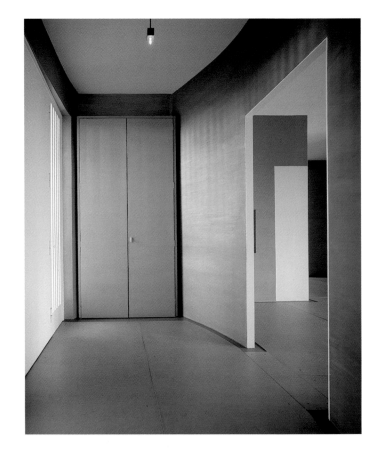

On top of the unconventional use of color, other details grant the home a character of its own.
Among the most noteworthy are the metallic surface of the lower floor and wooden furniture designed
by the architect.

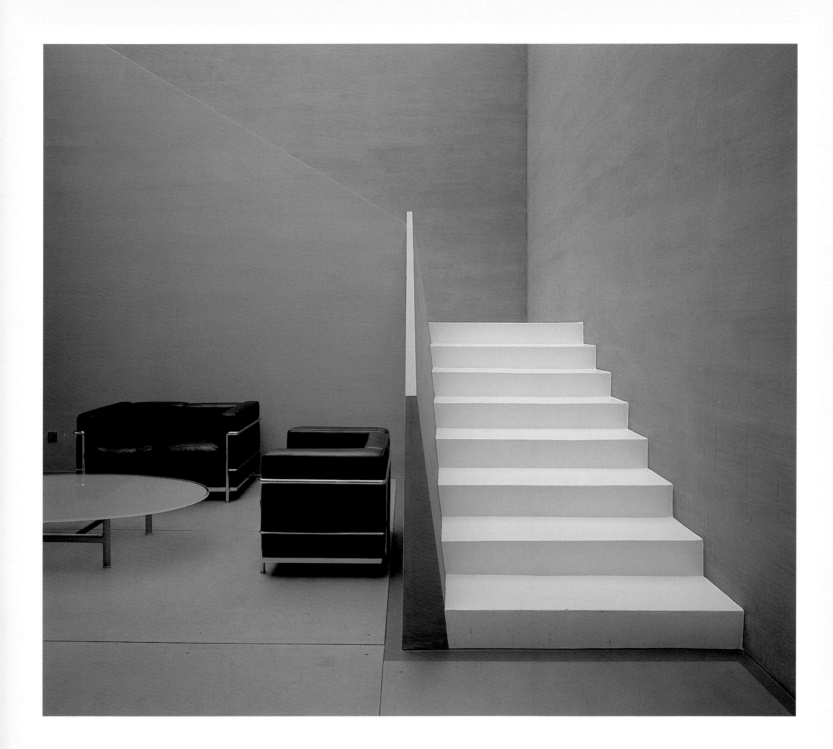

Minimalist qualities and the bold use of color combine in interior spaces to create foci of attention and accentuate contrasts. The use of color, especially warm ones like orange, red and yellow, enrich the visual experience of the different rooms.

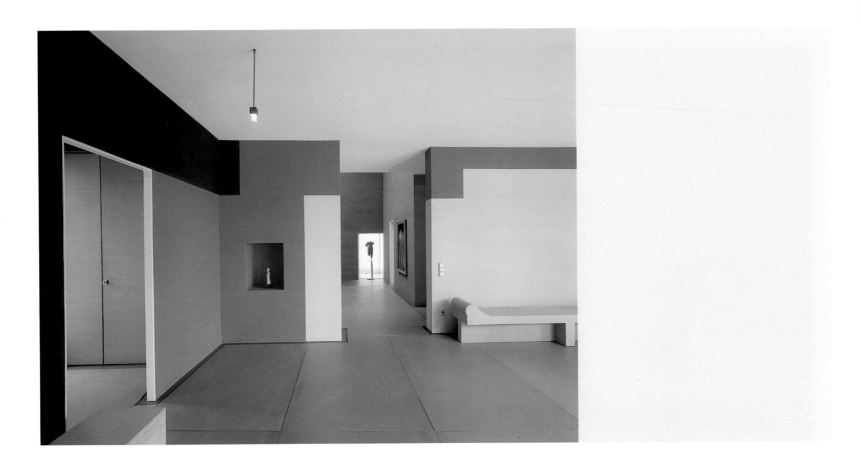

A large insulated window stands where the exterior dining room wall once stood. This adds more visual depth to the room and greatly increases the amount of natural light it receives.

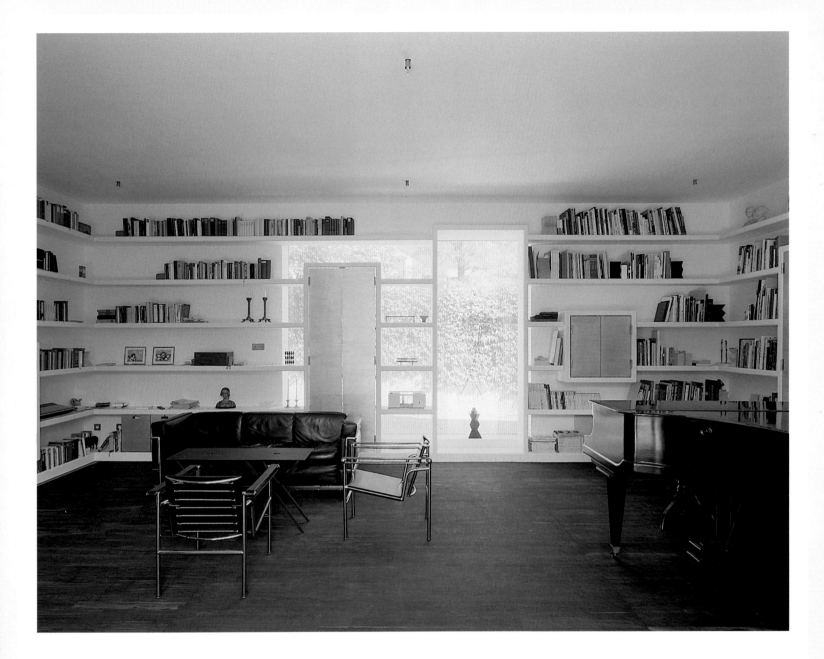

The remodeling gave rise to diaphanous spaces, where natural light may now enter more freely. The new design stands out for the unconventional use of color, appropriating the plastic strength of abstract painting for architectural ends.

House in Torrevieja

Architect: A. Fernández | **Location:** Torrevieja, Alicante, Spain. 2001 | **Photos:** Eugeni Pons

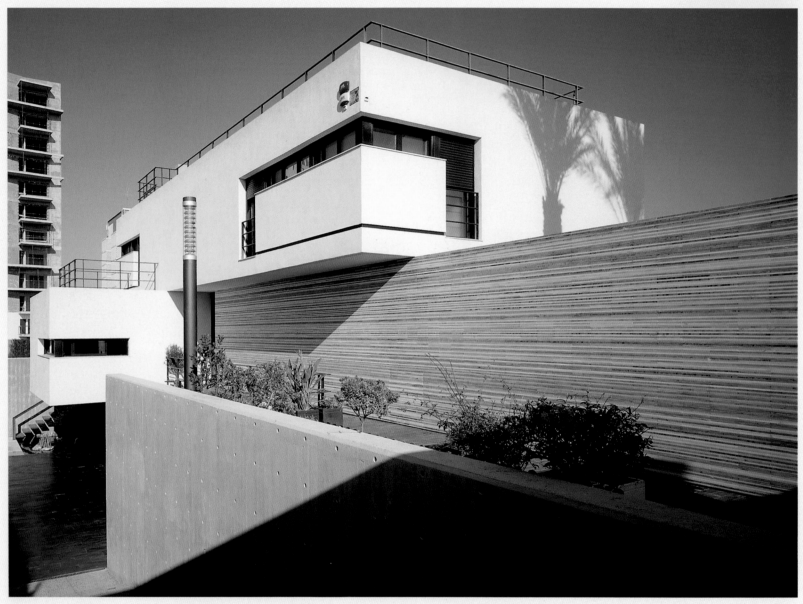

A rigorous balance of proportion defines the home. The intersection of two rectangles forms a right angle, with sides of similar longitude. A wall attached to the main body of the home balances the two sides of the angle. The wall also homogenizes the dimensions of the two buildings that make up the structure. Viewing the building from the interior of the angle, toward where the posterior façade opens up, produces a visual sensation of perfect symmetry between the parts.

The main façade, defined by the play of volumes between the two rectangles, offers a very different perspective. Instead of lining up with one another, the rectangles seem to cross and project beyond the vertex created by the intersection.

The entire building is articulated by its simplicity of line. From the front façade, the only element that appears to interrupt the linearity of the surface is the positioning of the upper floor windows. The windows play with elemental geometric forms through the combination of vertical and horizontal lines.

In the façade opening to the garden, dramatic differences in design approach to the two levels may be observed. The lower level exemplifies an open space design, where the structure is barely perceptible. Simple concrete pillars are the only visible division between interior and exterior. This makes the living room space a kind of open-air porch thanks to sliding enclosures tactfully camouflaged within the structure. Upper level interiors are hidden behind a much more closed façade, the only openings being two large windows in the center.

A distinct feature of the home is the wall that crosses the main body of the house. The wall extends toward the exterior and consists of superimposed black-and-white marble plates, producing an interesting optical effect.

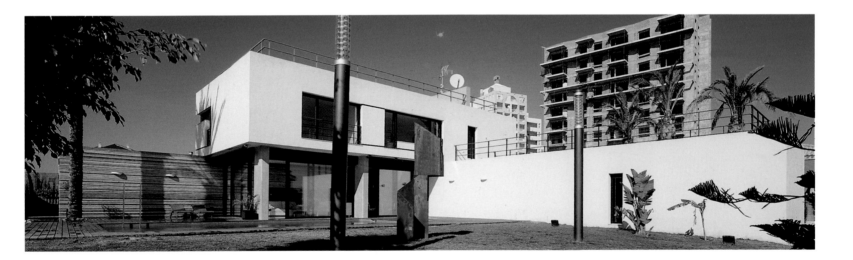

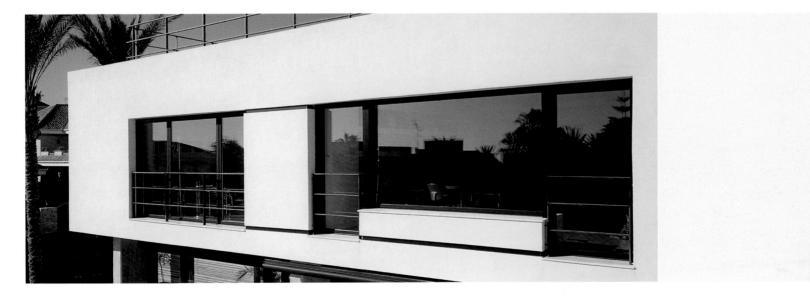

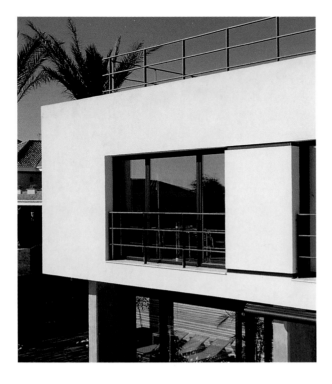

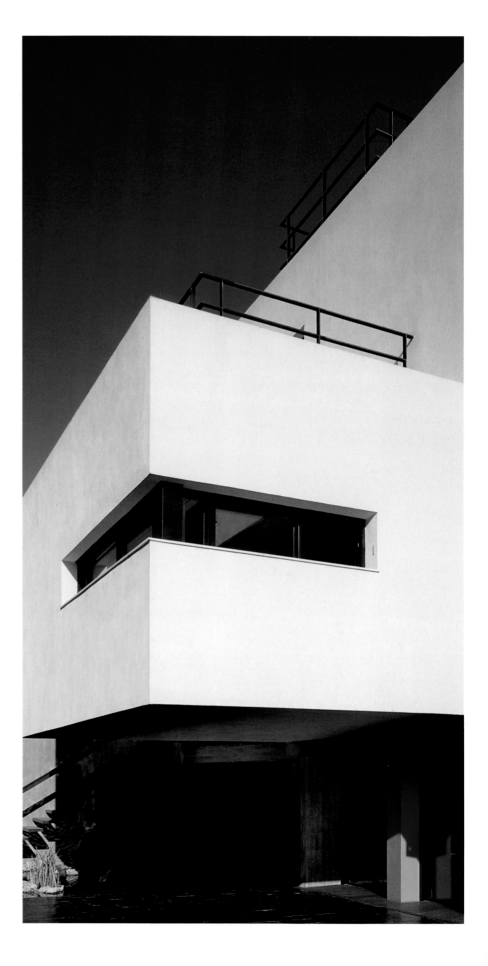

A building with perfectly balanced pro-
portions results from the inter-section
of two rectangles, despite the differ-
ent dimensions of each rectan-gle. The
exterior-oriented extension of the con-
taining wall of the main building
equalizes the longitudes of the two
rectangles. This creates symmetry be-
tween them.

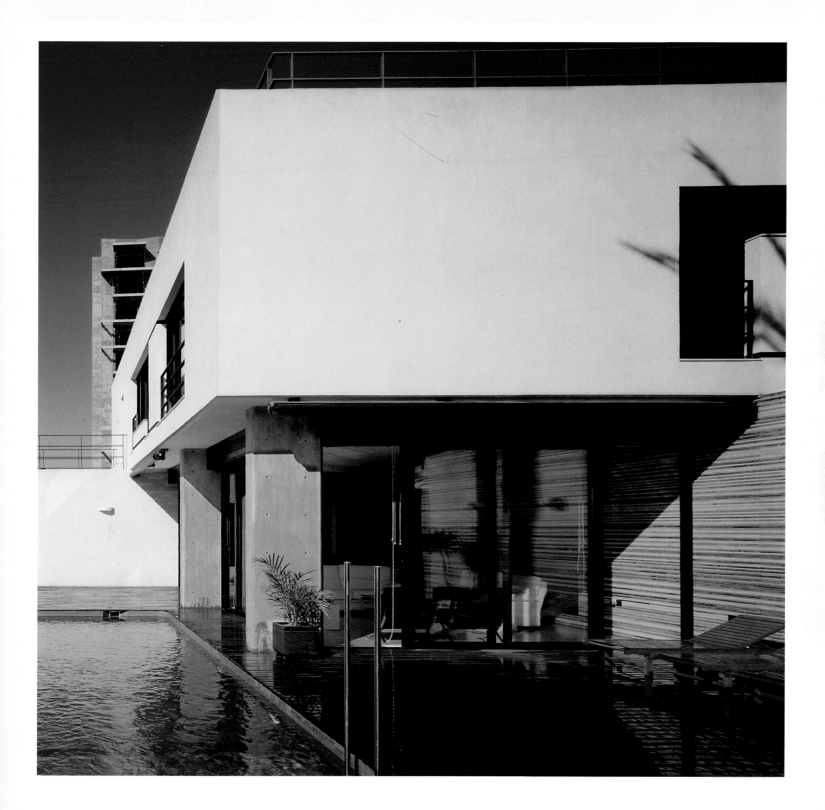

The perspectives from the front and back façades differ radically. Seen from the back façade, the union of the two rectangular blocks forms a right angle. A play of volumes suggesting movement is apparent when the blocks are viewed from the front or main façade.

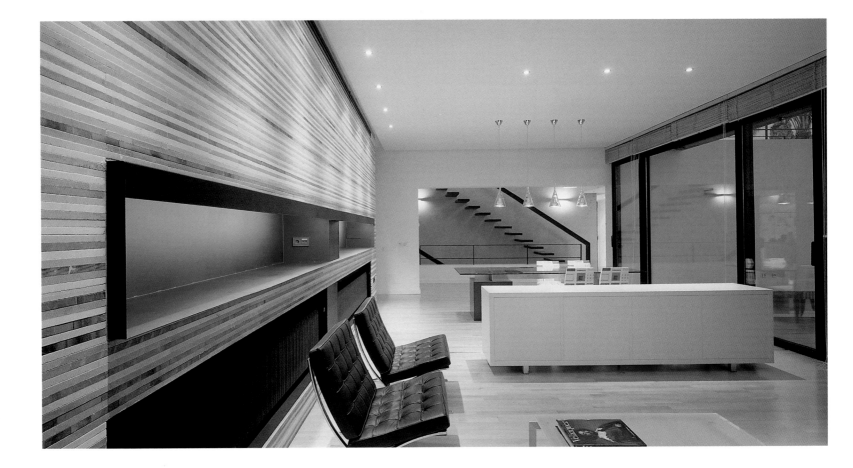

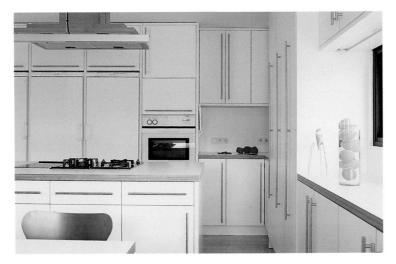

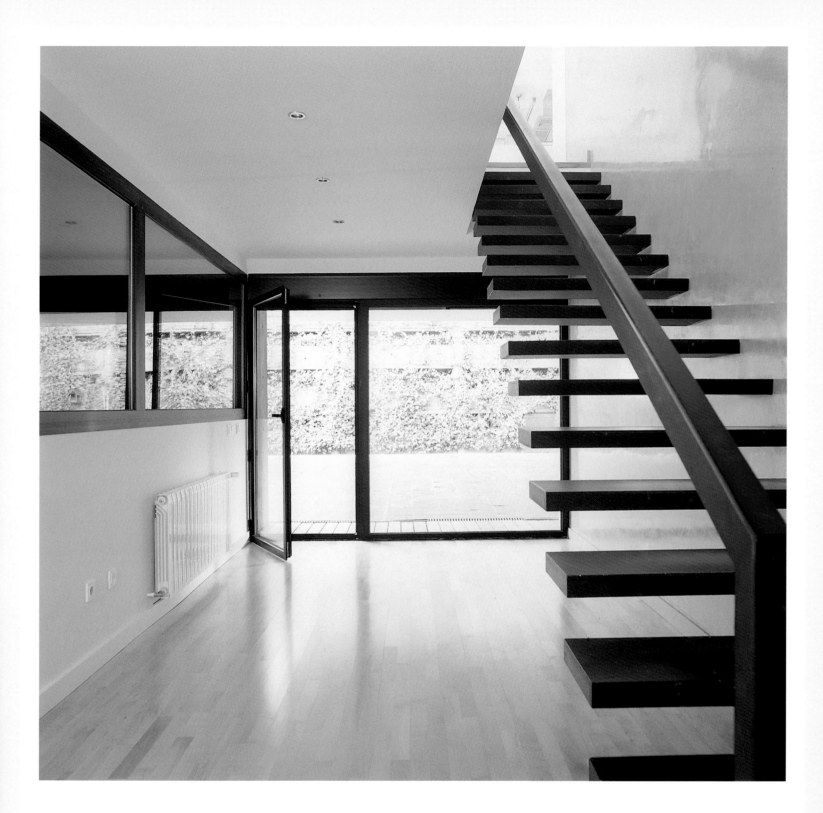

A distinctive feature of the home is the black-and-white marble-plated wall. The wall is note-worthy both as an interior presence, where it acts as a containing wall, and as an exterior one, where it encloses the terrace. The extension also creates visual continuity between the interior and exterior of the home.

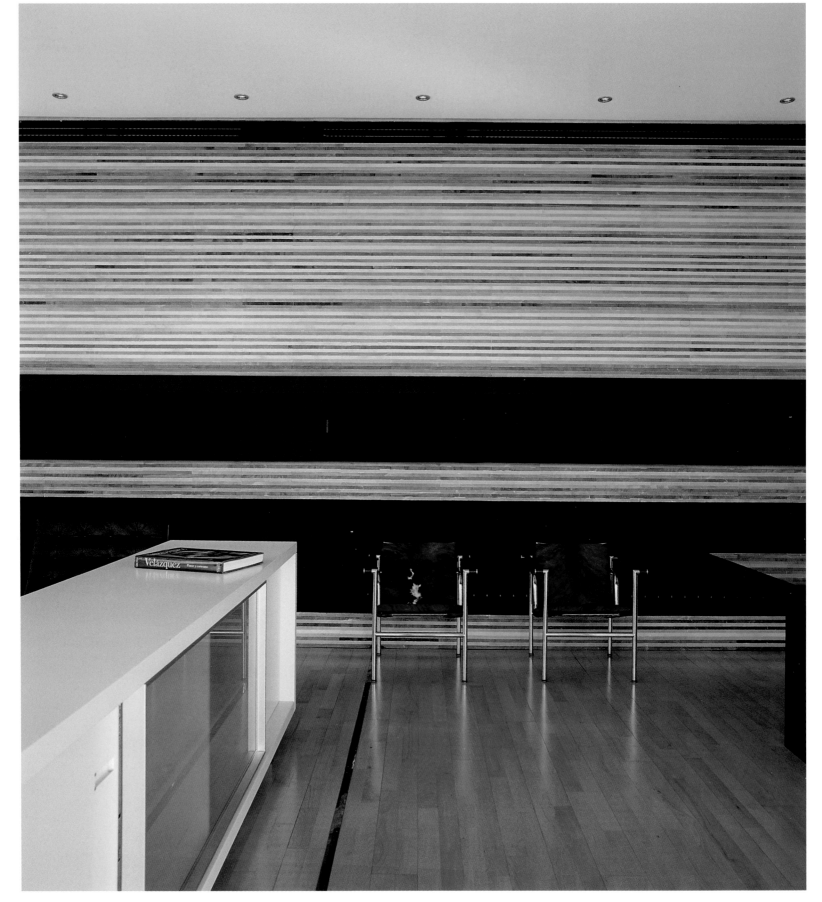

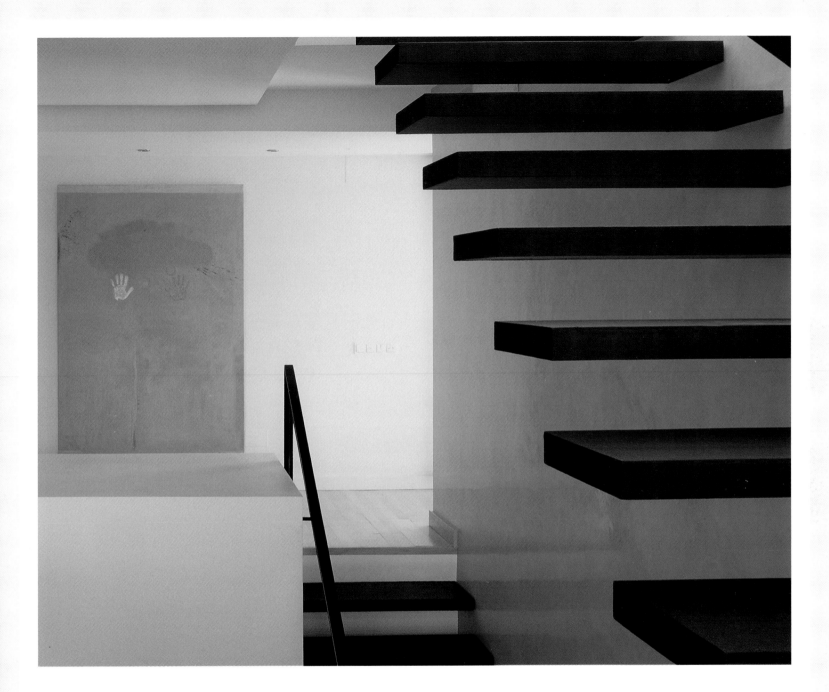

The lower level stands out for its clarity and complete openness to the exterior, due to the subtlety of the structure. In this space, a marble wall also functions as shelves that seem to be sculpted from the stone.

Sekine Dental Clinic and Residence

Architect: Edward Suzuki Associates | **Location:** Saitama Prefecture, Japan. 2001 | **Photos:** Furutate Katsuaki

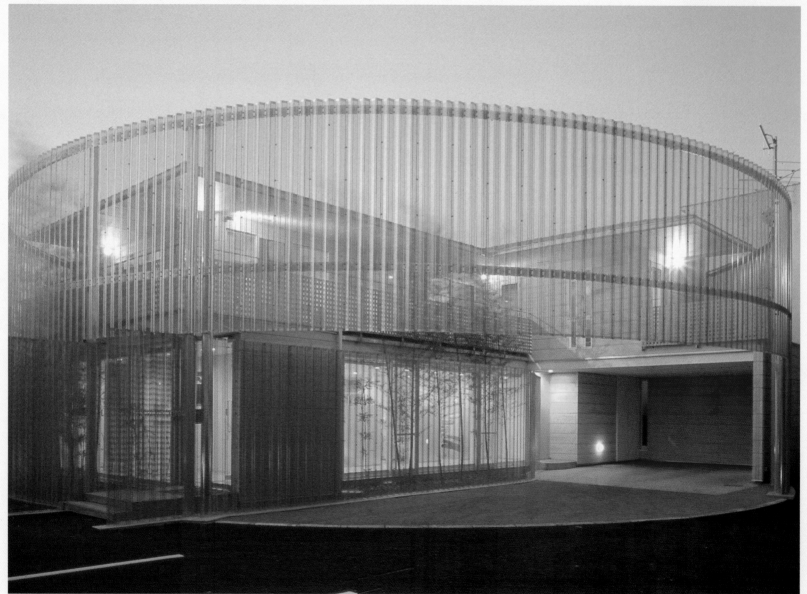

Much of Edward Suzuki's work explores the significance of conceptual duality in an architectural design, dichotomies that reflect the complexities of "man in the world" (e.g., life-death, good-bad). Architecture articulates this tension between two positions through the application of spatial concepts such as open-closed and interior-exterior. Not only spatial characteristics but, in certain respects, the geometry of the structure as a whole yields to duality. The design, which consists of a dental clinic and a home, verifies

this fact. The design volume shields the ground-floor clinic (111 square meters or 364 square feet) and second-floor home (105 square meters or 344 square feet) from the outside. Two geometrically distinct volumes –a circle and an orthogonal "box"– meet the necessities of the joint structure. The circle is an independent structure of perforated sheet metal. It provides formality while, at the same time, "hiding" and protecting a straight-lined interior element. Neither the circle nor the square predominates. This makes for an inter-esting play of shadows and transparencies, maintaining the tension between the two forms that appear simultaneously along the entire façade. Spatially, this volumetric contraposition, wherein the circle becomes a sort of skin of the structural interior, creates intermediate spaces that are utilized as landscaped zones. These spaces, along with the terraces, act as acoustic and visual guards of interior activity. They assure maximum intimacy in the residential space, despite its spatial contiguity to the clinic used by the public.

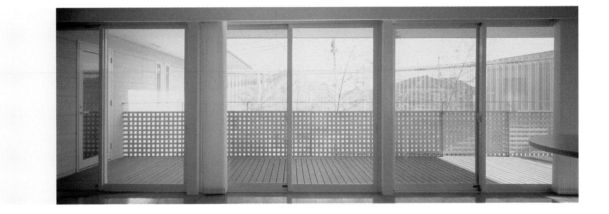

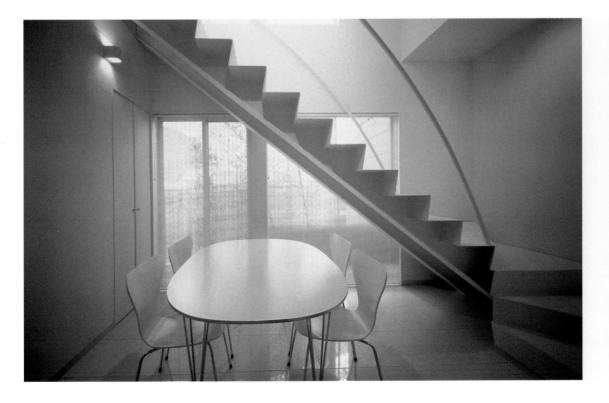

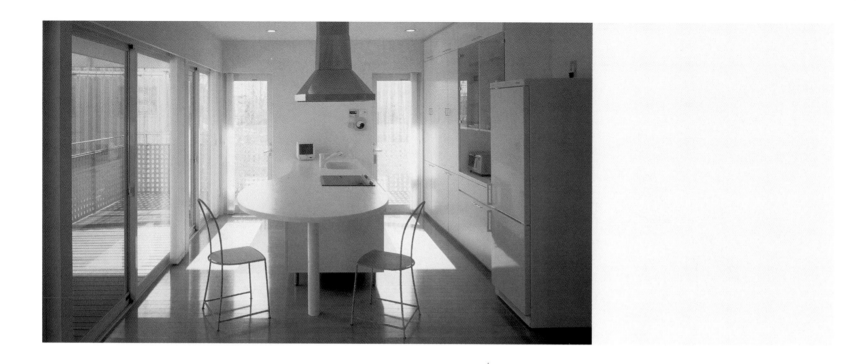

Spatial effects of the design volume define the floor plan. The "residual" space between the two forms creates, at the same time, an ample entry area that serves to organize the public spaces of the building. A strip at back of the house situates the private areas of the home.

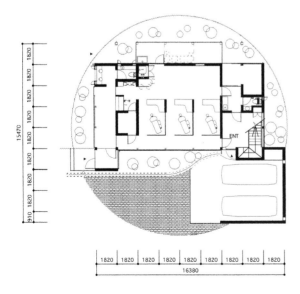

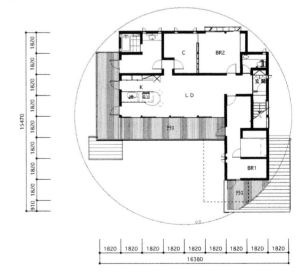

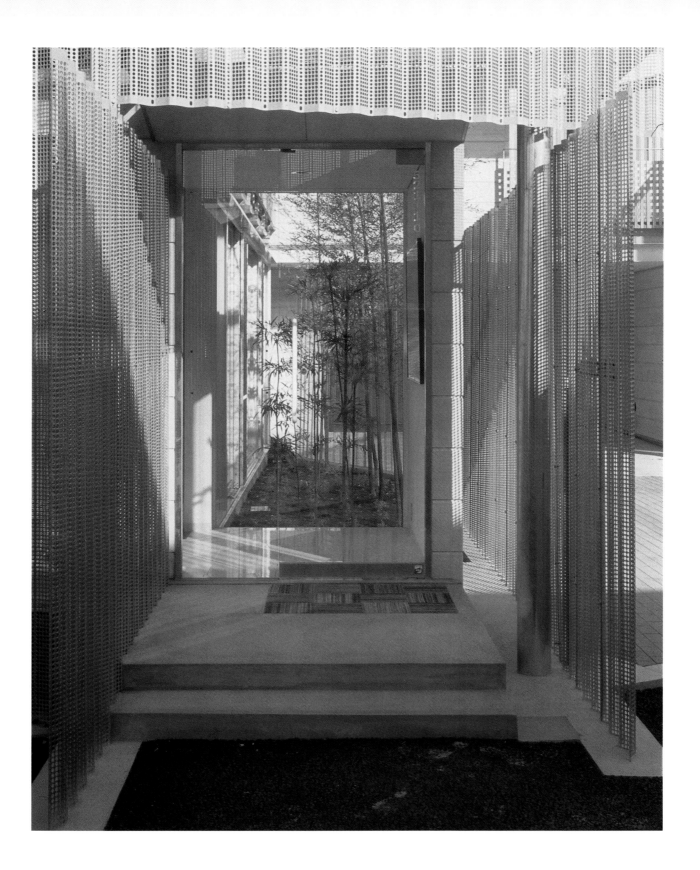

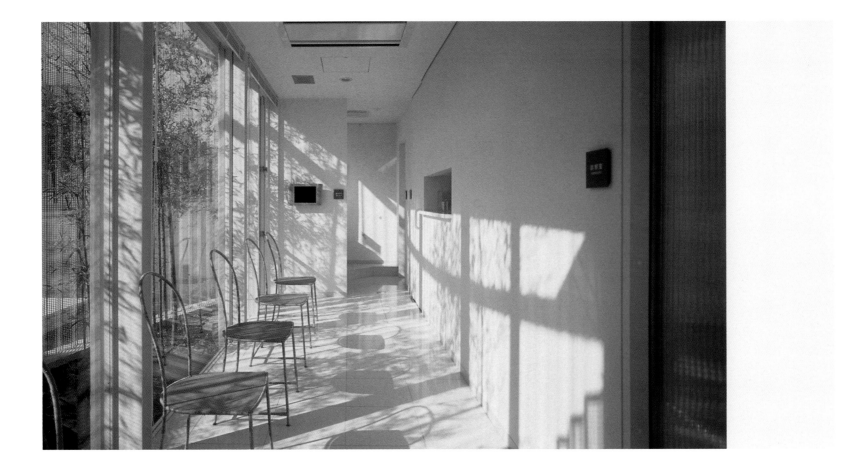

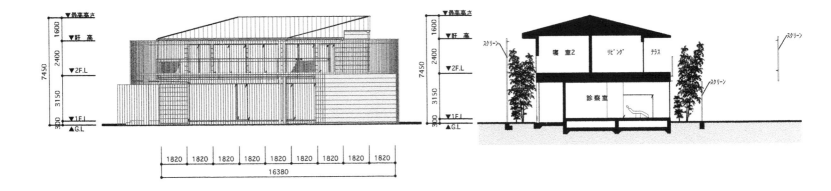

The use of the exterior circle as a protective skin for the interior volume allows both design forms to appear simultaneously. This membrane-like quality of the circle controls the light and gives rise to an intriguing interplay of light and shadow in the interior spaces.

Another Glass House Between Sea and Sky

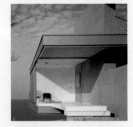

Architect: Shoei Yoh + Architects | **Location:** Fukuoka, Japan. 1991 | **Photos:** Satoshi Asakawa, Hiroshi Ueda

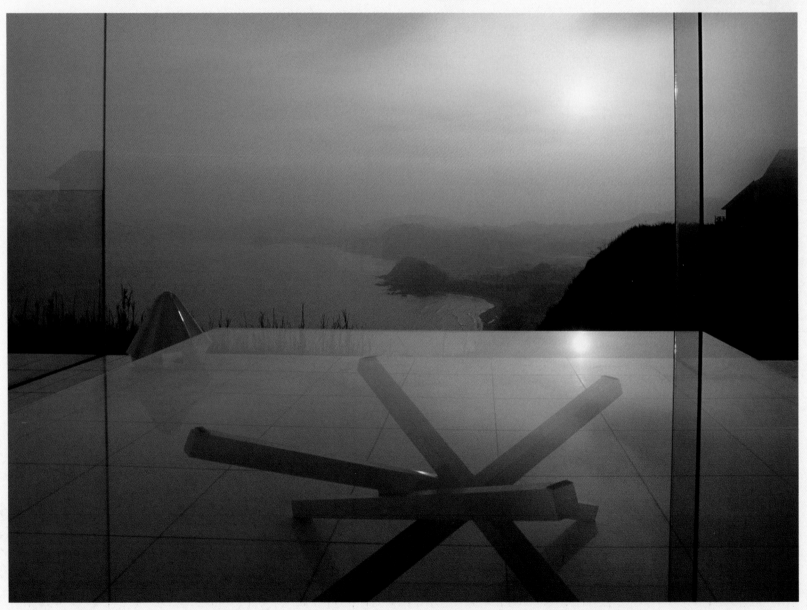

n the 1980's, Shoei Yoh began investigating the relations between his buildings and "place". Beginning with "Stainless-Steel House with Light Lattice", Yoh started to design buildings along the lines of environmental systems, employing constructive and structural methods that grew out of the dialogue established between nature and structure. The result is a relationship between the work and "place" that goes beyond "site location". Through the design of openings, enclosures and structural

approach become active elements of the place in which they are situated. A framework of relations thus follows, resulting in a complex network of tensions intensely related to context. This house, situated on a cliff 140 meters (460 ft) above the sea, bears witness to all of these relations. The cantilever structure allows for the development of new conceptual ideas: a statuesque-like element that "levitates" above the mountain is juxtaposed to the firm presence of the two structural walls. The tension generated between "place" and structure is reinforced by the duality that results from the treatment of volume and the structure itself.

The two parallel walls serve as an anchorage. They contrast with the transparency and lightness of volume of the house, which challenges gravity by projecting itself directly toward the cliff. Beyond the complex relations established with the cliff, however, the developmental simplicity of the ground plan allows for the flexible use of space, opening up the home's privileged views over the sea. At the same time, the geometry of both the ground and elevation plan permits a full appreciation of the structure as a whole, allowing the attention to remain focused on the developmental complexity that underlies the project.

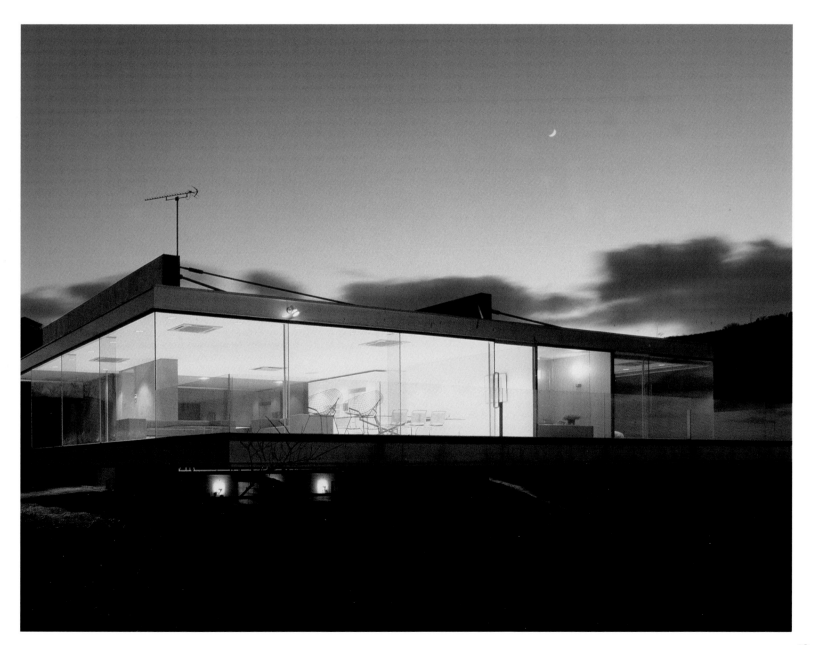

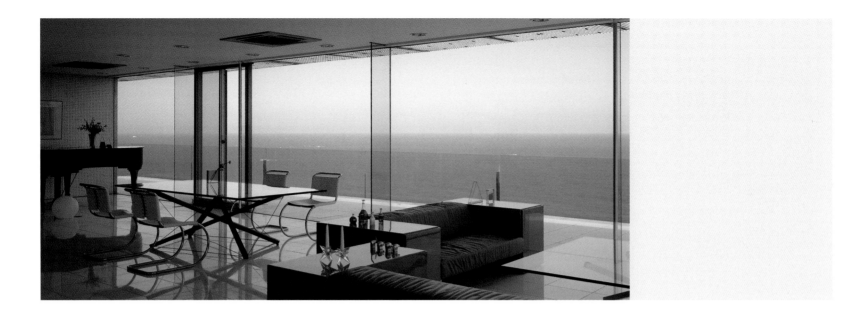

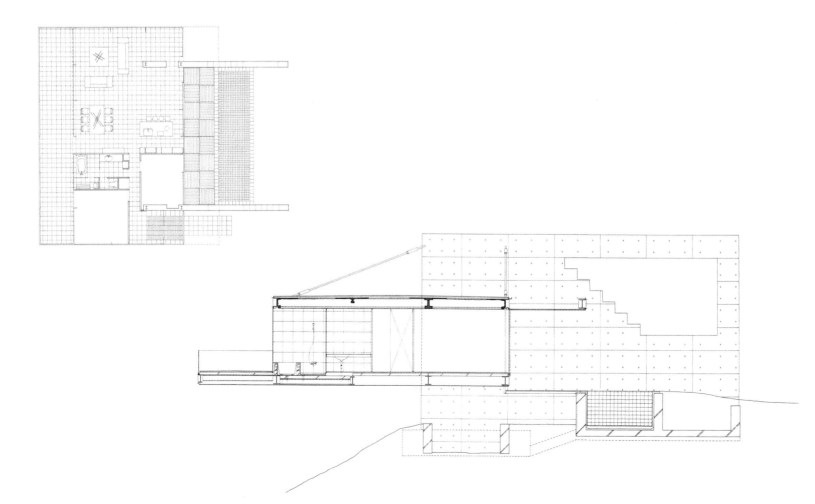

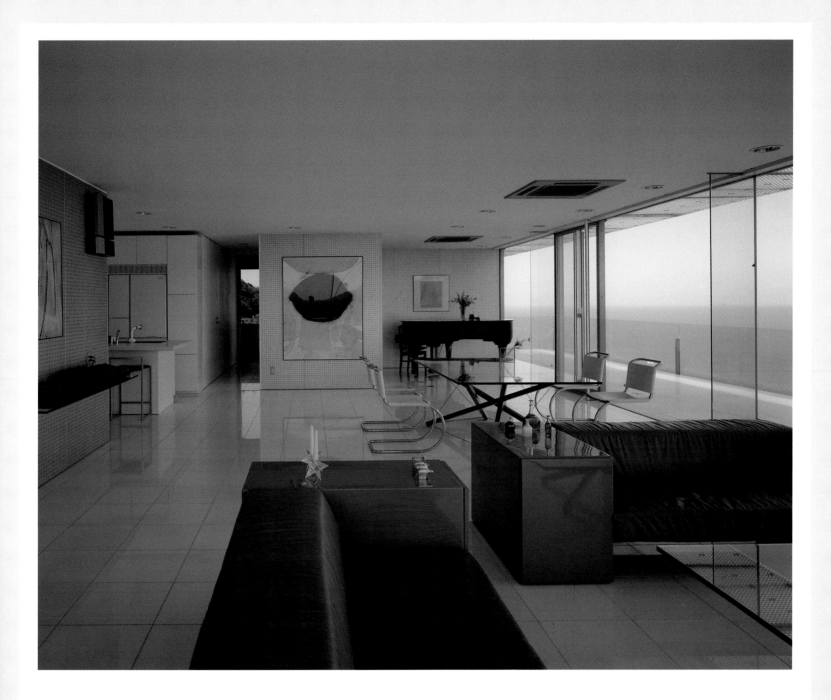

Two parallel walls anchor to the place a simple, light and transparent volume projecting over the cliff. This allows for the enjoyment of sea views from the main rooms of the house. A swimming pool between the walls completes the requirements of the project.

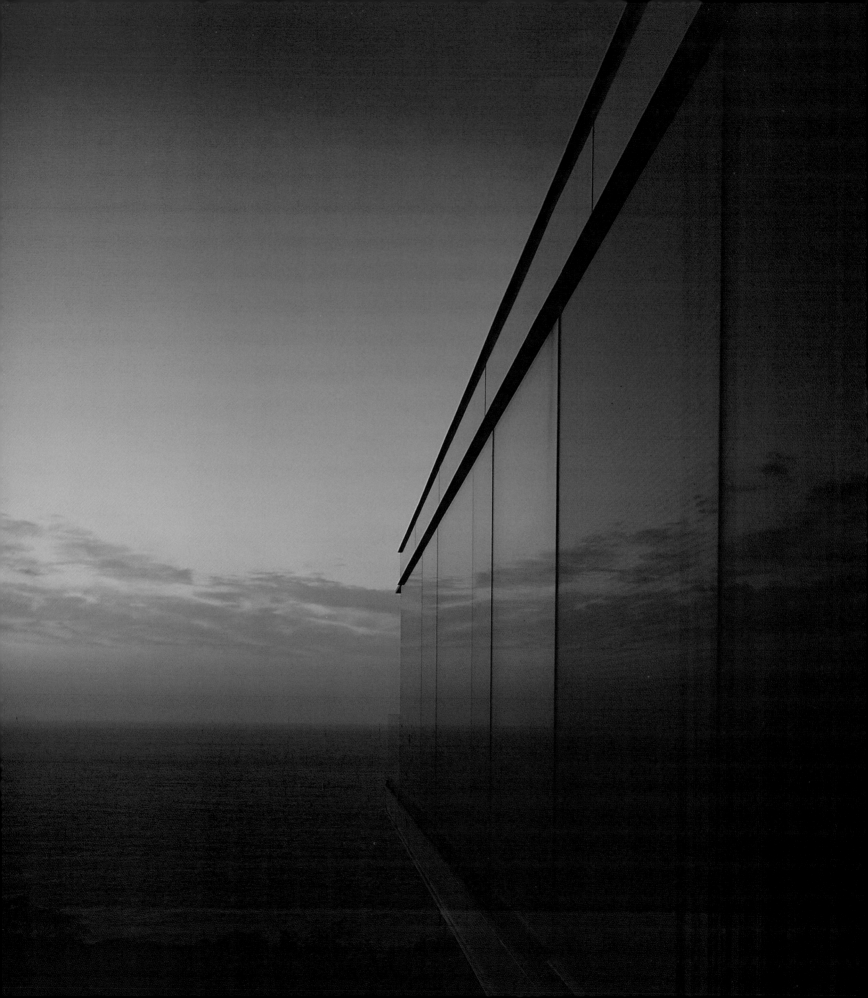

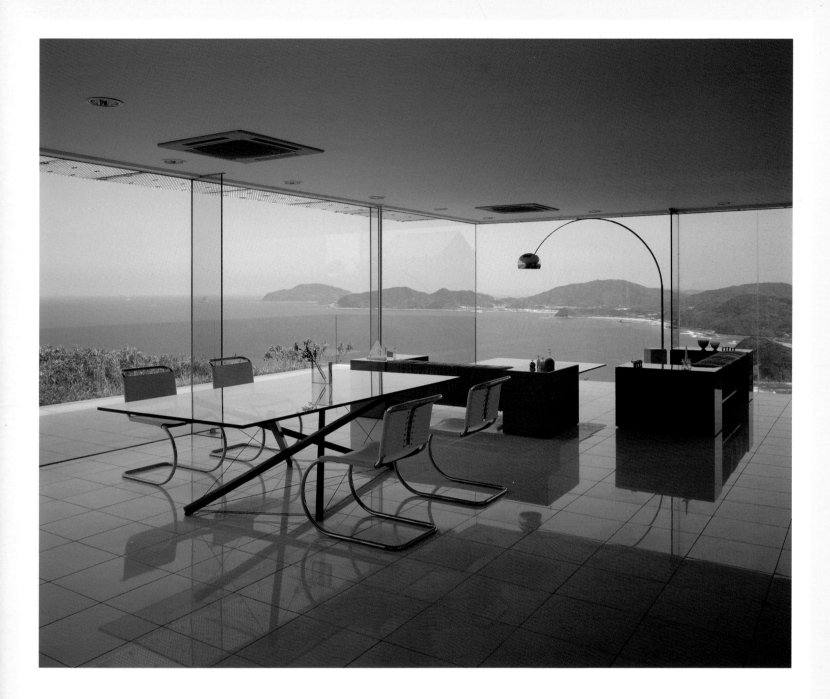

Beyond the complex relations established with the cliff, however, the developmental simplicity of the ground plan allows for the flexible use of space, opening up the home's privileged views over the sea.

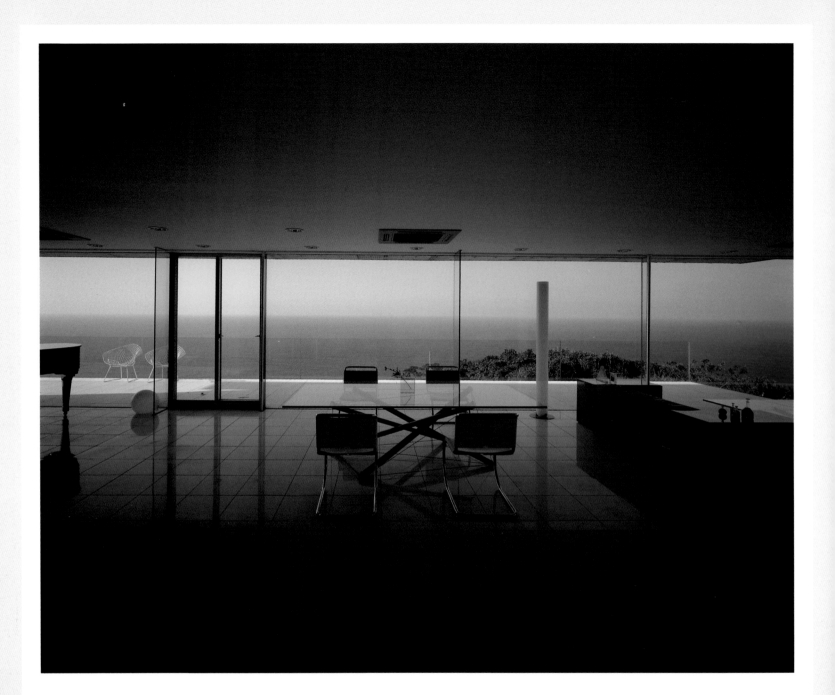

The transparent handling of volume brings about a breakdown of elements. More than a "crystalline box", two horizontal elements –roof and floor– are achieved, remaining vertically separate thanks to imperceptible glass panels.

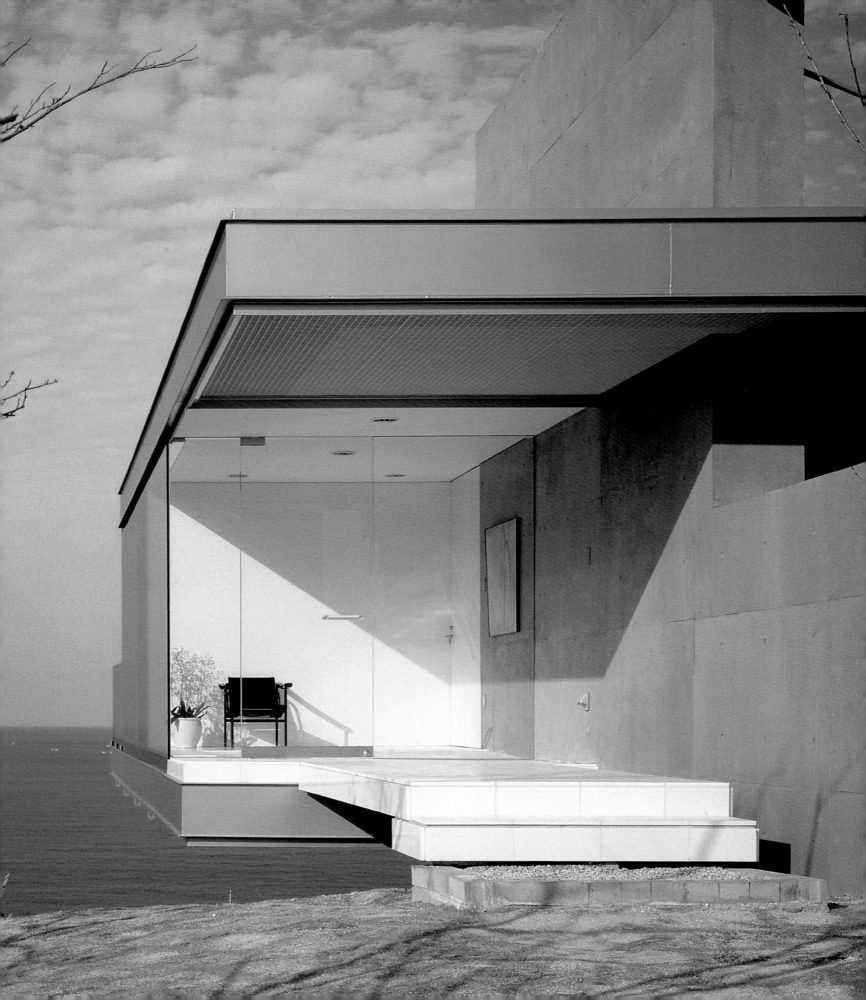

House in Aguascalientes

Architect: Mario Armella | **Location:** Aguascalientes, Mexico. 2001 | **Photos:** Alberto Moreno Guzmán

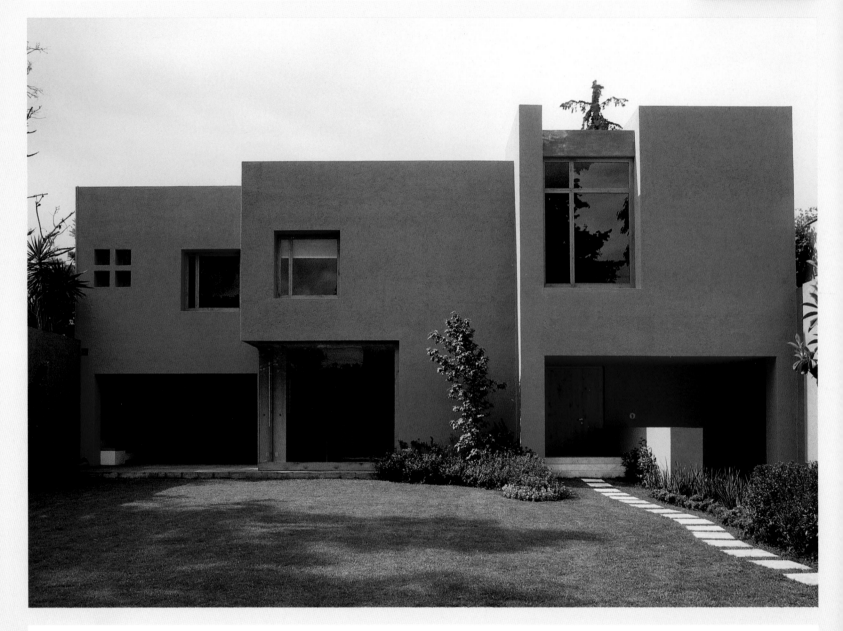

I n the words of Mario Armella, "our philosophy is to create architecture that is contextual and current, making use of contemporary design while at the same time conserving our roots, materials and building techniques." In this way, the design of House in Aguascalientes ties in conceptually with much of contemporary Mexican architecture, an example being the work of the well-known architect Luis Barragán. Armella, like Barragán, employs color as an architectural device, a means of expression aimed at

provoking sensations. The exterior of the home is painted in natural pigments symbolic of the land. Alternate use of terracotta and indigo-blue accentuate façade volumes, creating a sense of depth.

The space consists of flat and pure surfaces that rely on the eloquent strength of color for expression. Transitional spaces are of key importance, given their capacity for surprise. The result is sequential spaces that allow for the smooth transition from public to private, with interiors that gradually emerge as one enters the different areas of the home.

An access gives way to an interior patio with a fountain. Lemon trees and the soothing murmur of water may be enjoyed from inside the home thanks to an opening in one of the transitional spaces, a foyer whose circumference grants it a quality of sculpture. The positioning of the foyer makes it the central axis of the home, defining the spaces and communicating between the different levels.

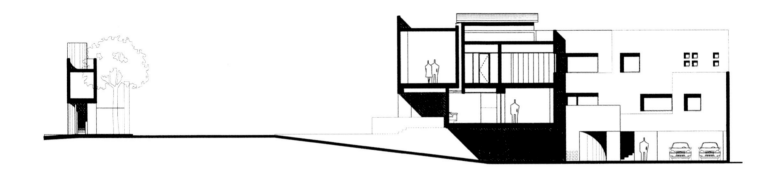

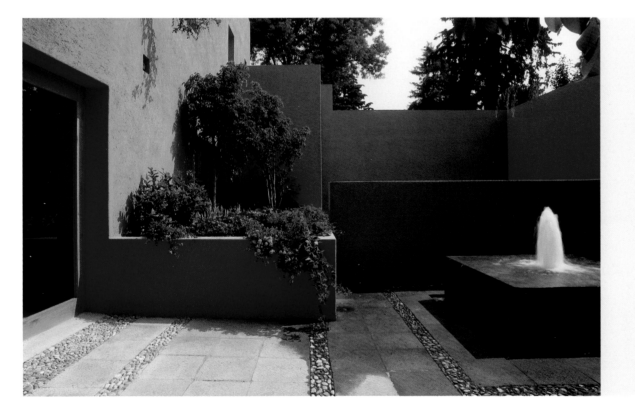

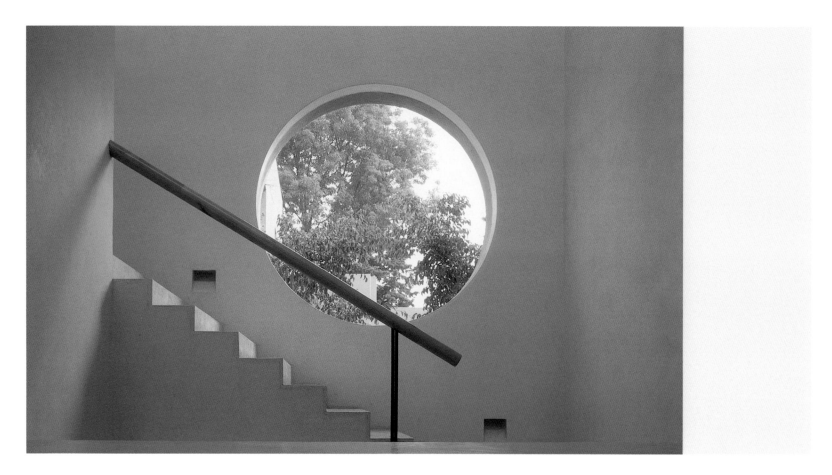

The layered surface of the façade is highlighted by the use of color as an architectural device to create sensations. The rustic application of natural, earth-tone pigments establishes a direct connection with regional traditions.

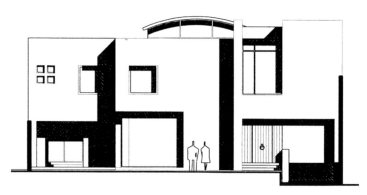

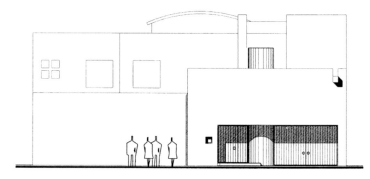

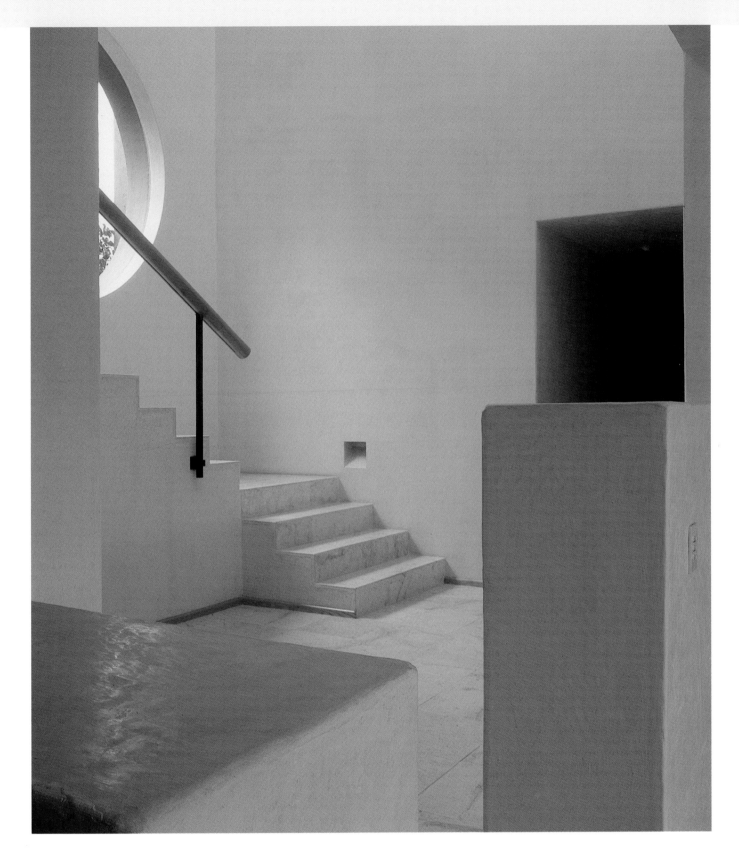

The opening in the foyer's exterior wall functions, on the one hand, as a formal tool that sculpts the space, permitting the observation of diverse architectural dimensions. On the other hand, it establishes -both physically and visually- a direct connection with the exterior.

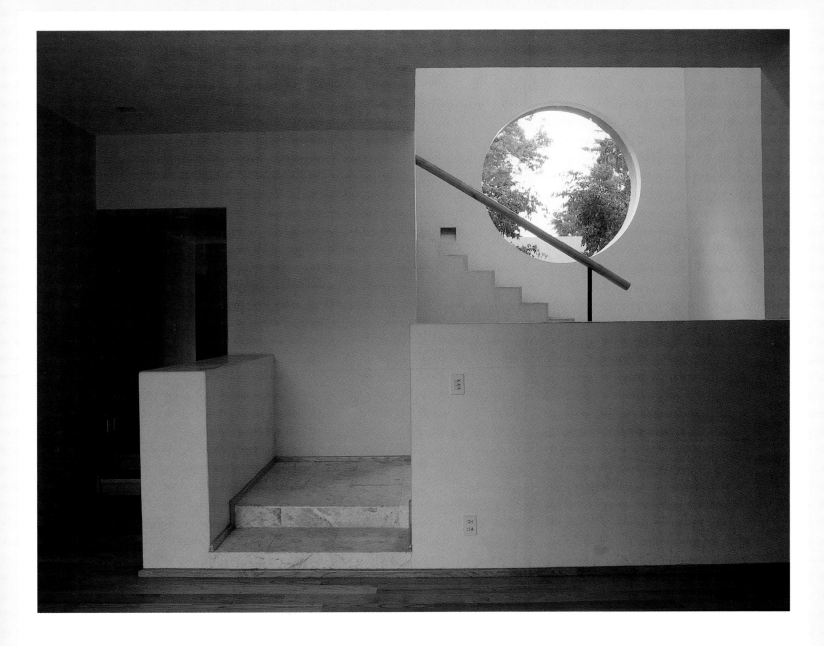

The interior patio, based on the design of La Alhambra, offers a serene and cool environment thanks to lemon trees and a fountain. A circular window allows for appreciation of the space from inside the home.

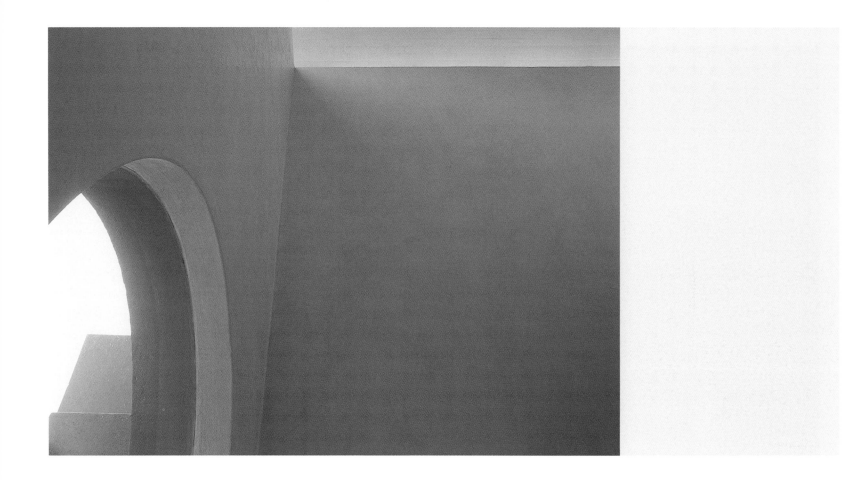

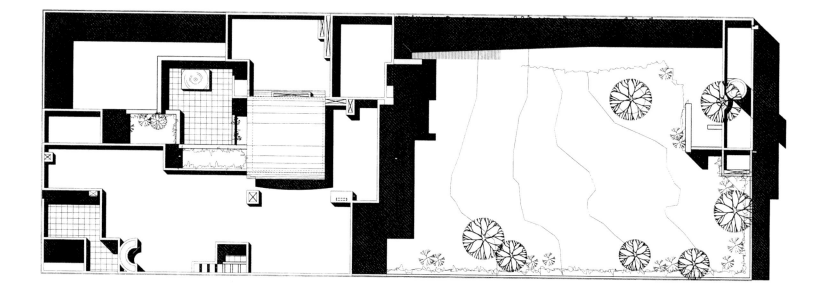

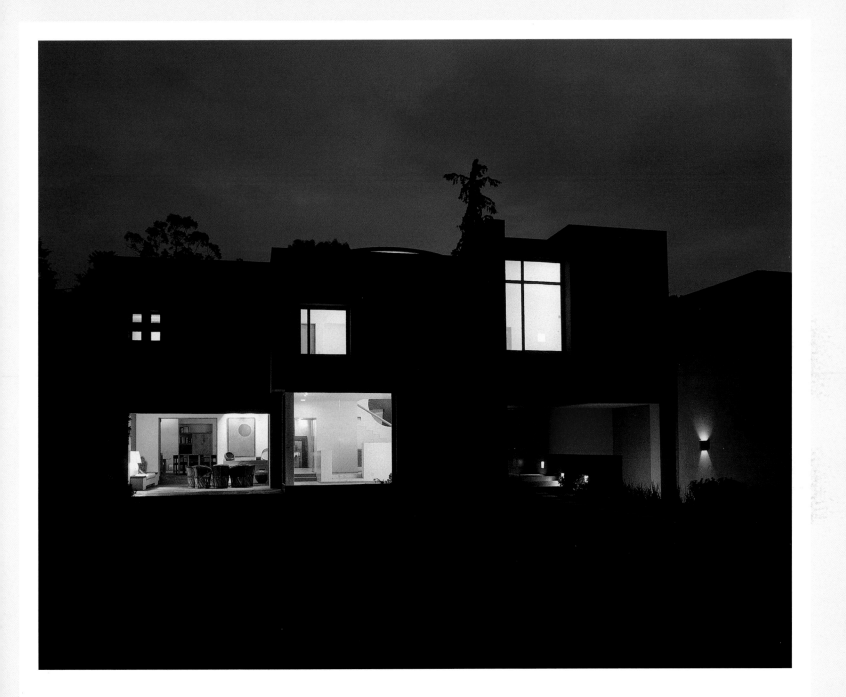

Transitional spaces allow the house to gradually unfold. Sequential spaces stimulate the capacity for surprise.

Katleman Residence

Architect: Marmol Radziner + Associates | **Location:** Los Angeles, USA. 2001 | **Photos:** Benny Chan

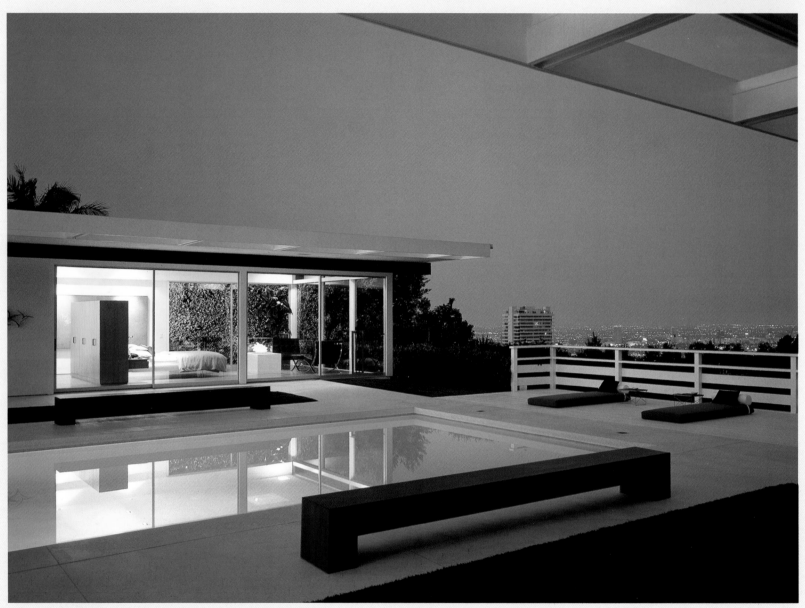

The design of this Beverly Hills home entails the renovation and enlargement of a structure designed in 1963 by Conrad Buff, Calvin Straub and Don Hensman. The house consists of two wings, one containing the bedrooms and the other the communal zones. The wings are organized around a wide patio with a pool. The remodeling aimed at simplifying all the elements of the house and reinforcing the dialogue between interiors and the large patio. This "return to essence" gives rise to a design that unfolds

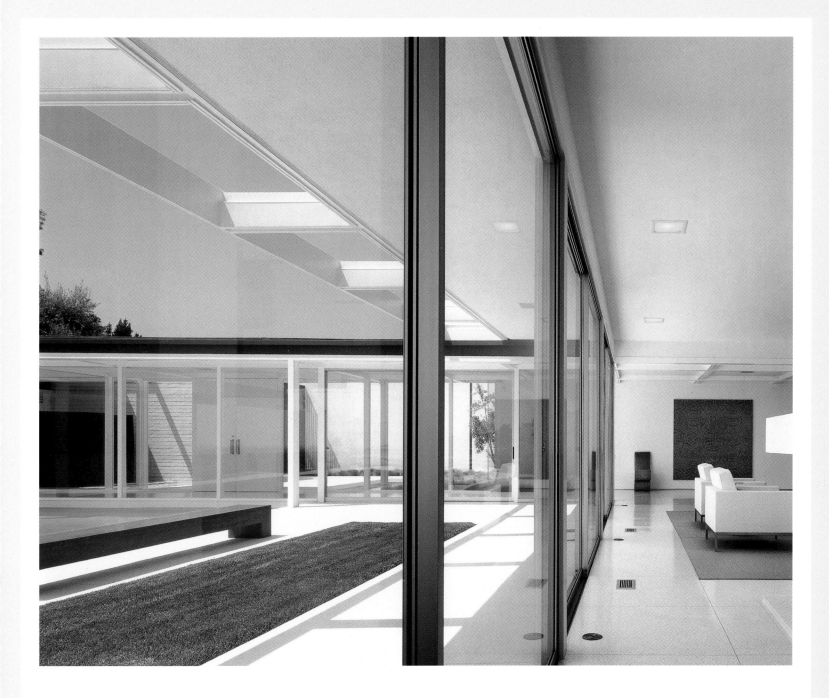

The initial remodeling approach seeks to maintain the modern character of the existing home. With this in mind, the architects put forth a design consisting of basic lines to emphasize the light and luminous character of the house.

Fontpineda House

Architect: A. Fernández | **Location:** Fontpineda, Barcelona, Spain. 2000 | **Photos:** Eugeni Pons

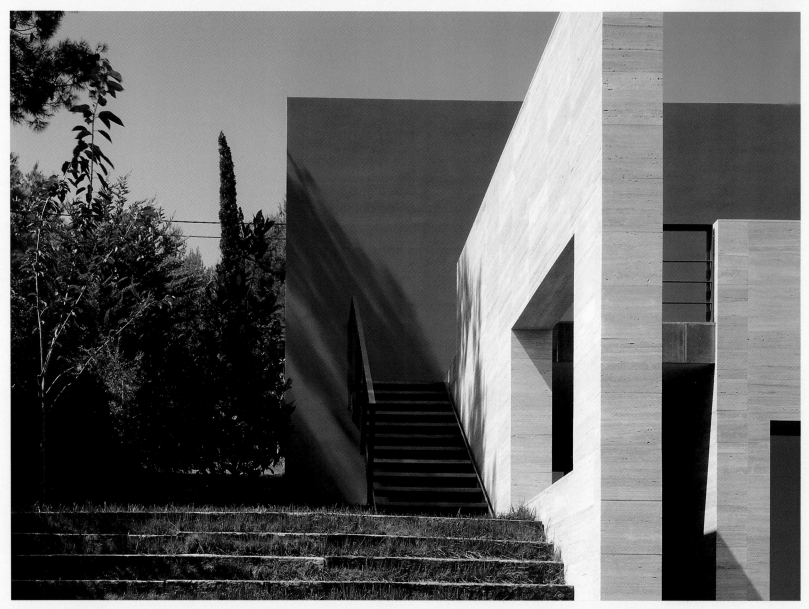

The design of Fontpineda House is defined by the remarkable interplay of levels, which allows for structural adaptation to terrain conditions. The breaking-up of façades into diverse sections also gives the building a certain fluidity. The sections overhang the structure, interrupting its linearity at different levels. From a longitudinal perspective, the three-level structure expands at its center and contracts at its extremes. From street level, the principal façade appears to be the closed surface of a single-level

home. Especially noteworthy is the glass enclosure projecting above the roof, which acts as a cover or framework for the stairwell that reaches the top of the home and communicates between the different levels. The glass projection also permits appreciation of the spatial design of the floor plan.

From the façade opening up into the garden, one may observe the division of the building into two levels. The levels are situated at different heights with repsect to the terrain, and serve to break up the visual uniformity of the façade.

An exterior characteristic of the home that grabs the attention is the use of color. Color's expressive strength becomes an autonomous constructive element. The application of red on certain surfaces underscores outline, calls attention to volume, and creates visual attraction zones that contrast with the polished, off-white stone covering the rest of the façade. The strength of color functions, at times, as a decorative element. The red-painted space left when the wood-slat shutters are closed assumes pictorial qualities that stand out above the pale stone background.

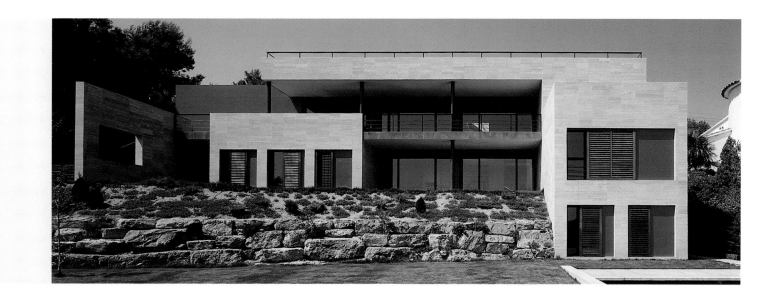

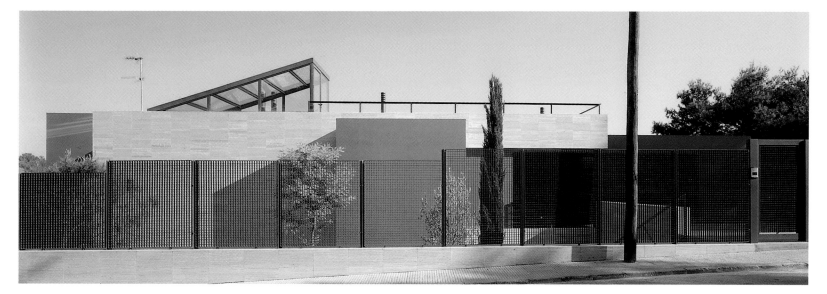

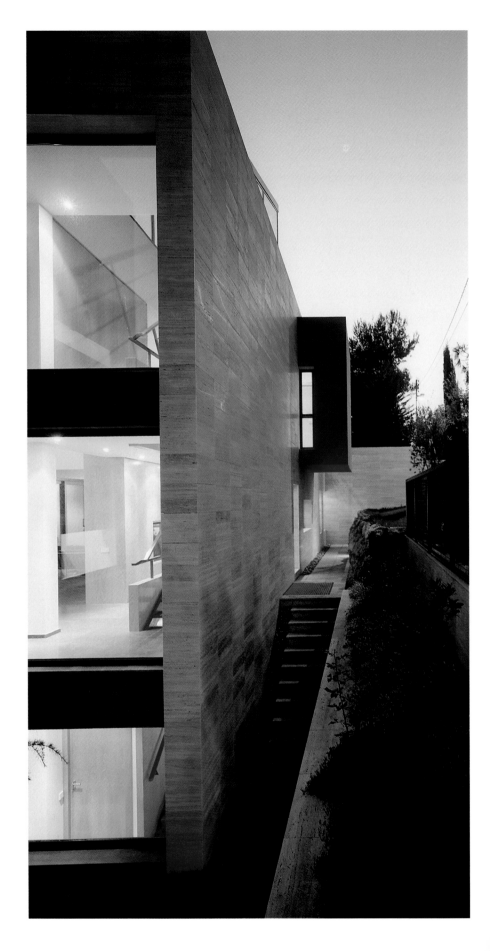

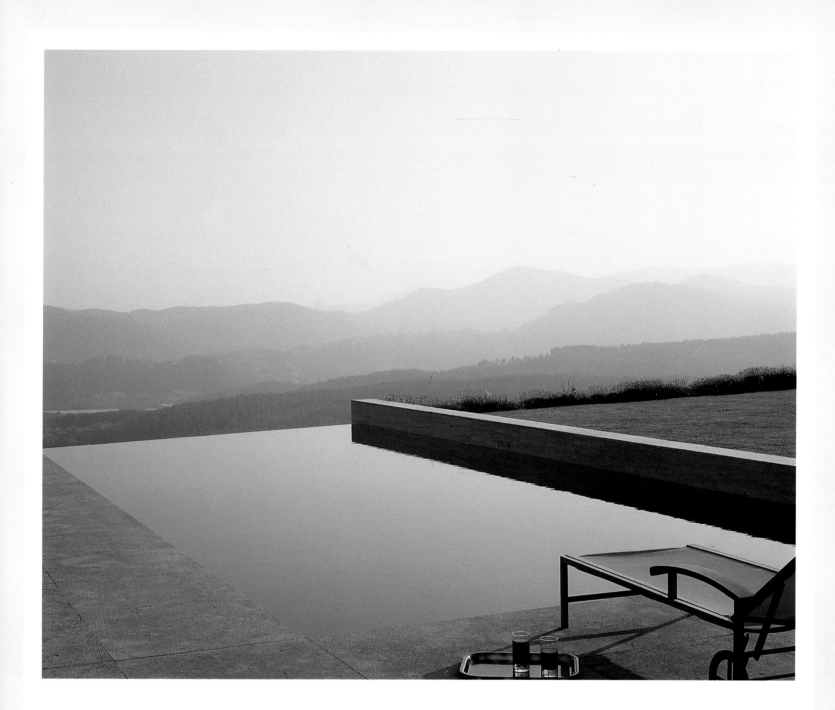

The sloping terrain determined the multi-level construction of the home. Depending on the per-
spective, the structure presents different levels. Looking at the building from the main façade,
only one level appears. Viewed from the lateral façade, the structure is arranged at three dif-
ferent heights. Two floors situated at different levels may be seen from the back of the house.

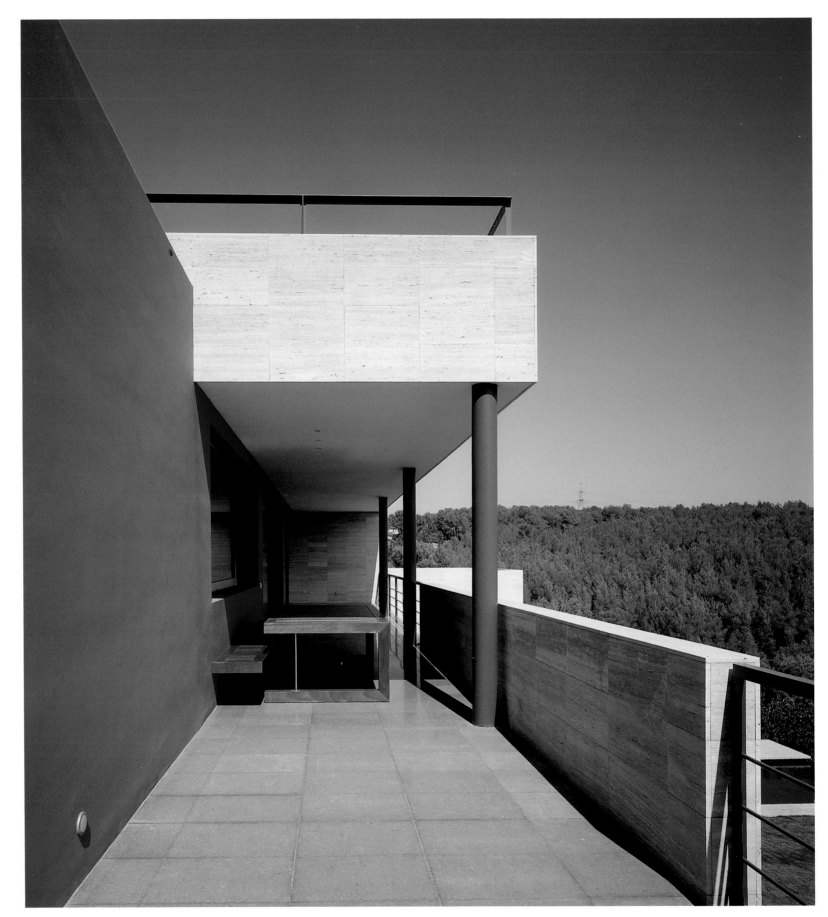

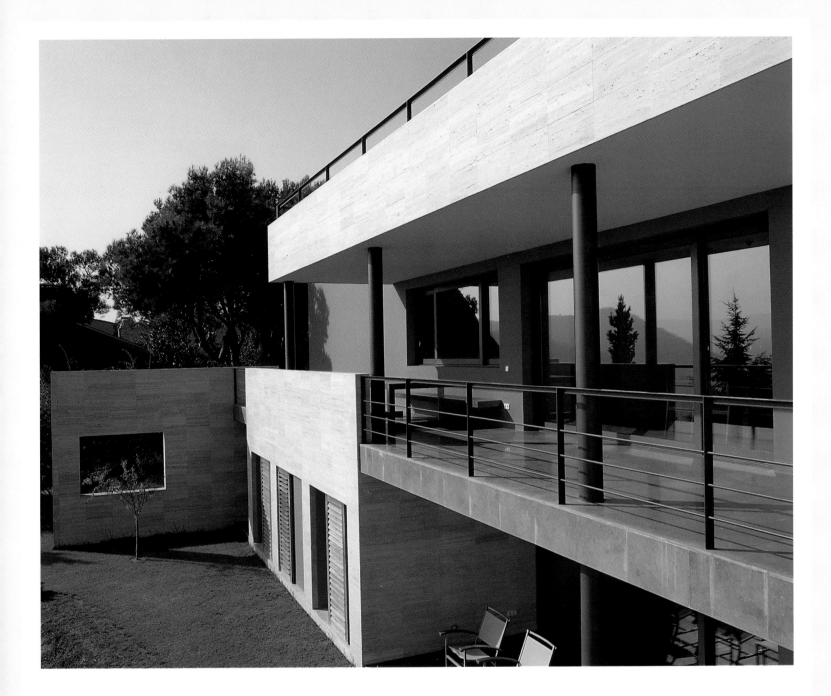

The main façade is noteworthy for the glass enclosure projecting above the roof, which acts as an innovative cover for the stairwell. The glass projection also allows for appreciation of the spatial design of the floor plan.

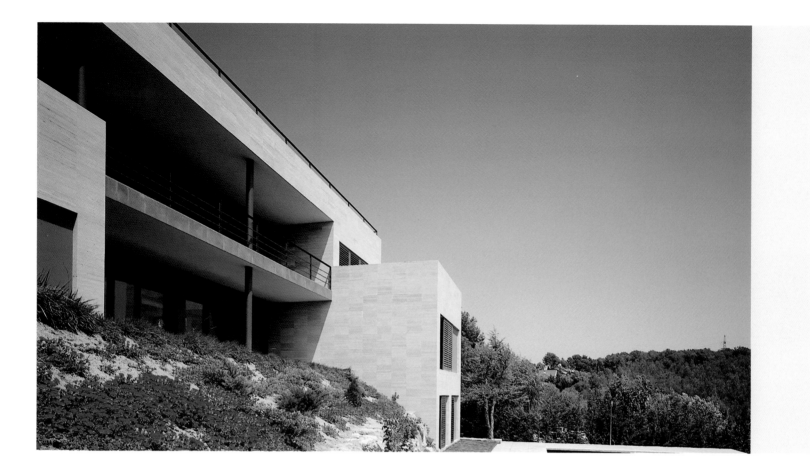

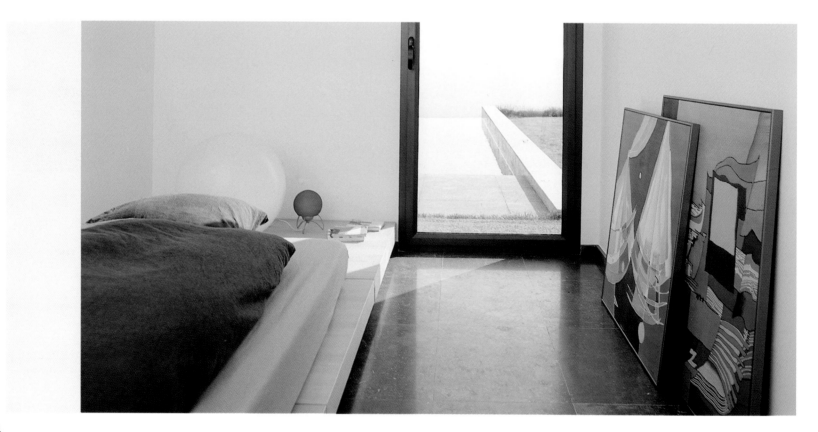

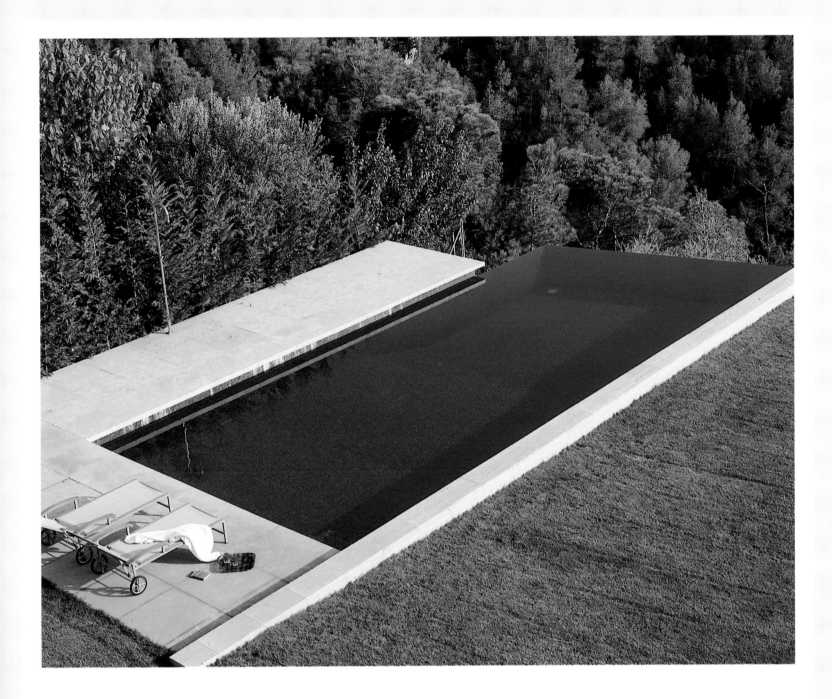

Color takes on architectural and decorative qualities in the home. The rotation of red-painted and polished stone surfaces creates contrast zones, accentuating certain volumes and outlines while softening others.

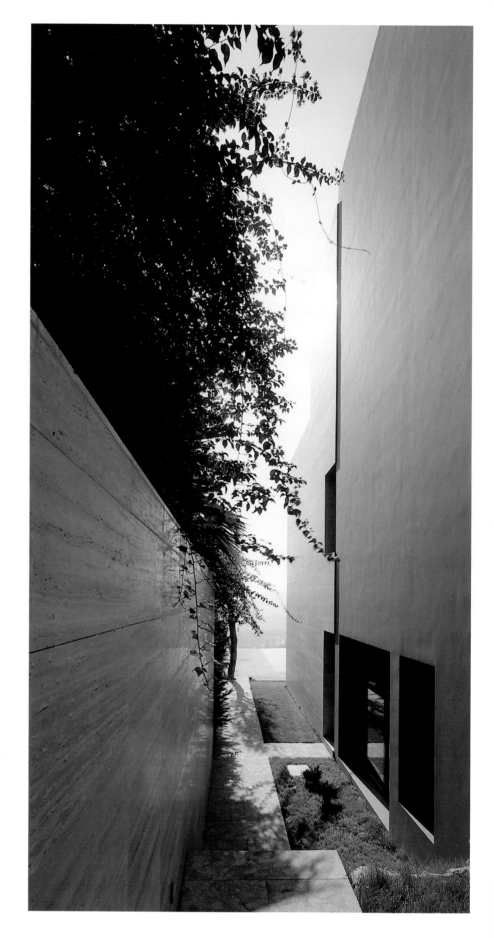

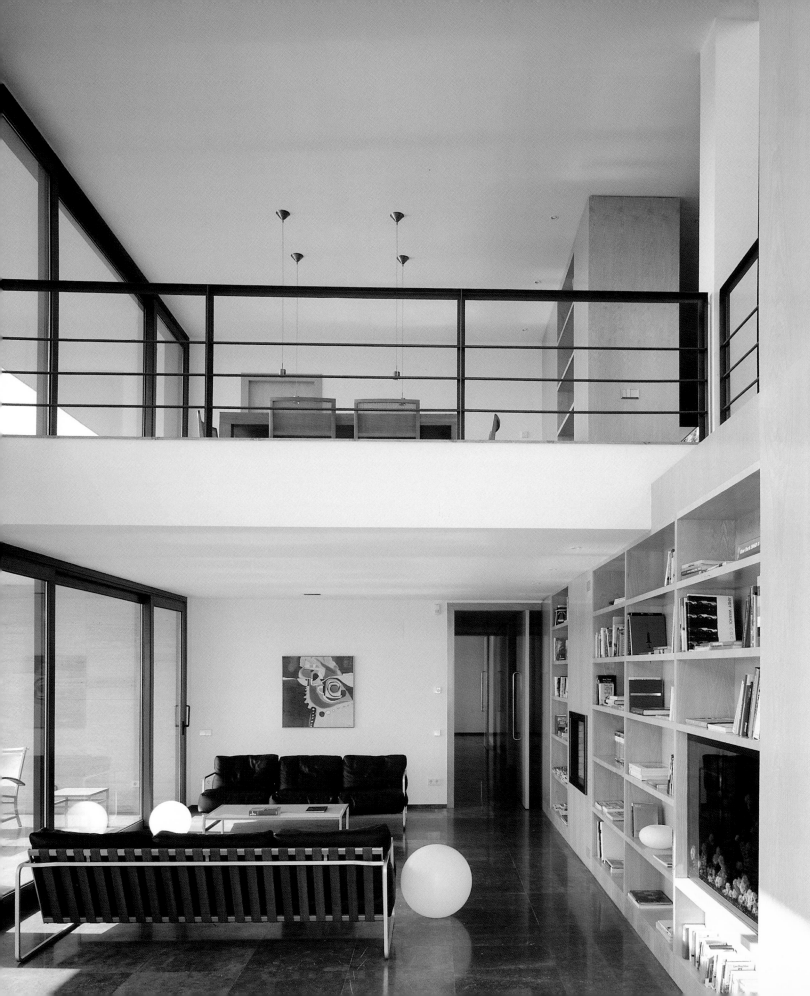

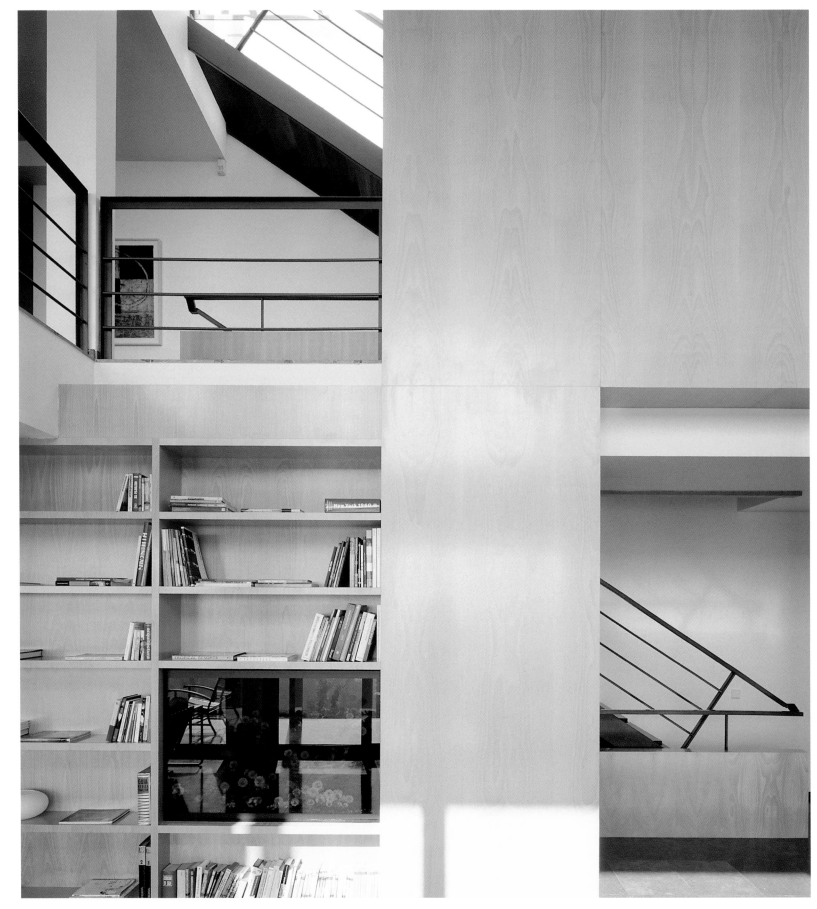

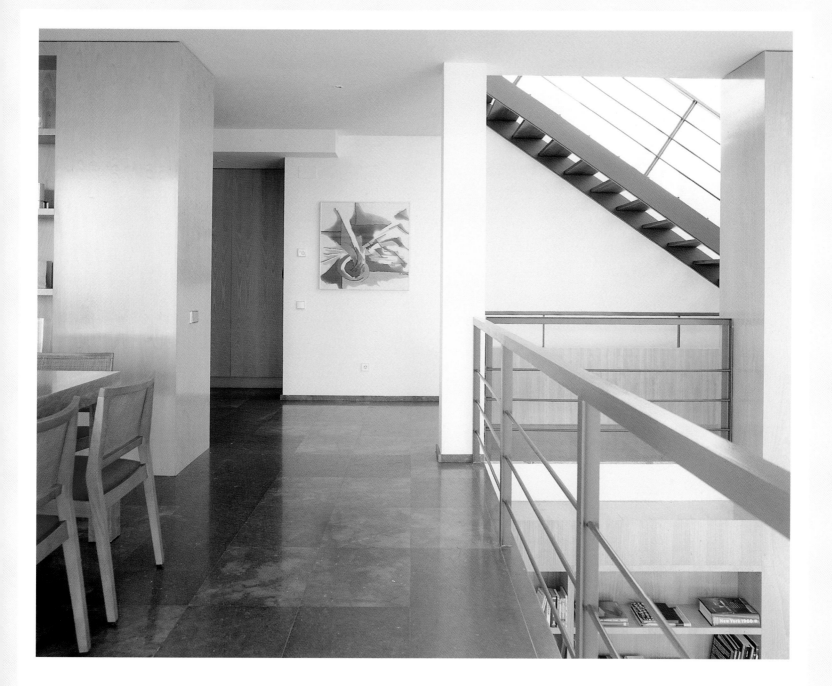

Interior spaces are organized around a central atrium situated in the living room and scaling the structure. The second level, where the dining room is located, was designed to offer to a complete view of the living room below.

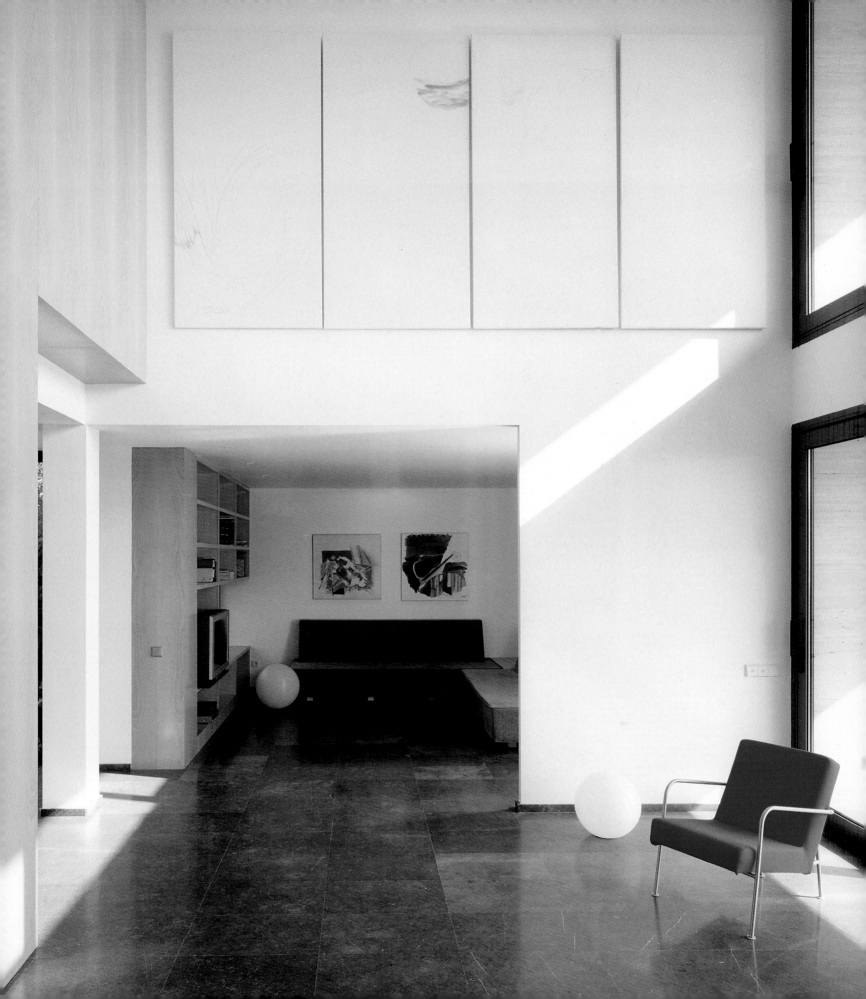

S House

Architect: Toyo Ito | **Location:** Ogumi, Japan. 2000 | **Photos:** Nacása & Partners

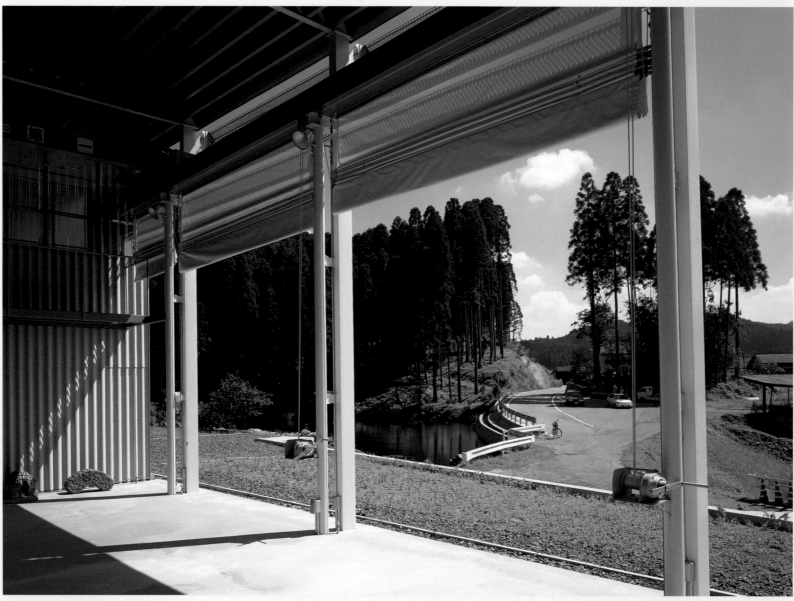

Toyo Ito's designs rank among the most innovative and revolutionary of recent years. His architectural language is characterized by organic arrangements centered on the transformation of nature, transparency, and open spaces. For Ito, wind and water are the strongest elements in nature, and their constant movement is linked to the energy of the constructed environment. In Ito's philosophy, the event takes precedence to the object. This is true of a pavilion designed specifically to admire a cherry tree in full bloom.

Here architecture takes the ideal form of a filter of light conditions and air, permitting optimum viewing of the tree.

In the case of "S House", the "house as event" was defined by the owners, an artist couple who wanted their home to serve simultaneously as workshop, cultural center, and center to exhibit their own work. The owners favored a direct relation to the exterior so that neighbors or curious passers-by could view their artistic activities.

Completely open spaces alternate with spaces that are closed with prefabricated elements and unfinished materials. These divisions convert, in the interior, into vertically translucent "skins" that play with the diverse effects of light. The design of a clear area or level does not seek a homogeneous effect. To the contrary, its aim is to create differentiation, which here is achieved through subtle variations that suggest a change of activity.

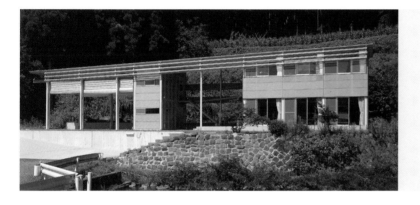

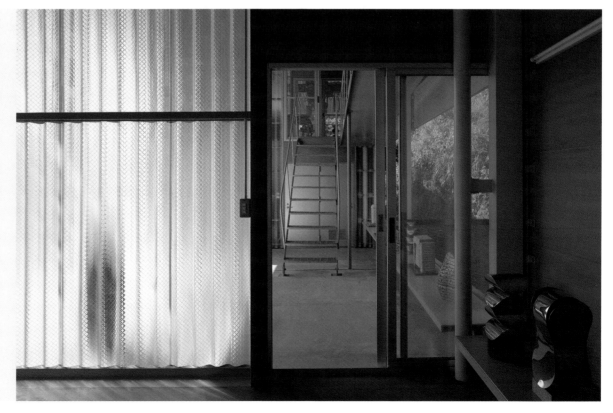

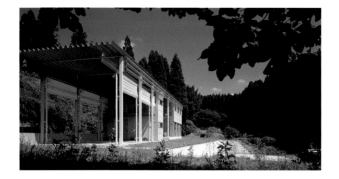

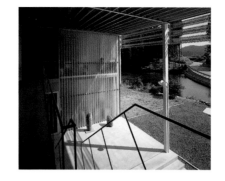

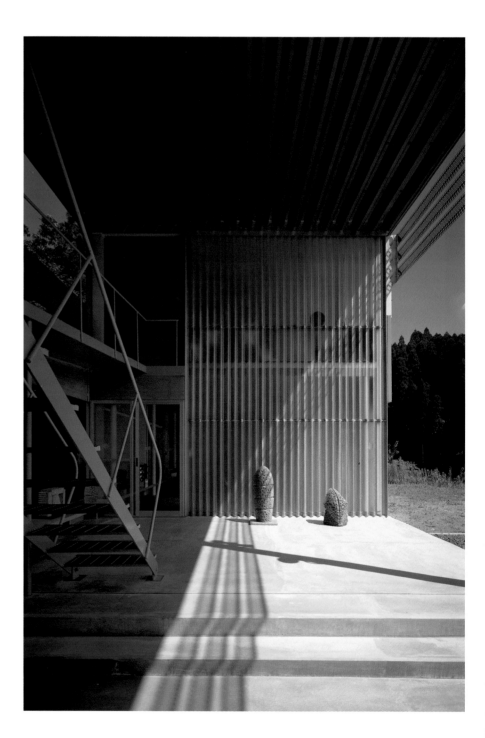

The home is situated on the bank of an artificial pond beside a mountain slope. The architect was not concerned with integrating the structure to the landscape through topographical modification or adaptation to the slope.

To isolate the house from the landscape, Toyo Ito designed a perfectly flat and rectangular artificial platform that could be placed in other settings.

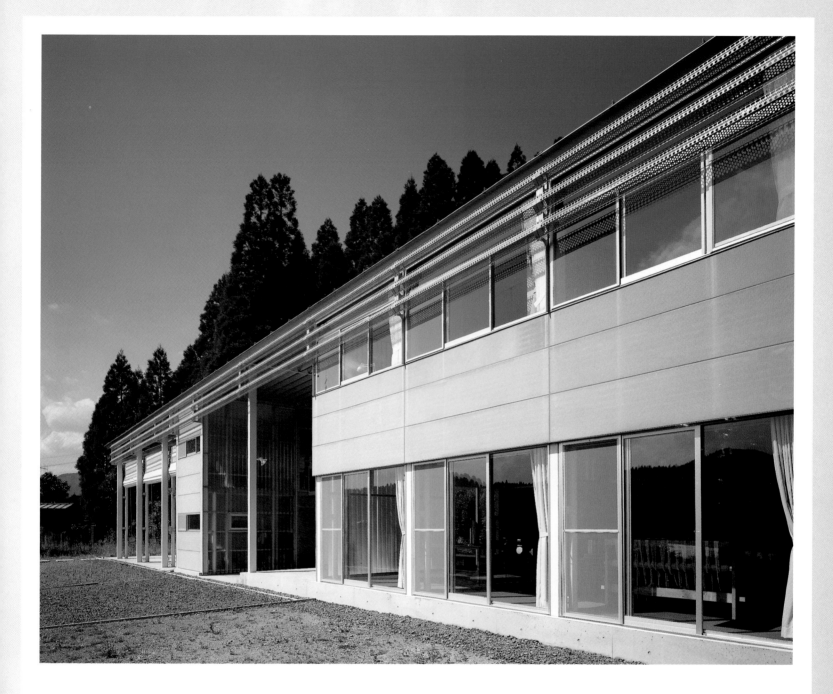

Below the roof, there are alternating closed and open spaces. In addition to the metallic roof, the concrete covering of the façade holding two large windows also stands out. The color gray dominates absolutely the chromatic scheme of both the interior and exterior of the home.

CH House

Architect: Baas Architects | **Location:** La Garriga, Barcelona, Spain 2001 | **Photos:** Eugeni Pons

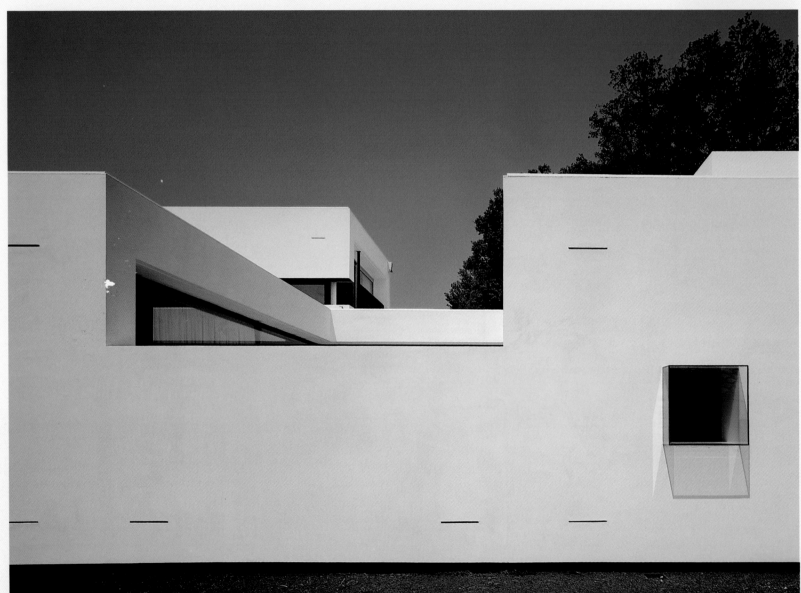

Terrain conditions determined the formal design of the building. The longitudinal façade abuts the neighboring houses and opens up at both ends, where the garden has more depth. The façade that gives way to the garden was designed to serve as a kind of autonomous framework. It extends beyond the glass enclosure of the interior space, creating an independent area for the porch. The framework joins exterior to interior and organizes the diverse domestic spaces.

The study keeps the same margins established by the framework on the lower floor. In other words, the enclosure recedes several meters with respect to the façade line, creating a space with open-air views of the landscape.

The interior of the home is situated around a patio. In addition to permitting natural light to enter the back part of the house, the patio was designed to separate the children´s area from that of the parents. Its fluid form parallels the façade giving way to the garden.

An opening in the lateral façade —which encompasses the study space— also functions as a kind of framework in its resemblance to a display window with views of the kitchen and dining room. Other objects along the longitudinal façade enhance the sense of a "box" or framework. Glass cubes, for example, adorn the wall and function as unconventional skylights. In other places, the wall seems to break away from the structure, giving rise to a small annex that interrupts the structural uniformity.

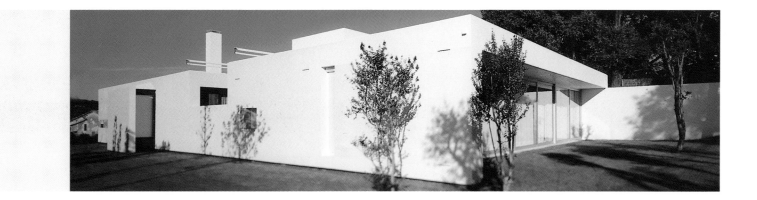

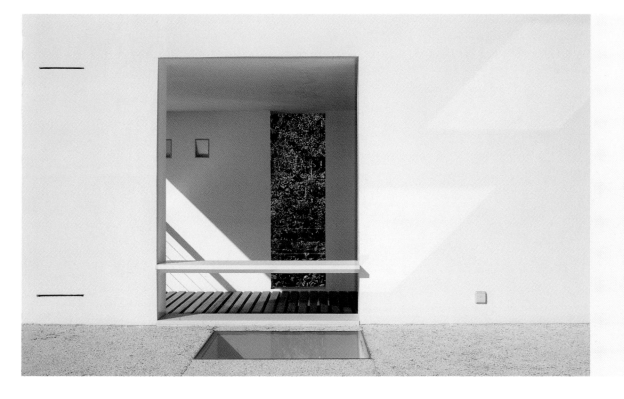

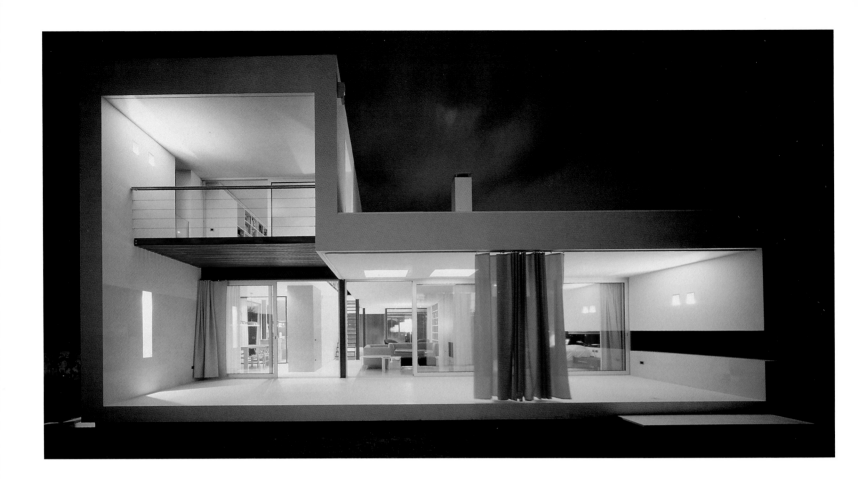

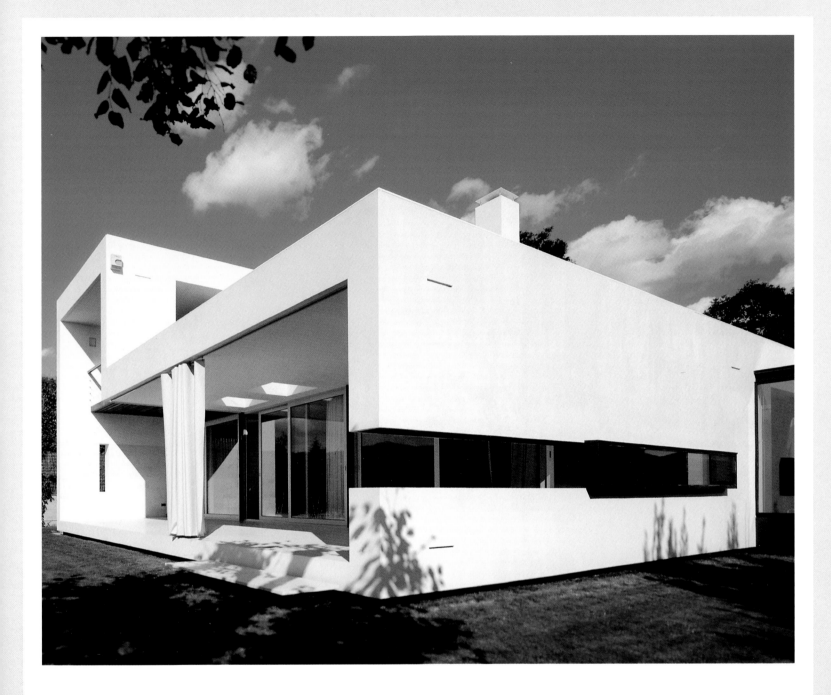

To maintain privacy, the architects designed enclosed longitudinal façades, the extremes of which are glass. Small openings in the lateral façades, as well as other architectural features, make for excellent interior lighting.

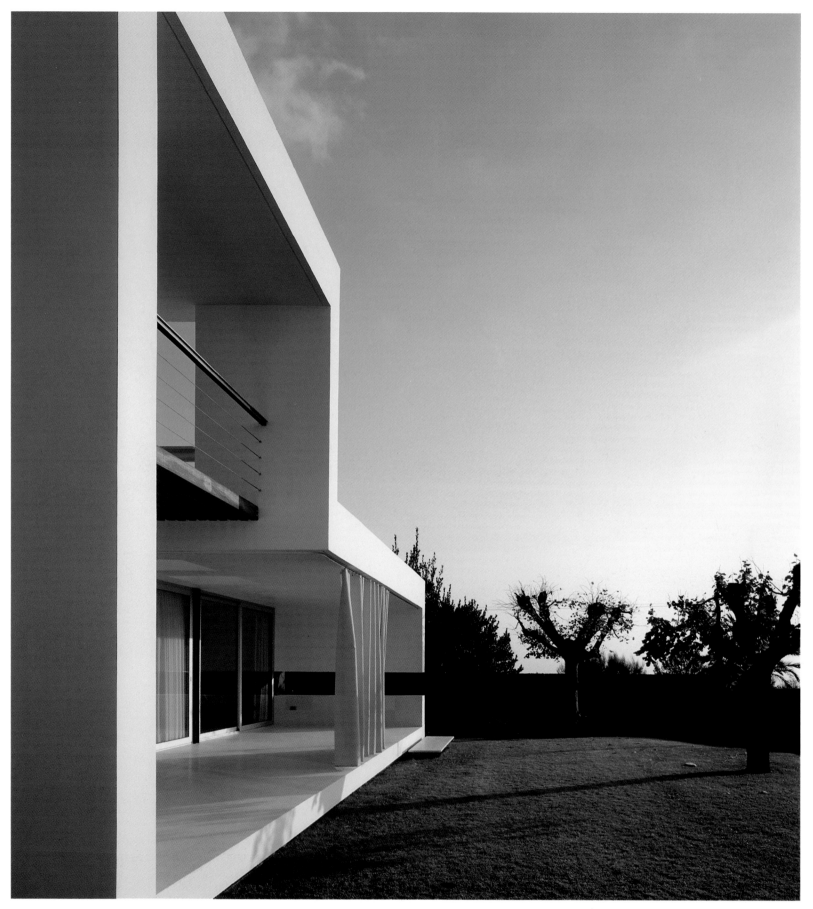

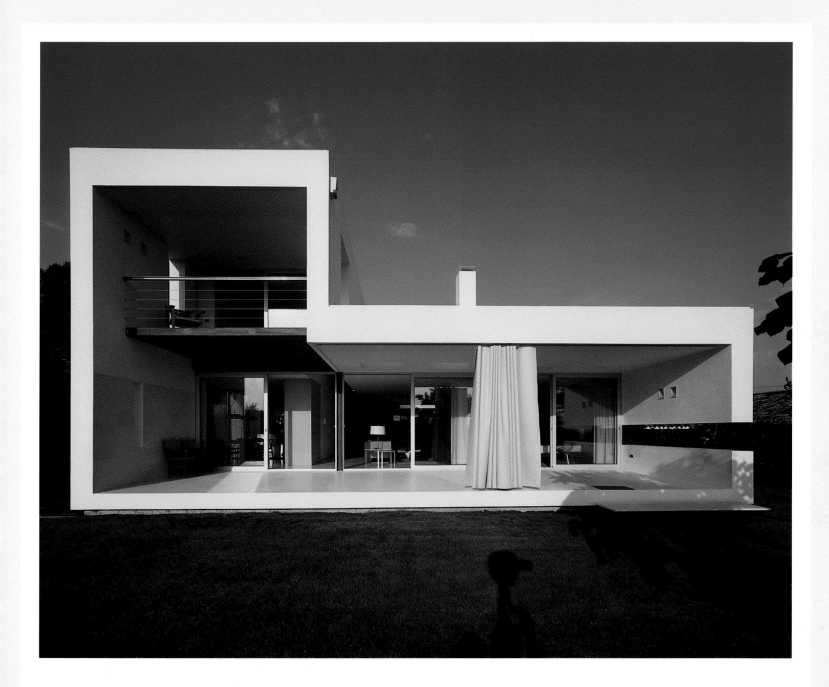

The façade giving way to the garden stretches beyond the enclosure, serving as a framework for the entire home. The space created by this projection has been utilized to situate a porch, which seems an extension of the interior.

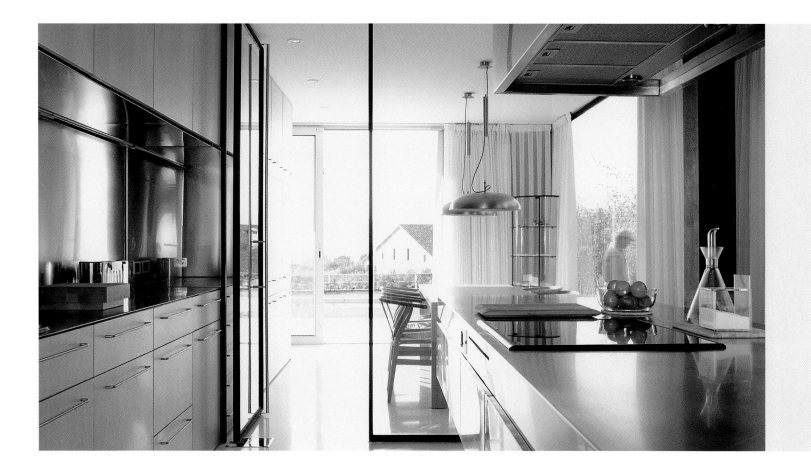

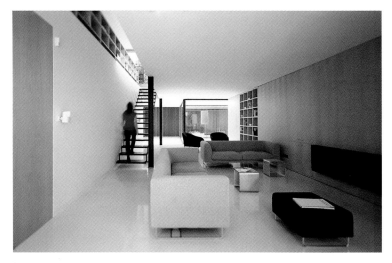

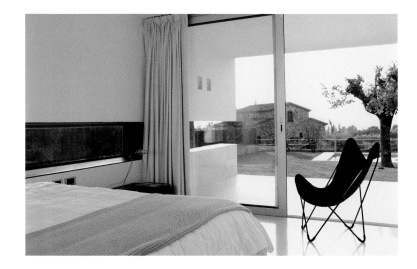

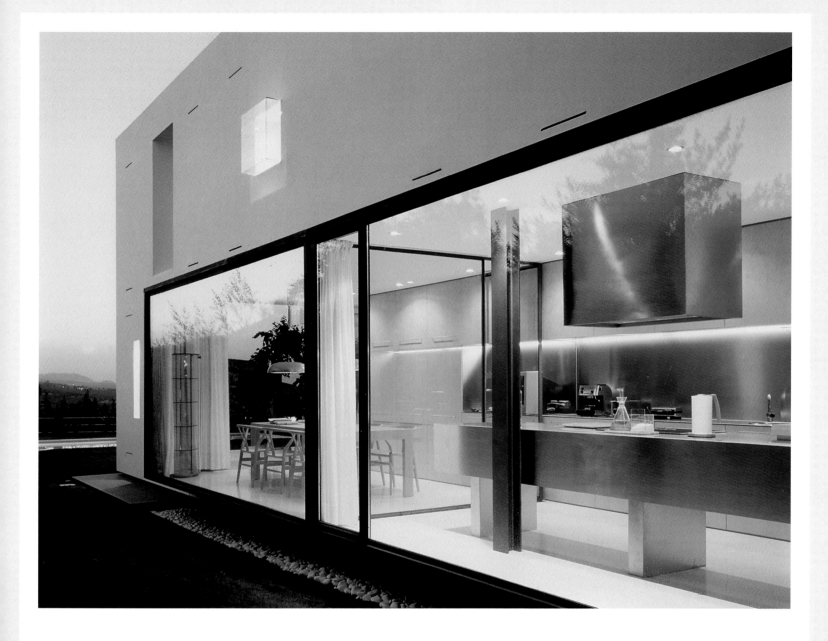

The concept of a "box" or framework appears again in the lateral façade s, where certain formal elements make the construction more dynamic. Transparent glass cubes affixed to the wall allow natural light to enter the darker areas of the house.

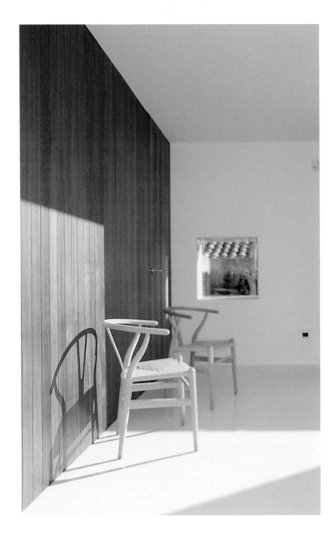

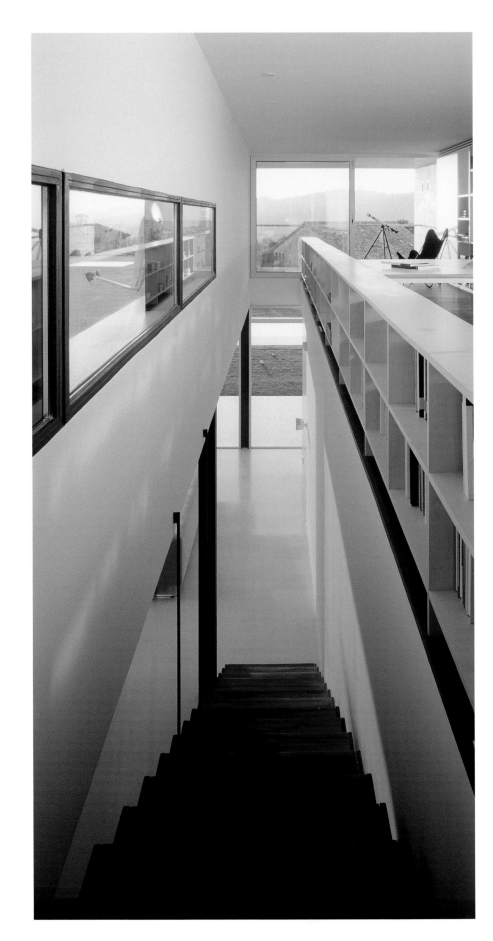

A glass-walled interior patio was designed to illuminate the rooms at the back of the house, while maintaining a sense of privacy. The patio also functions as an architectural device that sets off the children´s area from the parents'zone.

Y House

Architect: Katsufumi Kubota | **Location:** Iwakuni, Yamaguchi, Japan. 2000 | **Photos:** N. Nakagawa

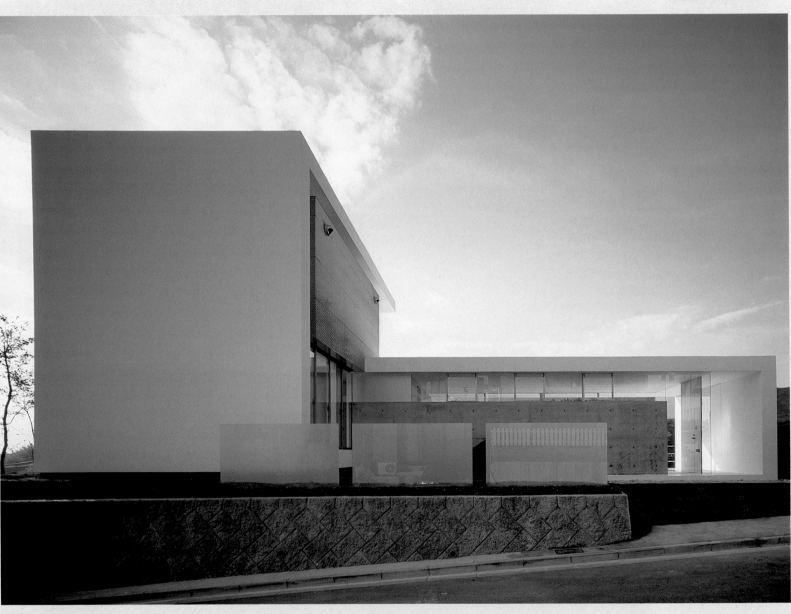

Kubota used the most elemental geometric forms in the design of this house, located outside of the city of Iwakin in a markedly suburban district. A large rectangle with elongated lines serves as the structural base of the building. One of its sides meets perpendicularly with the other unit of the home, a two-level square, making for an "L"-shaped layout. The rectangle is designed like a box, closed by its four sides but open in the intermediate surfaces. Each façade is elaborated differently. The façade over-

hanging the crag and looking out on an enormous stretch of prairie and mountain is totally covered by sliding glass panels, which may be opened completely. This converts the interior into a privileged lookout where the breeze and light may circulate freely. The Japanese philosophy of communion with nature is put into practice through the bonds established between the home and its natural setting.

Regarding the posterior façade, which faces the street, the architect had to resort to a concrete wall in order to block the interior of the home from indiscreet views. Still, Kubota wanted to minimize the visual impact of the tightly arranged concrete block. He does so by keeping the height of the wall at a studied minimum. Instead of allowing the wall to block the façade all the way up to the roof, Kubota designed a glass strip between the wall and the upper limit of the construction. This alleviates considerably the visual "weight" and allows natural light to flood the home through two façades.

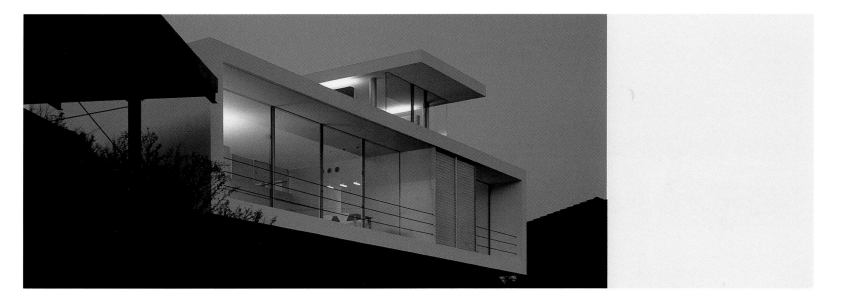

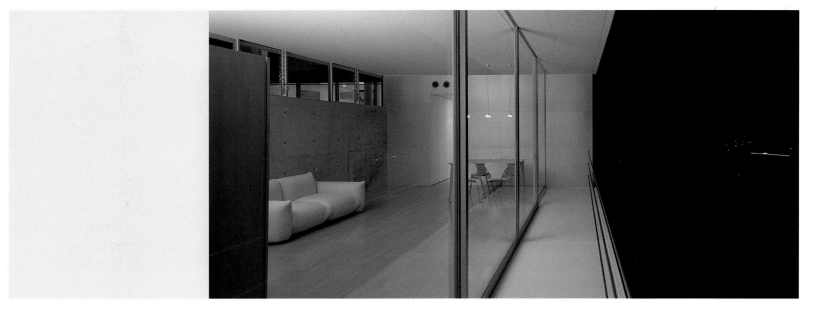

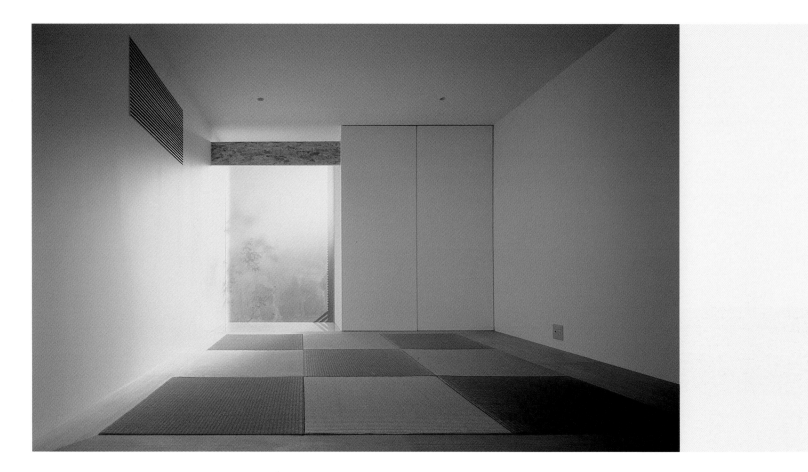

The crossing of a rectangle and square produces the home's essence of line. At the front façade, the upper part of the square rises above the rectangle. All the walls are glass, in keeping with the concept of maximum transparency characteristic of this type of construction.

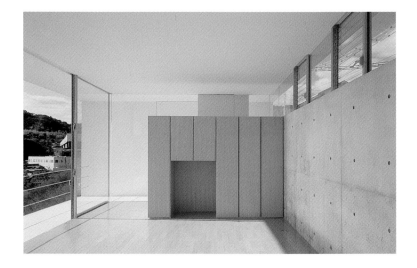

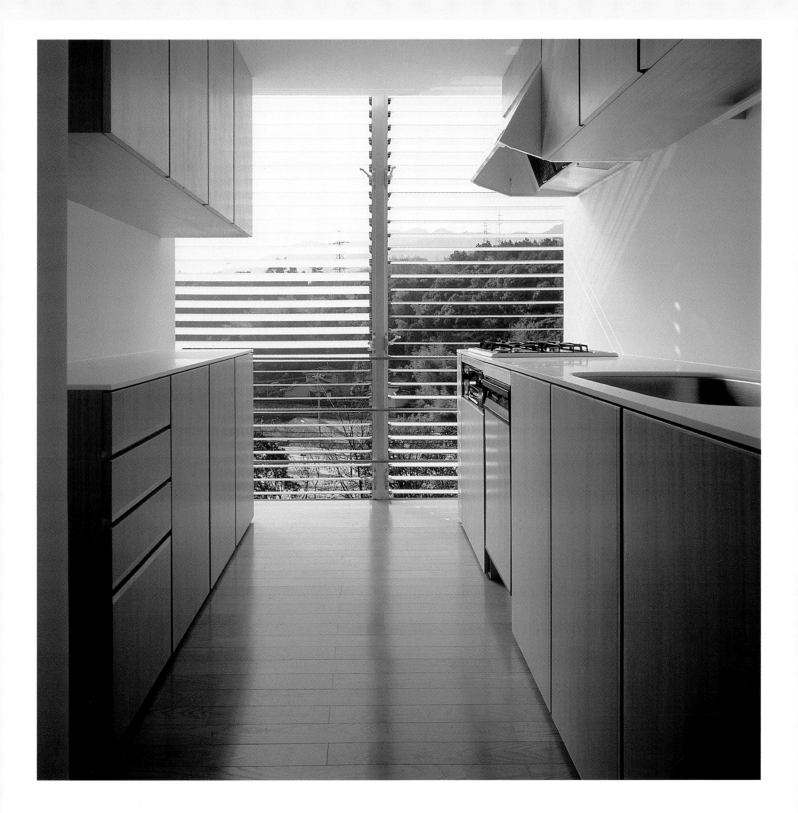

Interior floors and the different containing units, such as kitchen cabinets, are made of wood. This grants warmth to the diverse areas of the home, in contrast to the frigidity of the concrete and glass.

Sala House

Architect: Tonet Sunyer | **Location:** L'Ametlla del Vallès (Barcelona) 1997/1999-2000 | **Photos:** Eugeni Pons

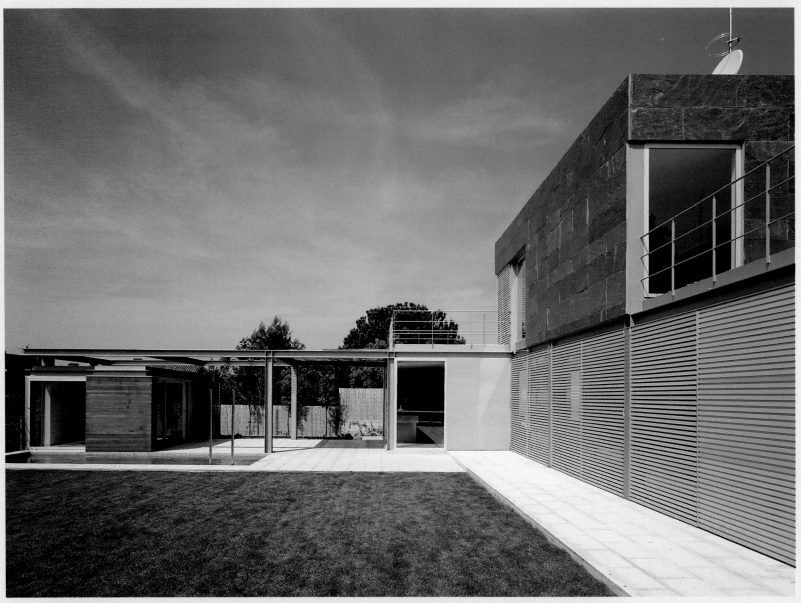

The building design of this rectangular, one-family home is based on elemental geometric forms. At one end of the rectangle, there is a slate-covered cube atop the main building's flat roof. Access to the home is gained through the main façade, which is sunken into the terrain. A wide trench between the façade and the terrain allows natural light to enter the interior of the home through large windows.

The open area has been used to annex two volumes to the lower floor. Perpendicularly situated between the lower level and the terrain, the annexes serve as a kind of anchorage for the construction. Grass covers the roofs of the two rectangular annexes, making for unique ornamental gardens that contrast chromatically with the building's omnipresent gray.

The posterior façade, in front of which extends the garden, presents a light and permeable wall thanks to aluminum slats. With the blinds fully open, the interior becomes a large space giving way to the garden. With the slats closed, the space takes on the aspect of a hermetically sealed aluminum box.

The simplicity of approach extends to the interior spaces, which are situated around a corridor that crosses the entire front part of the home. The entrance area, where a set of stairs communicates to the upper section of the home, is a two-level space, although from the exterior its double volume is imperceptible. Upon entering the home, the two-level character is revealed by a glass runway accessing the library.

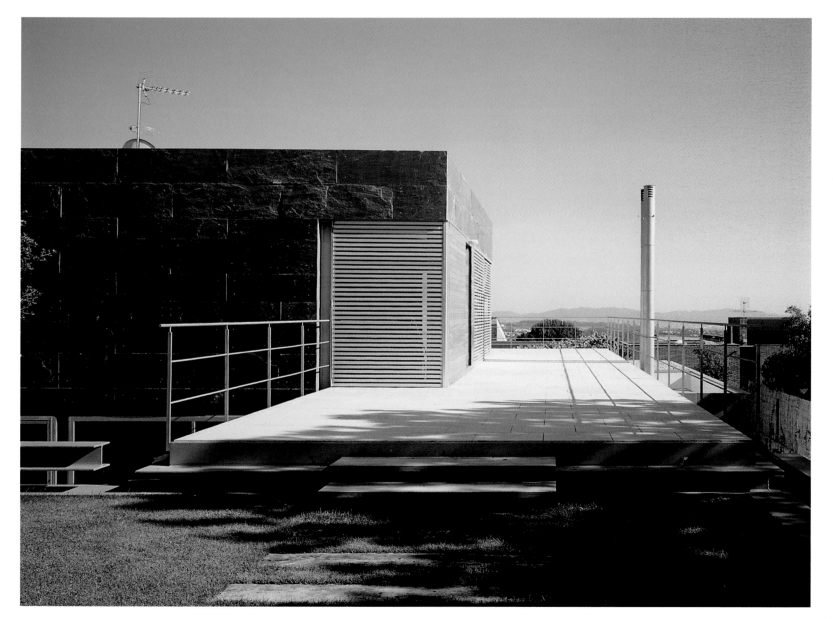

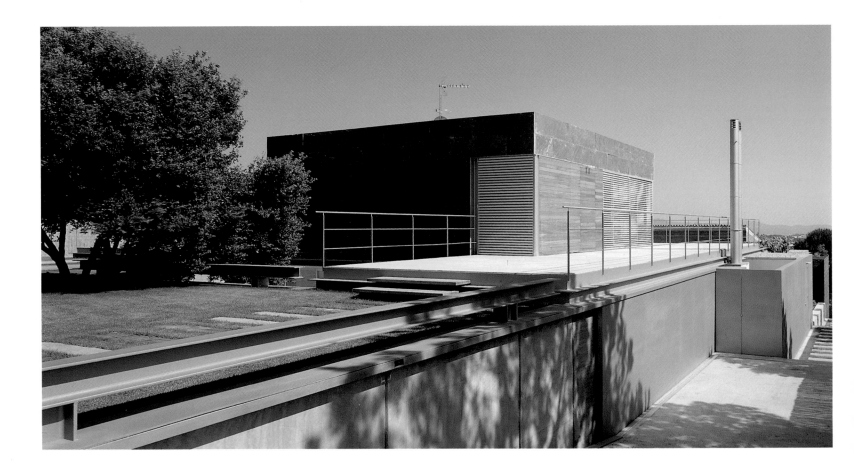

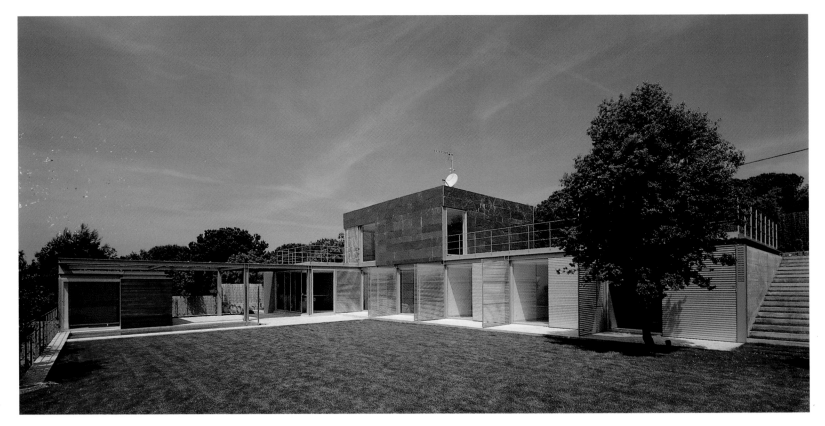

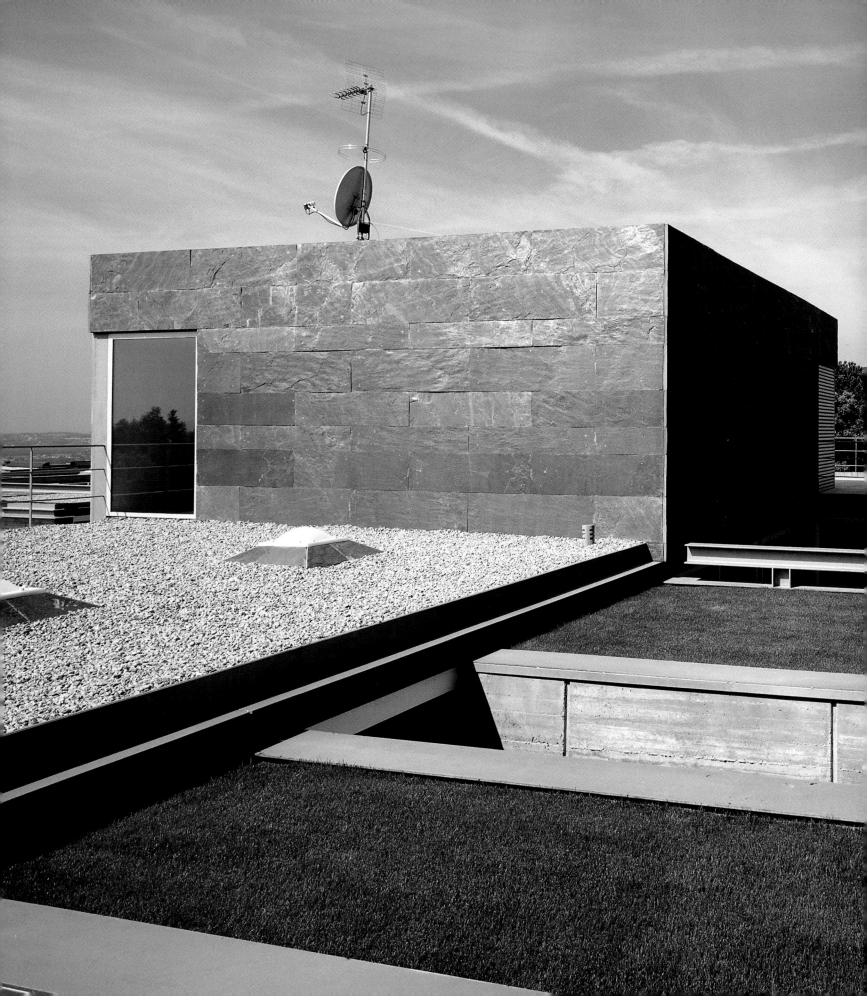

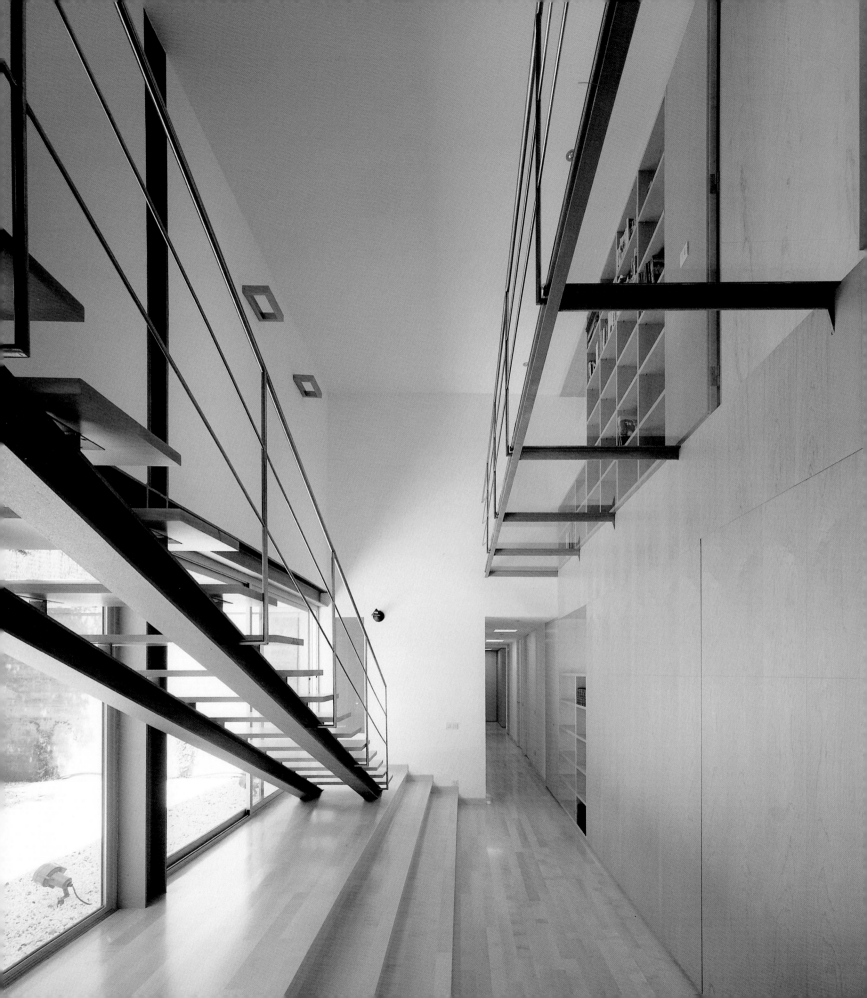

Tagomago House

Architects: Carlos Ferrater – Joan Guibernau | **Location:** Ibiza, Spain. 1999 / 2001 | **Photos:** Alejo Bagué

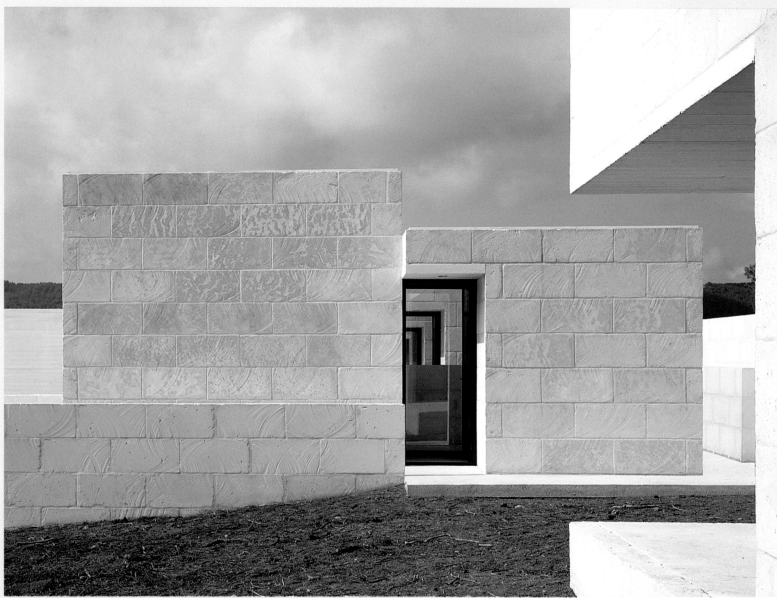

 esigning a home on the island of Ibiza implies an inevitable compromise with local customs. For on the island there is a strong tradition, both constructively and spatially speaking, of isolated homes. Rural houses of the zone have grown in accord with the needs of the occupants, who add parts and spaces around the operations of the main house or base of the complex. The volumes and spaces of this house, located in Eulalia del Río with views of the sea and the island of Tagomago, are organized along the same lines.

Key to the layout approach of this design is a main nucleus upon which smaller, isolated buildings depend. This approach also meets functional necessities. The use of the house as a vacation home, for example, implies flexibility with respect to space and the number of inhabitants. A longitudinal axis articulates the various parts of the complex, organizing the transit between interior and exterior spaces without fixing limits between them. Sea stones, white concrete and wood add the finishing touch to this new home on the island of Ibiza.

While respect for local building traditions is explicit in the complex, the constructive methods employed are very much contemporary. For example, the load-bearing walls are made of concrete block with air chambers, and are covered with traditional stone. Pristine exteriors and the use of materials in a state of nature give the complex a quality of withdrawal. According to the architect, this "offers the tranquillity and serenity characteristic of a monastery," while at the same time establishing a new dialectic with local architecture.

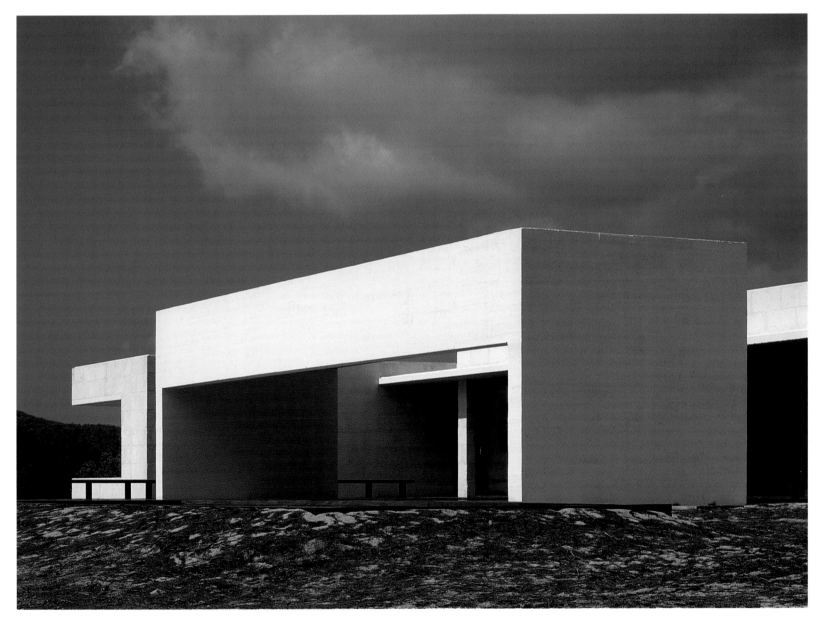

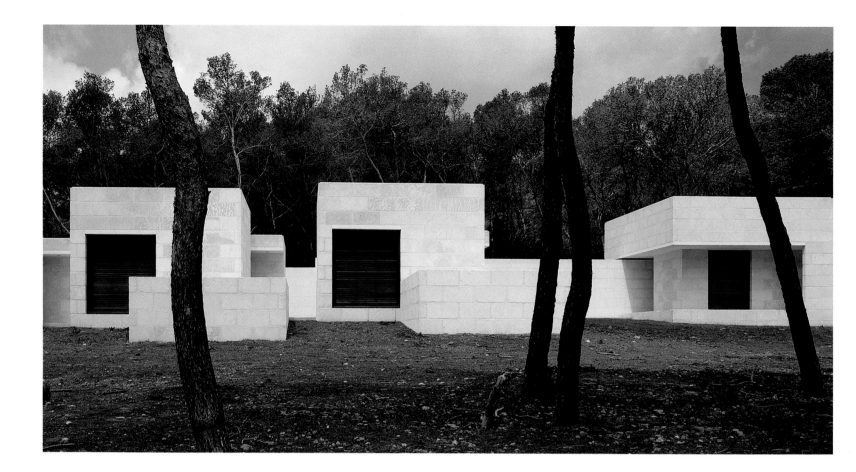

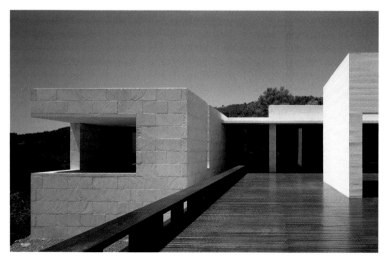
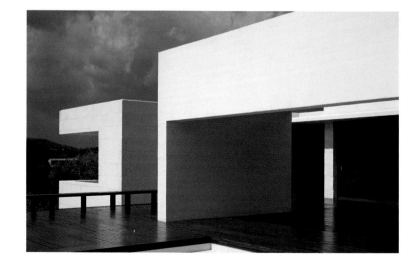

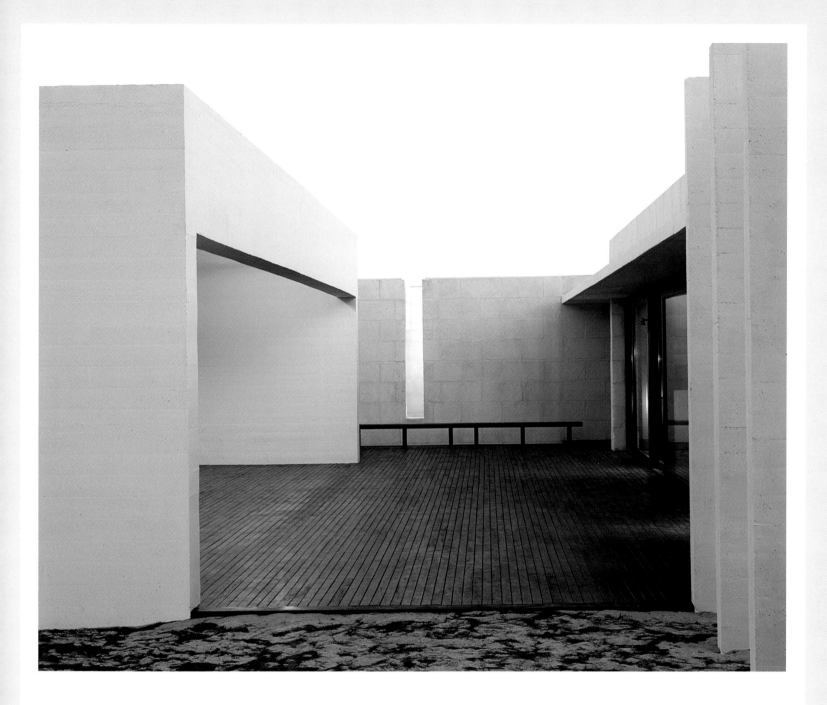

Four supplemental buildings to be enlarged in the future are situated around a main nucleus. The design of isolated buildings allows use of the house to vary with necessity, as well as permitting progressive and flexible use of spaces.

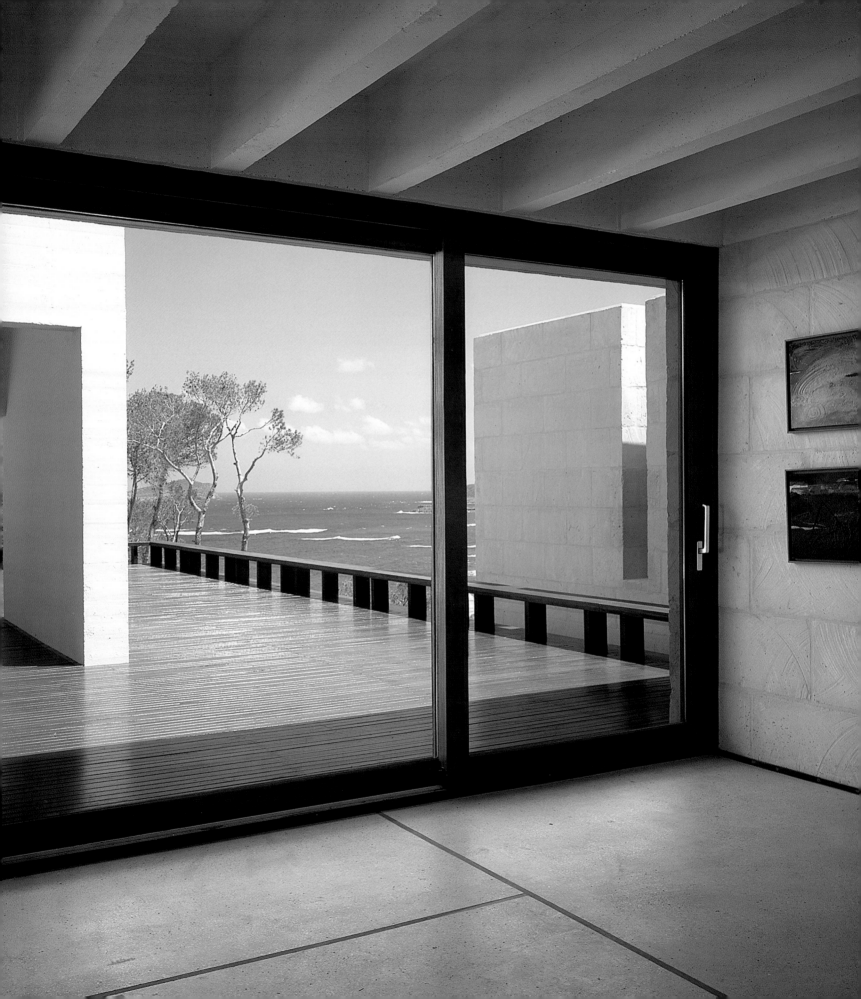

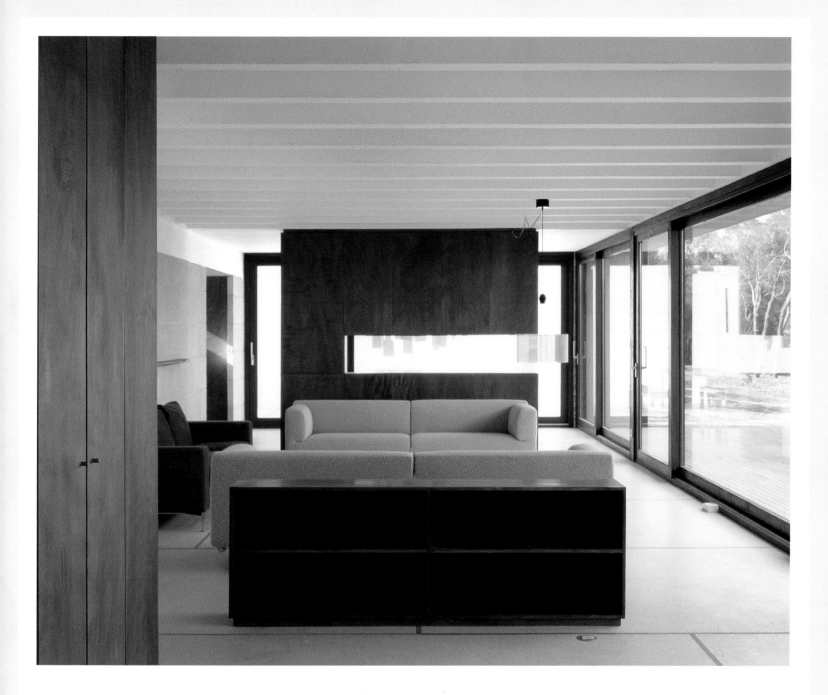

An open-air terrace mediates between the house and the exterior. A large, white, reinforced con-
crete canopy shadows this space, where a pool that visually relates to the interior is situated.

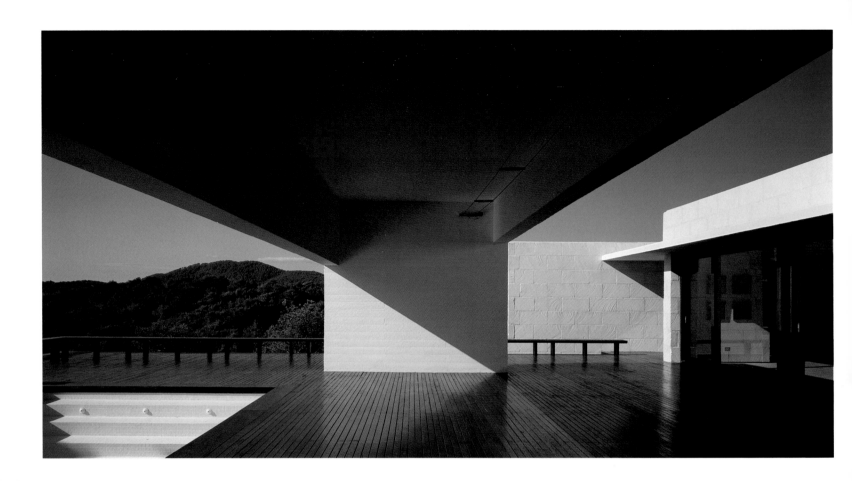

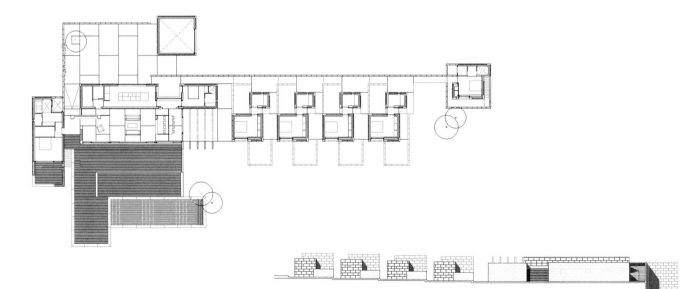

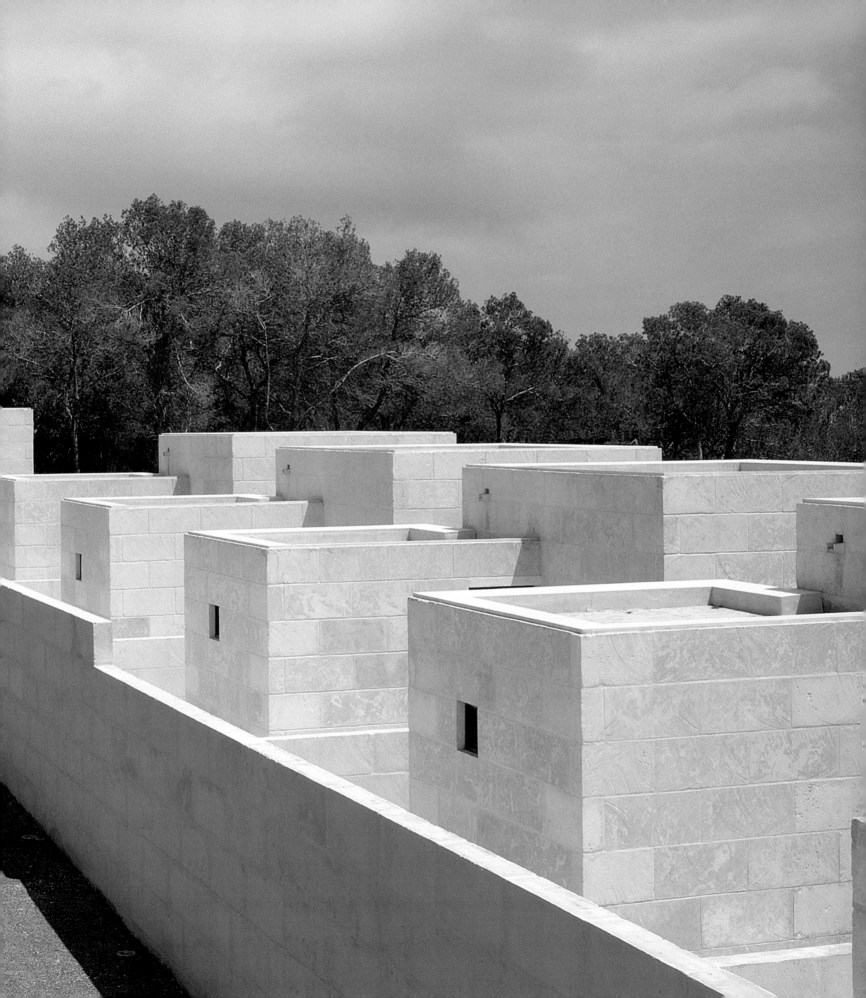

INB House

Architect: Maki and Associates | **Location:** Tokyo, Japan. 2001 | **Photos:** Shinkenchiku-sha/Toshiharu Kitajima

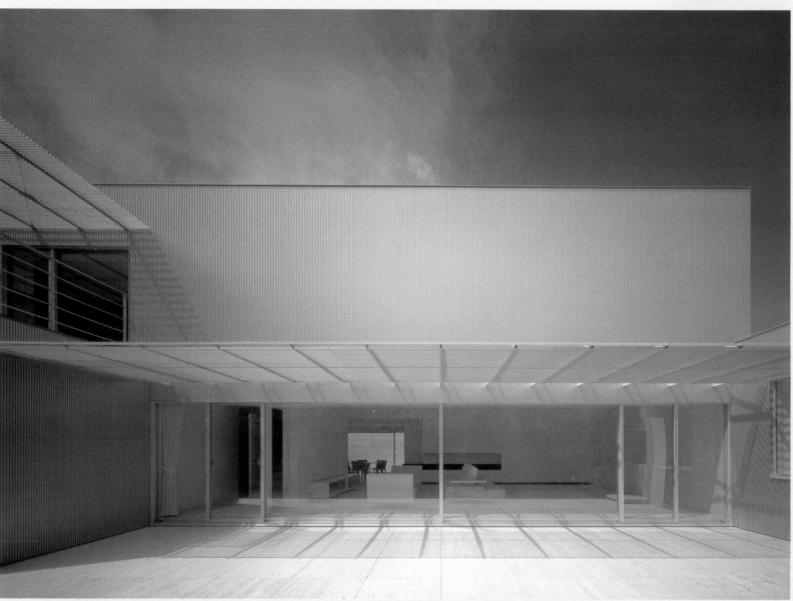

The work of Fumihiko Maki charts the different tendencies of the architect's professional development. The trajectory reflects Maki's ongoing search for and interest in new technologies and architectural languages. Of Japanese origin, Maki, a member of the Japanese Metabolist Group in the 1960's, was connected for many years to American culture. The result is creations that reflect a personal vision of two worlds. A "rational" design approach is the key to the creation of spaces conceived along the lines of

human needs. Maki's architecture, on both a grand and small scale, never loses sight of its principal objective: human beings and their needs. Maki generally utilizes typical modern materials such as metal, concrete, and glass. The combination of these materials with new technologies transmits the sense of clarity and lightness of many of his buildings. It should come as no surprise that many of these concepts are repeated in "INB House", situated in the heart of Tokyo. A young couple with a son lives in the home, a volume of clear color and simple, orthogonal lines divided in two to comply with the zone's height restrictions. Marble and aluminum enrich typical concrete and glass materials. The intrinsic properties of these materials tend to project an image of solidity and even weightiness. Yet, in this case, a contrary and attractive sense of lightness is achieved in the all the spaces. The combination of lightness and the treatment of light produce an interesting spatial sequence based on movement and shadows.

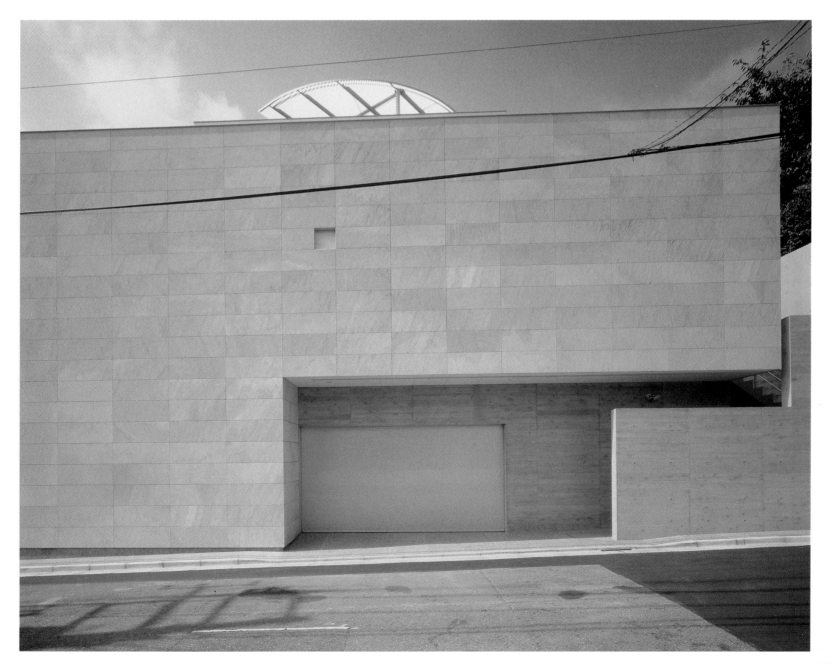

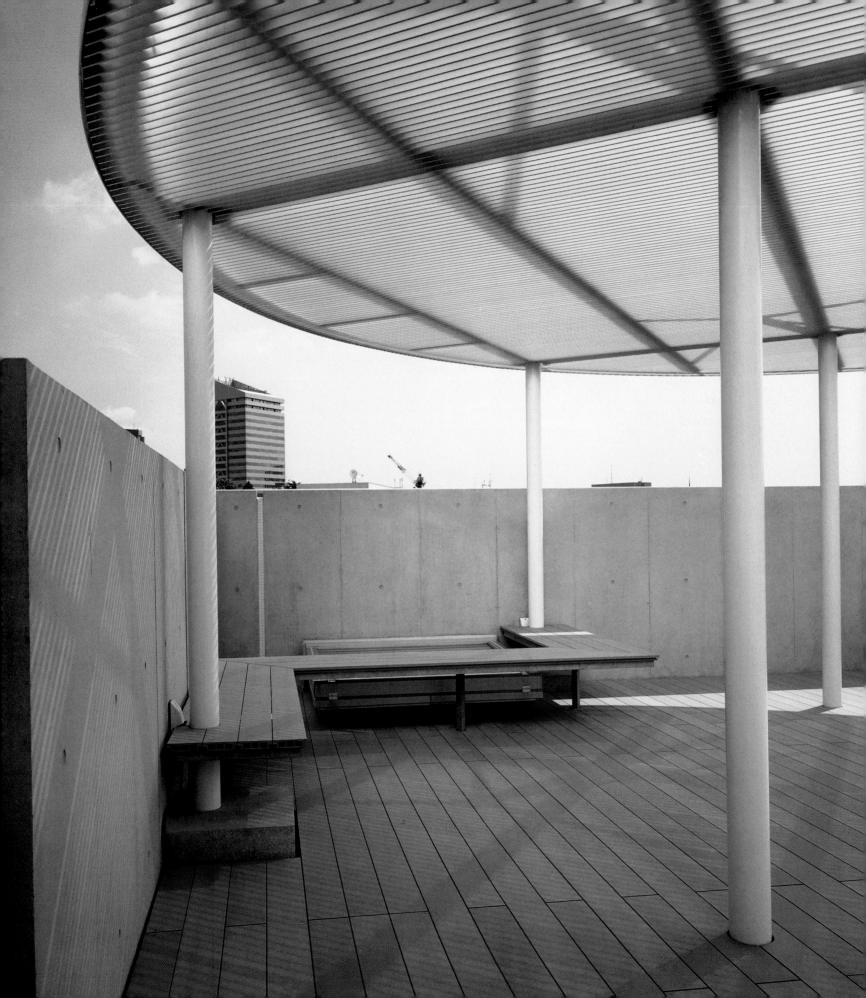

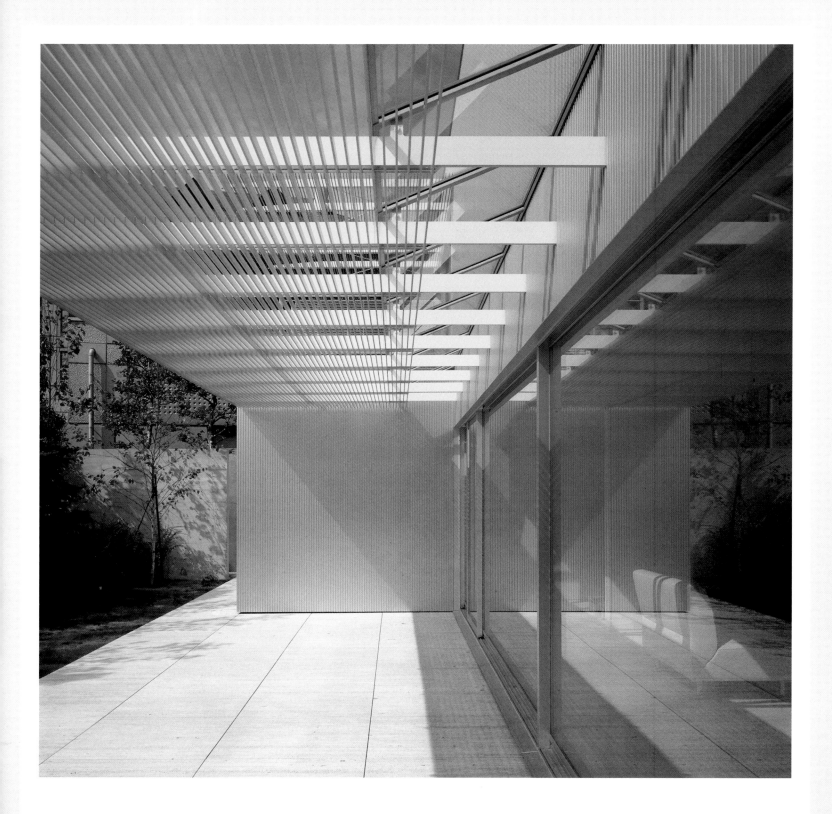

A landscaped space and exterior terrace of travertine marble serve to extend the living room-dining room area. A glass plane separates the exterior from the interior. Previous page: View from the lookout-terrace on top of the living room-dining room area (Roof level). A concrete wall protects and defines the perimeter with benches, while the pergola throws attractive light onto the space.

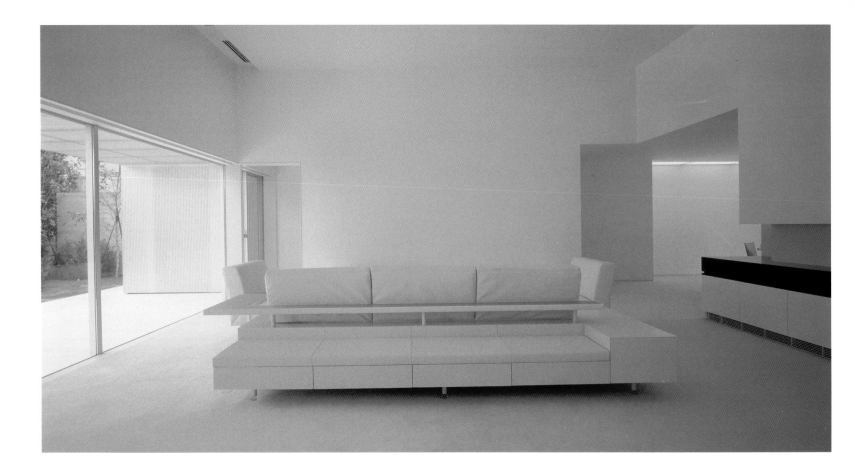

The home is arranged in two volumes due to height restrictions. The first floor consists of communal spaces and the main room of the house. There are two rooms on the second floor. A free-standing stairway accesses the lookout-terrace, set atop the living room-dining room and offering admirable views of the city.

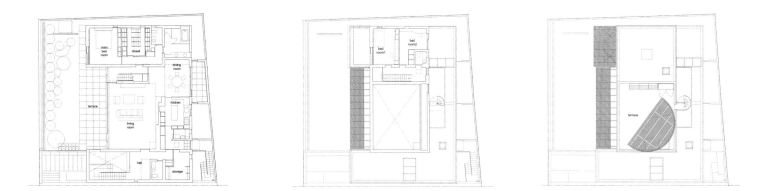

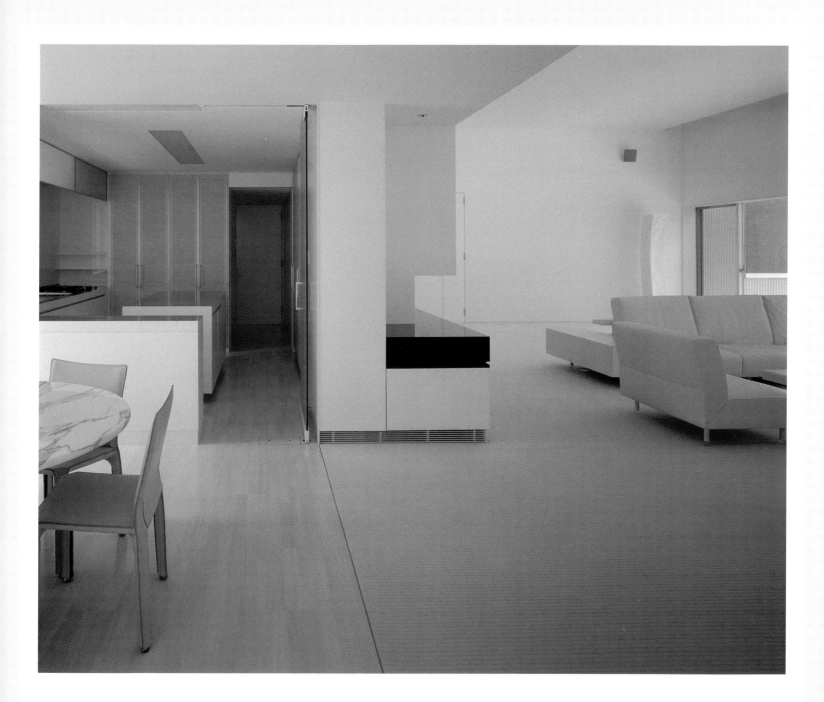

The spatial sequence is fluid. Minimalist articulation of the areas of the home allows for the flexible use of space. Fixed volumes contain permanent installations only in places where they are indispensable.

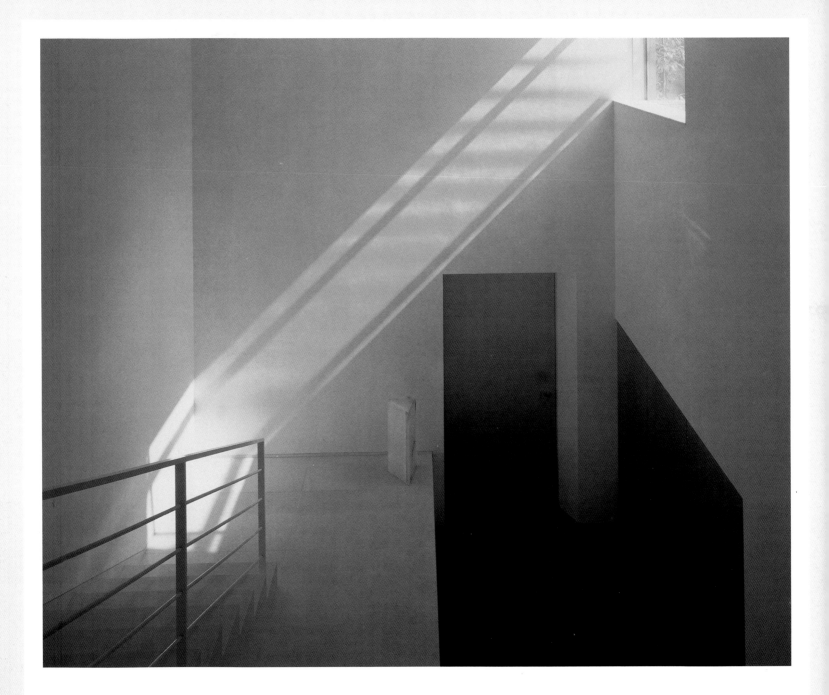

The use of concrete in elements that serve to define the ambiance of the home and the use of glass as a kind of membrane, combine with the marble to give the design a totaling sense of lightness. The attractive treatment of light and carefully studied openings reinforce this character.

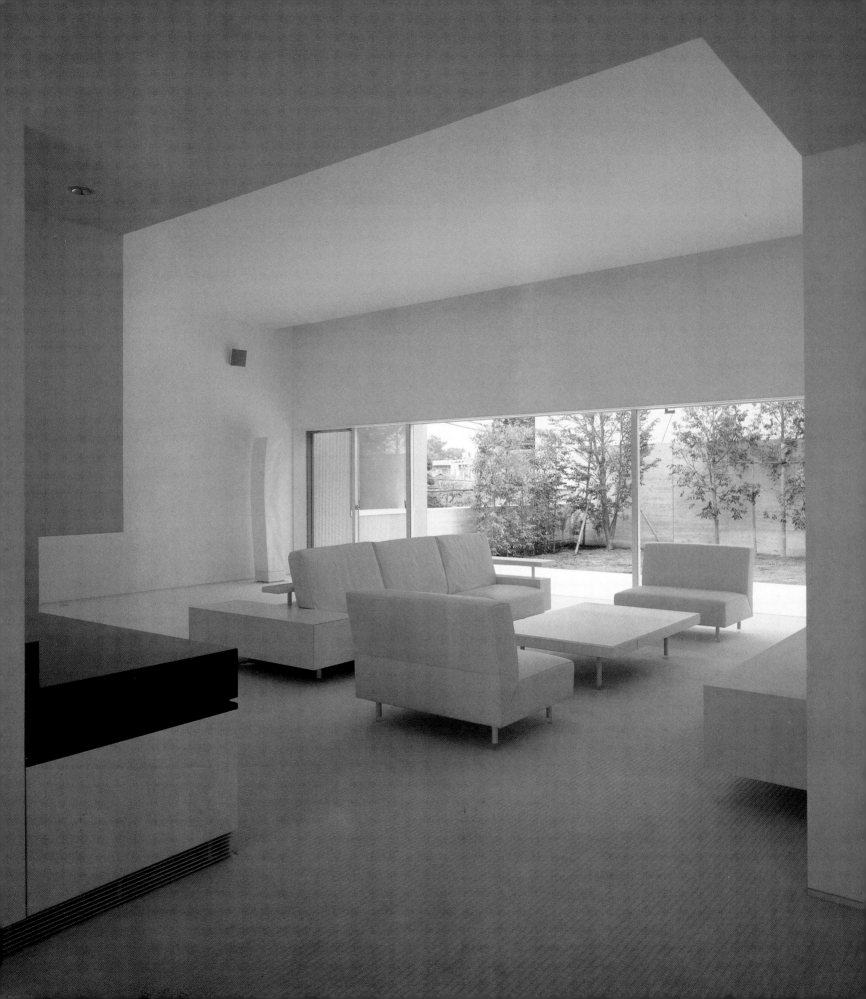

4 Homes in Barcelona

Architects: Carlos Ferrater and Joan Guibernau | **Location:** Barcelona, Spain. 2001 | **Photos:** Alejo Bagué

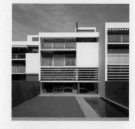

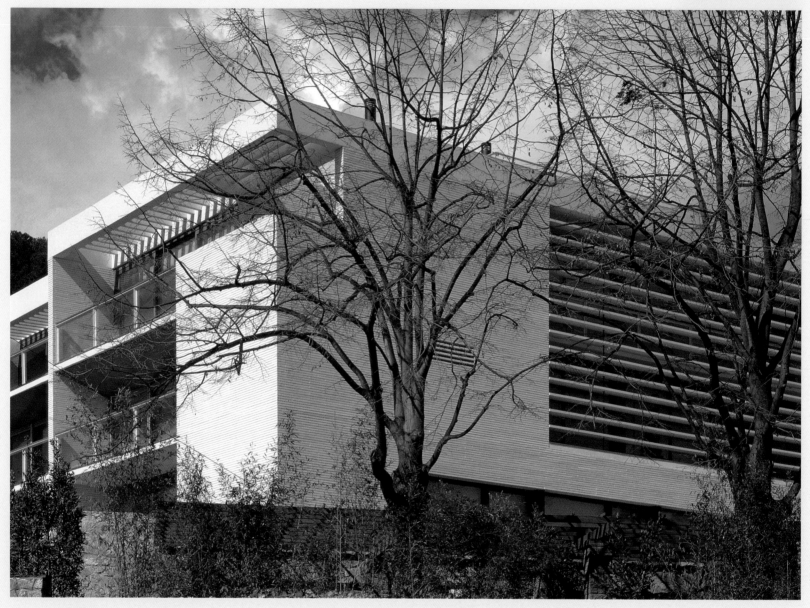

The design involves the construction of four contiguous, one-family homes embodying some of the formal constants in the architecture of Carlos Ferrater. In "4 Homes in Barcelona", Ferrater counted the collaboration of Joan Guibemau, an associate since 1993. The homes have an identical layout and structure. They are divided into four floors with a square roof space utilized as a kind of terrace.

Absolute privacy is assured by staggering the front façades. The body of each home is independent, stretching longitudinally such that the posterior façades do not touch. This gives the buildings a geometric symmetry, with a front that opens up to the garden and a back that flows into a dry rock garden and communal space of land below.

The structural walls have a constructive element typical of Ferrater's creations. Pieces of pre-fabricated white concrete, whose form and measure grant the wall an industri-al-like flow, update the traditional brick wall from whose additive quality Ferrater's walls take inspiration.

The interior is noteworthy for the transitional spaces between different areas of the home. The patio, situated at the back of the house and lighting the kitchen area, is designed as a small glass body that incorporates the empty space between the two volumes. A corridor serves as a nexus between the living room and back part of the house. The corridor also functions as a large skylight, giving rise to a play of light and shadow among the direct and overhead illumination.

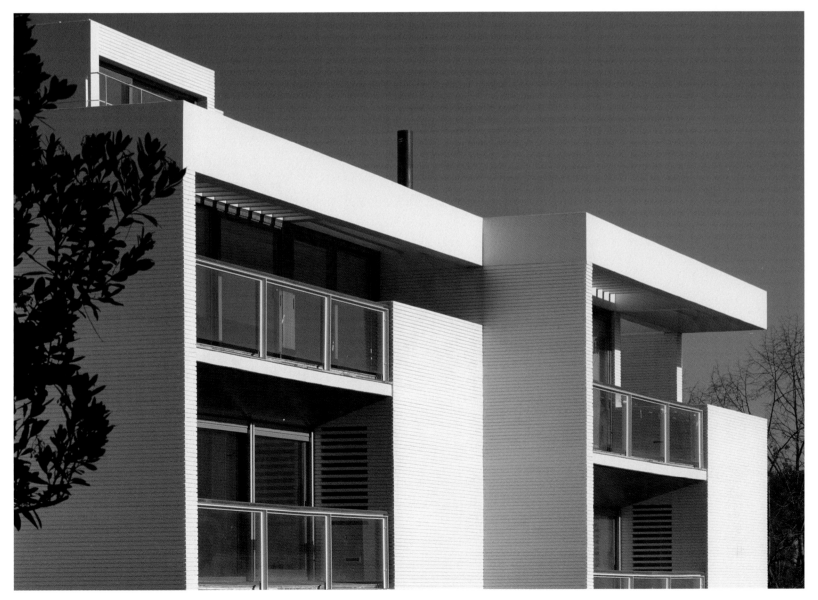

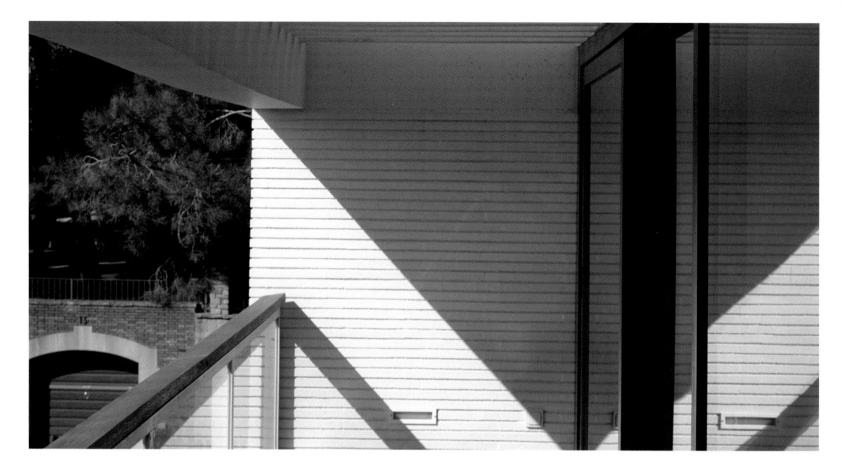

The front façades are attached but staggered. This vertically fragments their linearity and increases the privacy of each home. In back, the volumes of the different homes extend in such a way that each structure stands as an independent body.

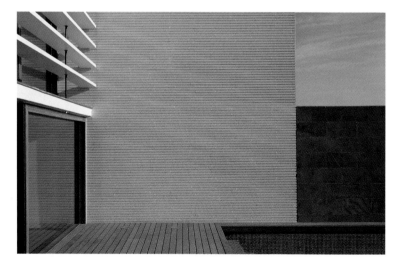

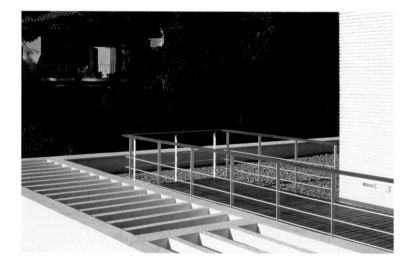

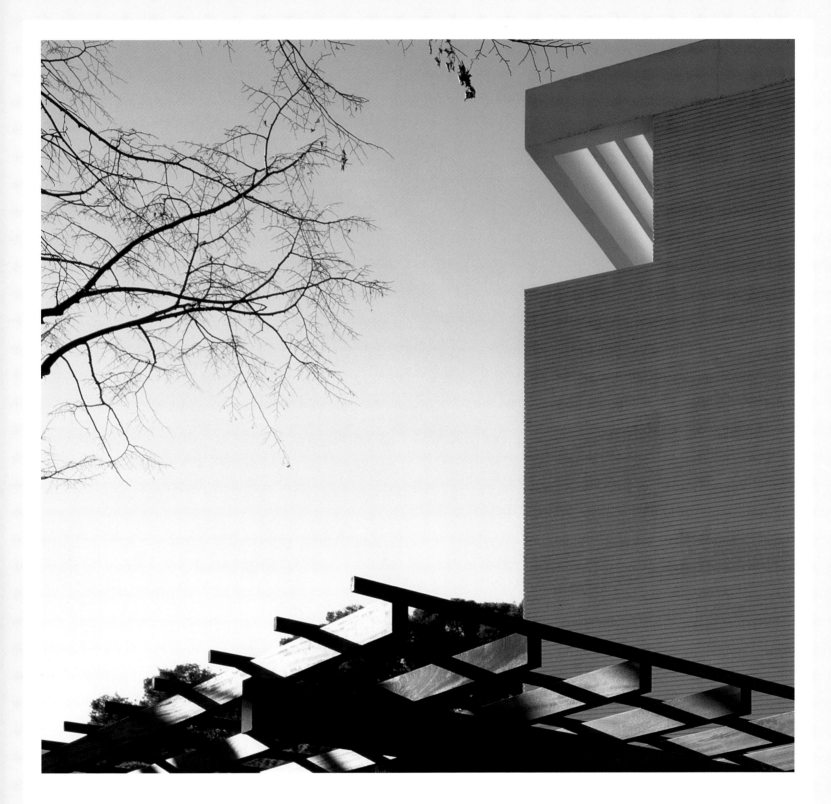

Pieces of pre-fabricated white concrete were used in the building construction. This material avoids vertical junctures and leaves a deep horiztonal groove in the course of the concrete pieces. The white concrete is reminiscent, both in detail and texture, of soothing artisanal materials.

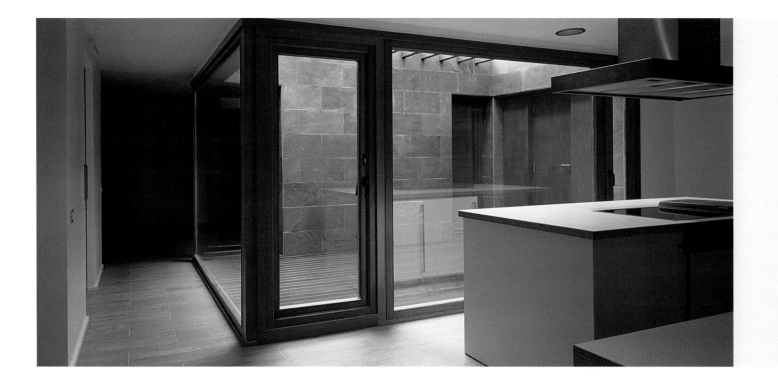

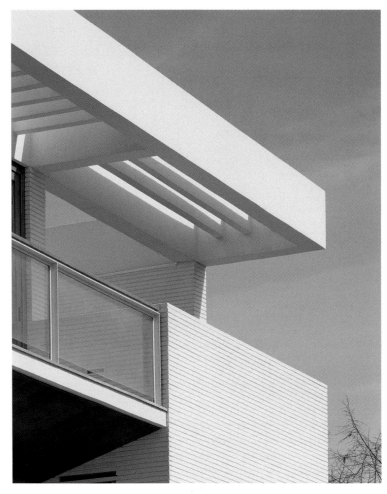

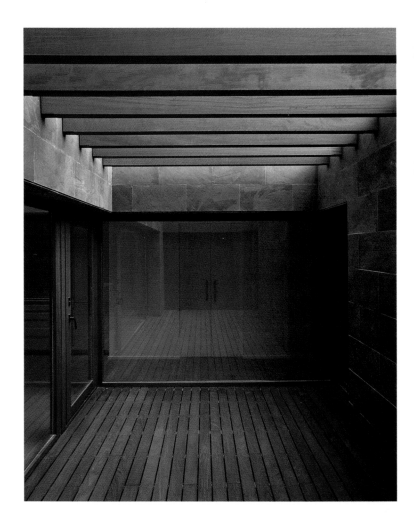

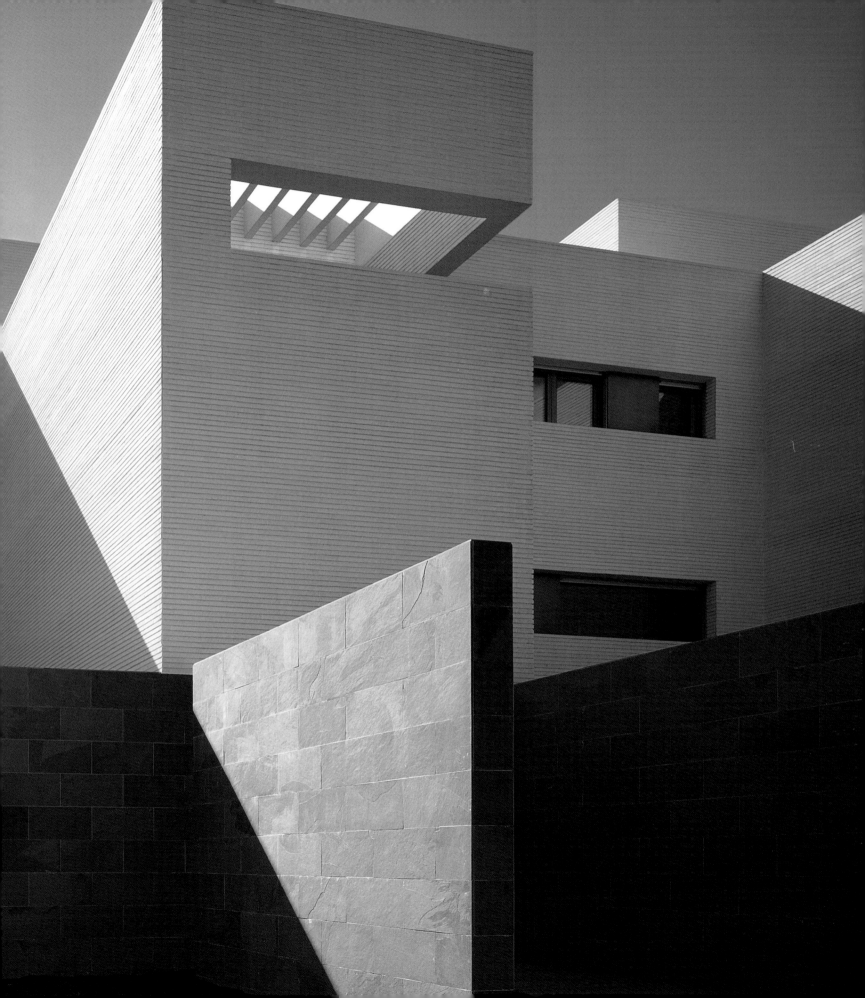

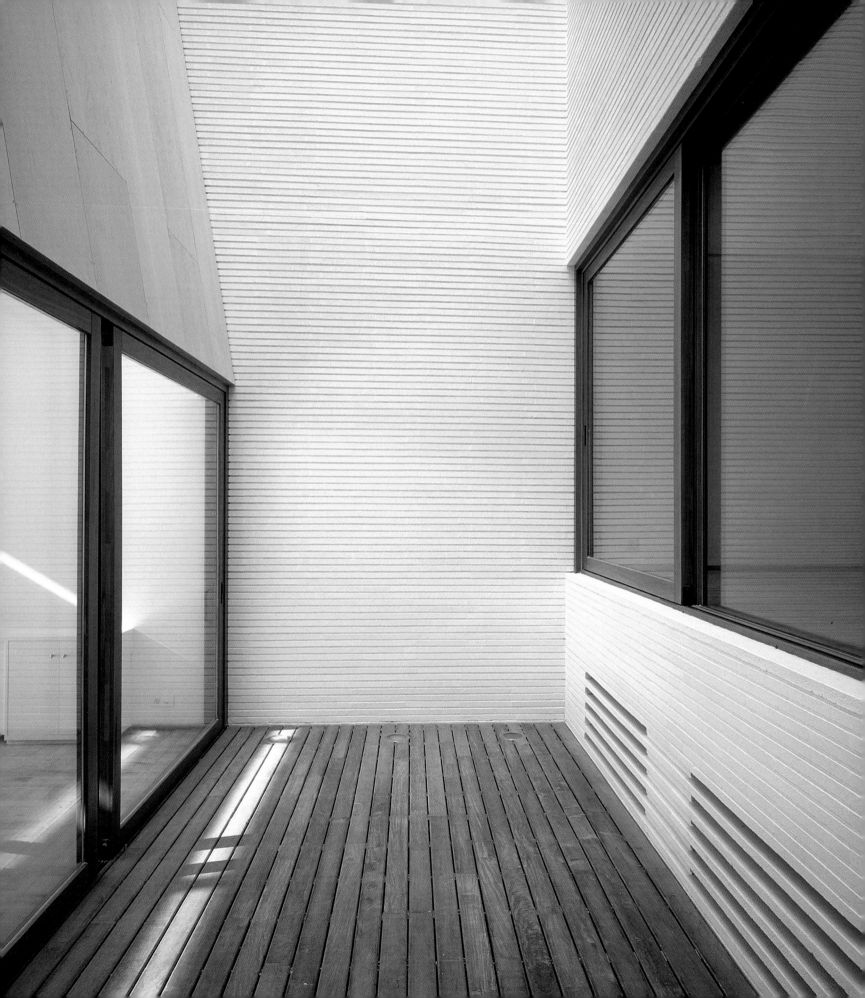

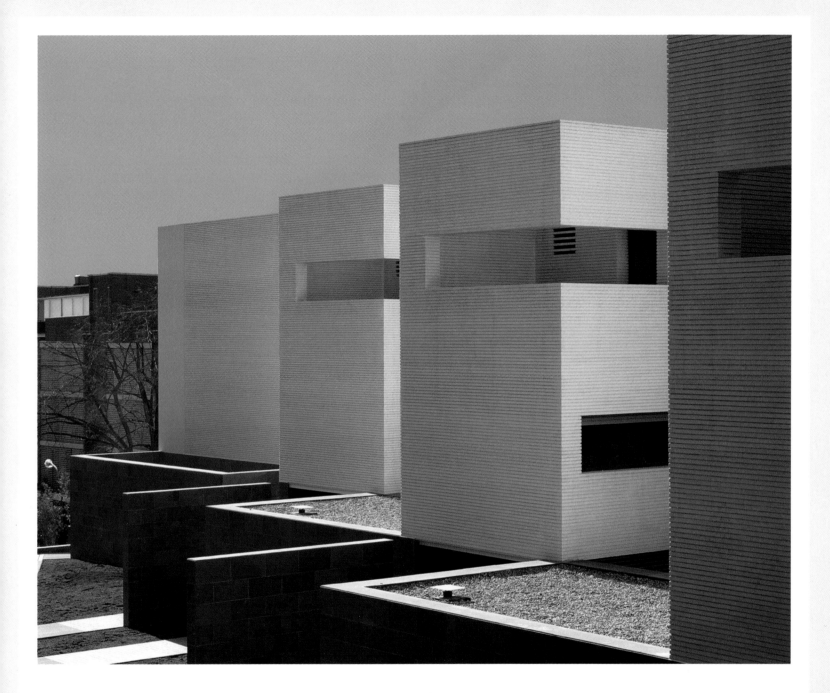

The construction demonstrates how the search for minimal forms of expression and elegance demands maximum technical precision with regard to materials and their application. The interior design consists of various transitional spaces that act as both nexuses and diverse points through which natural light may enter. This makes for an attractive play of light and shadow.

Wohnhaus Wierich

Architect: Döring, Dahmen, Joeressen Architekten | **Location:** Recklinghausen, Germany. 1995 | **Photos:** Stefan Thurmann

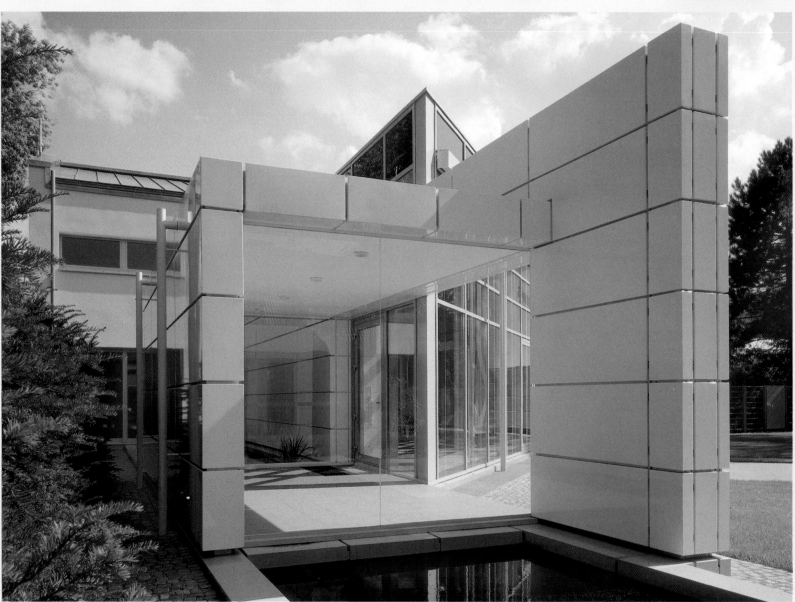

Acommon element in the work of this German team is the use of pure volumes. In some cases, the element is utilized without alteration, while in others it is developed along the lines of variations governed by clear geometric rules. The house, located in the northern part of the Ruhr region of Germany, reflects this sort of design. A single volume utilizes the geometric directrixes of the cube and contains the large spaces of the home below a gable roof. A second element, by a virtue of a 45-degree plane in the front

façade, opens the volume toward the garden, in a south-westerly direction. The plane inclines towards a gallery, visually and spatially enriched by two artificial lakes and a space offering views of the landscape. A small pavilion puts a finishing touch on the complex. In this way, as well as through simple geometric variations, the open spaces, designed in collaboration with Bernhard Korte, are totally integrated and the layout reflects its relation with the volumetric treatment. One side of a fully defined rectangle extends by means of an isosceles triangle, opening up the garden to the living room. Geometric rationalism also governs "free" elements of the design. The guest bathroom, for example, is a freestanding cylinder with perfectly flattened sides. In addition to the main house, the complex includes a top floor apartment. The apartment is accessed by a separate stairway that also offers way to the main house.

Nordosten

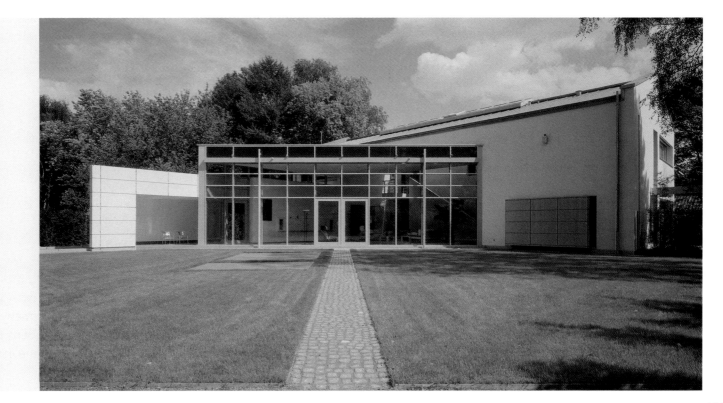

The 45-degree plane inclines toward a gallery, a large space with two artificial lakes alongside. A small pavilion completes the picture.

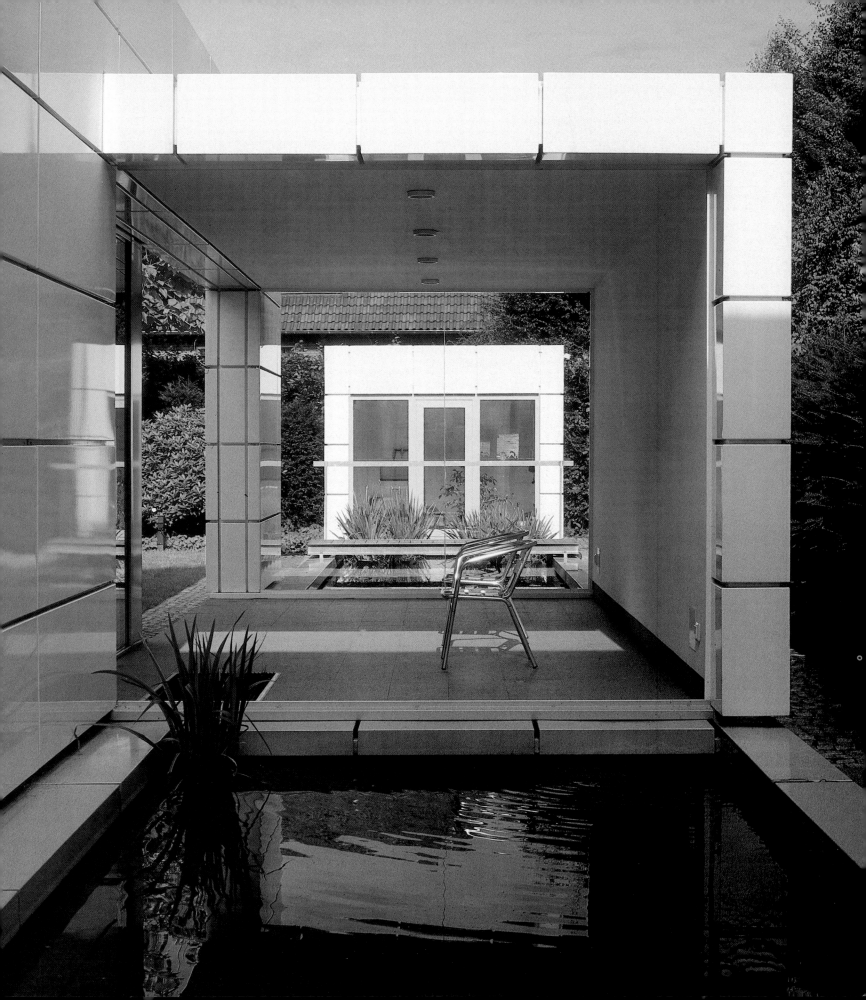

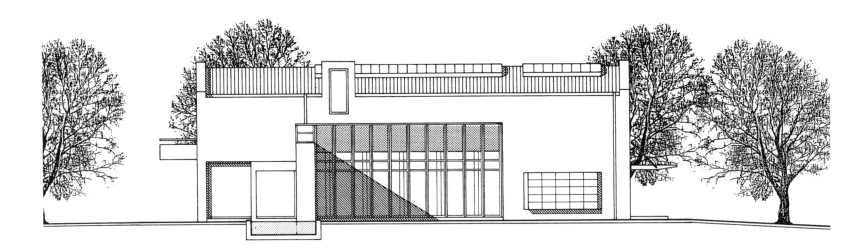

A rectangle demarcates the general space of the house. On one of its sides, there is an opening towards the exterior space by virtue of a triangle set at 45 degrees to the rectangle's façade.

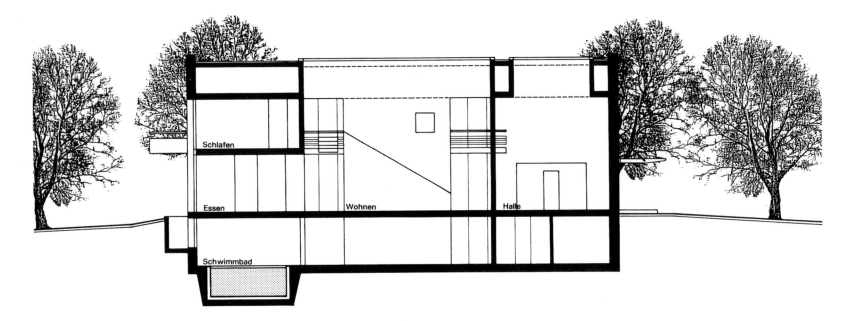

Schlafen

Essen Wohnen Halle

Schwimmbad

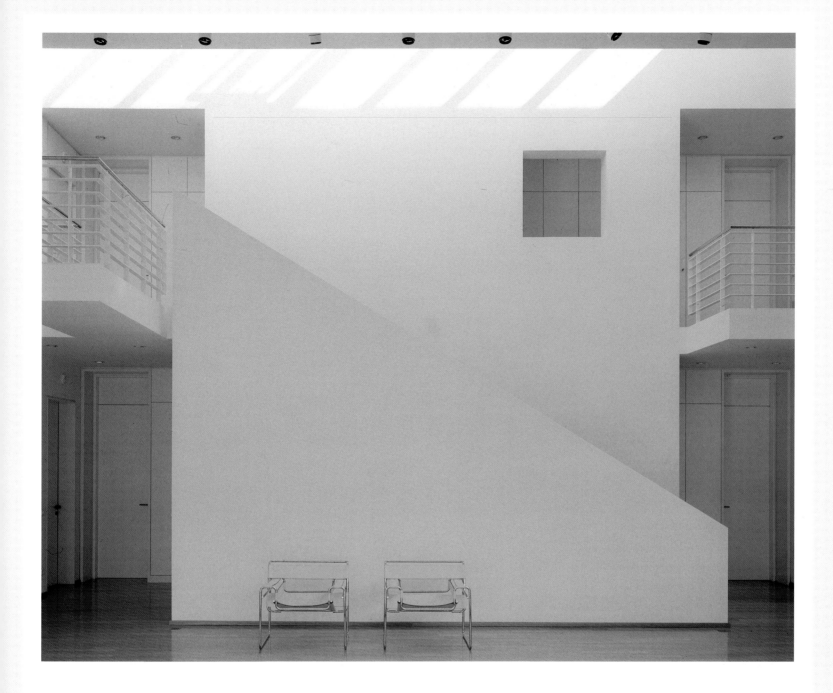

Two parallel planes contain the main stairway to the home. On one plane, a slanting wall follows the inclination of the stairs. On the other, balconies that maintain visual contact with the main area of the home perforate the dividing wall.

Vallromanes House

Architect: Joan Bach i Segui | **Location:** Vallromanes, Barcelona, Spain. 2001 | **Photos:** Jordi Miralles

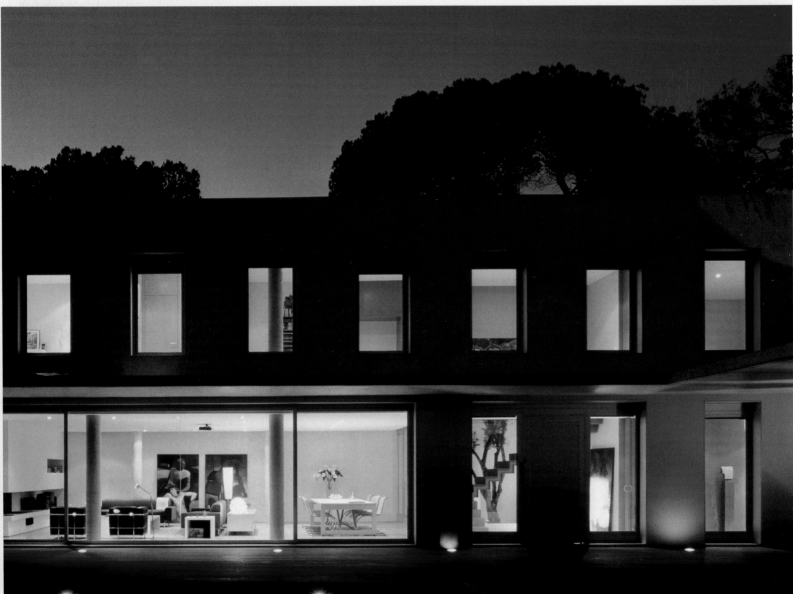

 implicity of line and transparency define this two-level, one-family home. From the exterior, the design arrangement of the diverse areas is perfectly ascertainable. The rectangular floor plan gives rise to a markedly horizontal façade. Noteworthy is the special placement of the windows, especially those of the upper floor, arranged with a precise symmetry that provides a sense of order and balance to the home. Eaves between the two levels divide the home into two equal parts and serve as a canopy to

block the entrance of light into the ground floor. The projection is irregular in that at one end it extends to touch a square structure –the owner's office– situated just in front of the façade. This establishes a unifying and integrating point of contact between the two buildings. An opening at the union is quite original. The aperture frames a tree, granting the tree qualities of sculpture as it rises between the two buildings like an object on display.

The concept of simplicity of line that dominates the façade is continued in the interior. The ground level is a flowing space where different rooms visually communicate. On the other hand, the upper level utilizes enclosures and patterns typical of the family home. The result is a house that exudes clear harmony between constructive components organized along a white-centered color scheme. In the interior, the black of some decorative elements provides a balanced contrast.

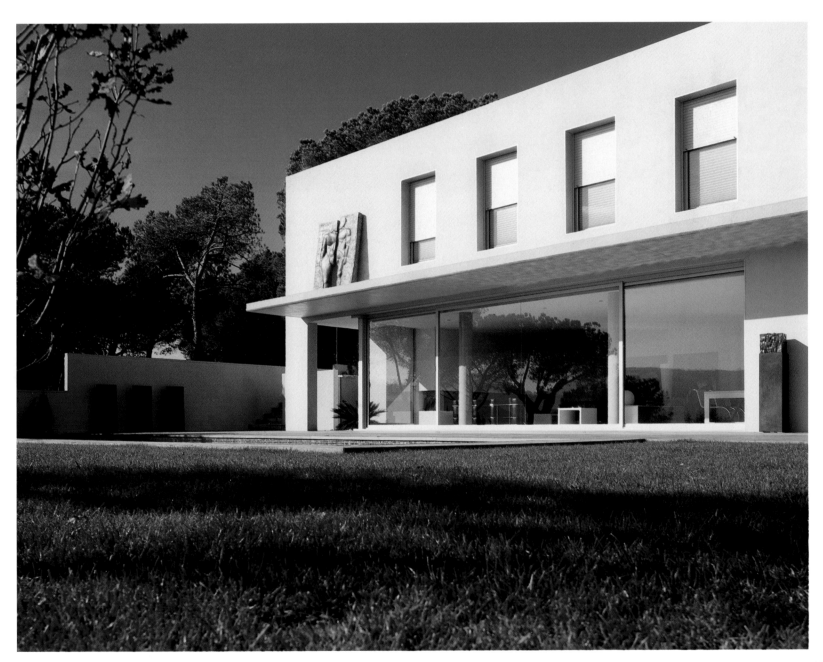

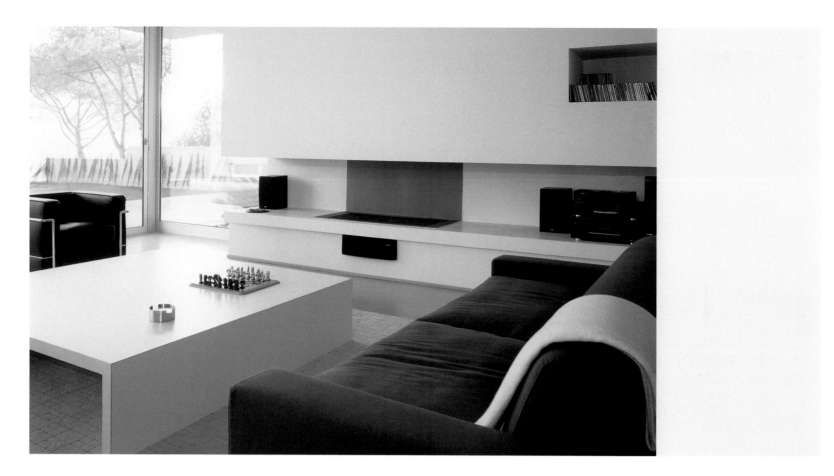

Seating surrounds a built-in chimney stretching horizontally across the wall. The sides of the chimney make for a shelf that seems built into the structure of the building.

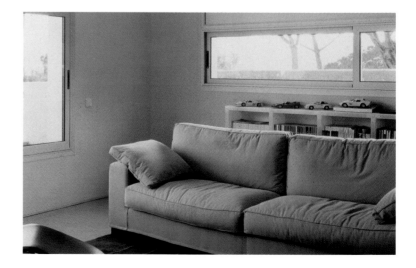

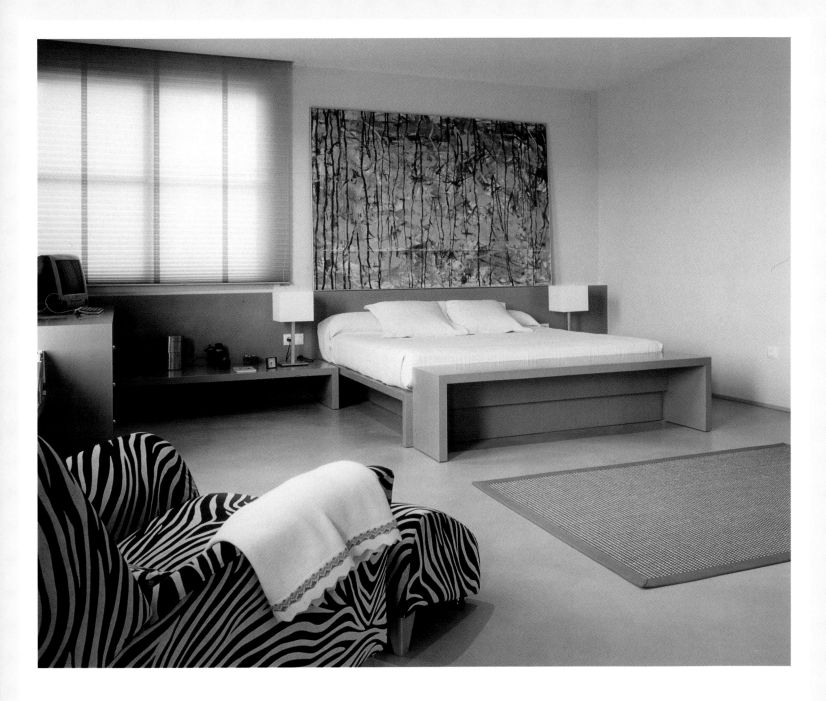

Regarding interior decoration, nothing has been left to chance. Emblematic 20th century design pieces, such as Le Corbusier armchairs and a chaise lounge, are combined with avant-garde pieces and furniture designed by the architect, such as a beech wood double bed.

Mies Van der Rohe ivory-leather and steel chairs, another emblem of 20th century design, prevail in a dining area that opens to an interior patio, increasing luminosity and sense of space.

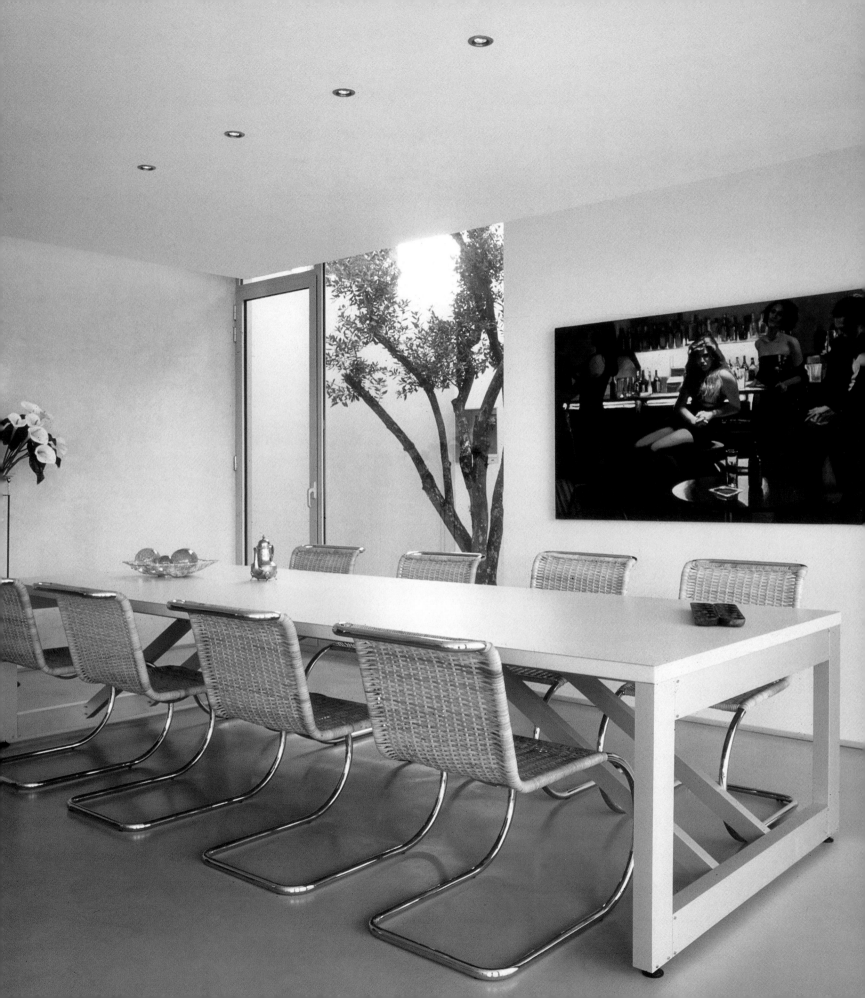

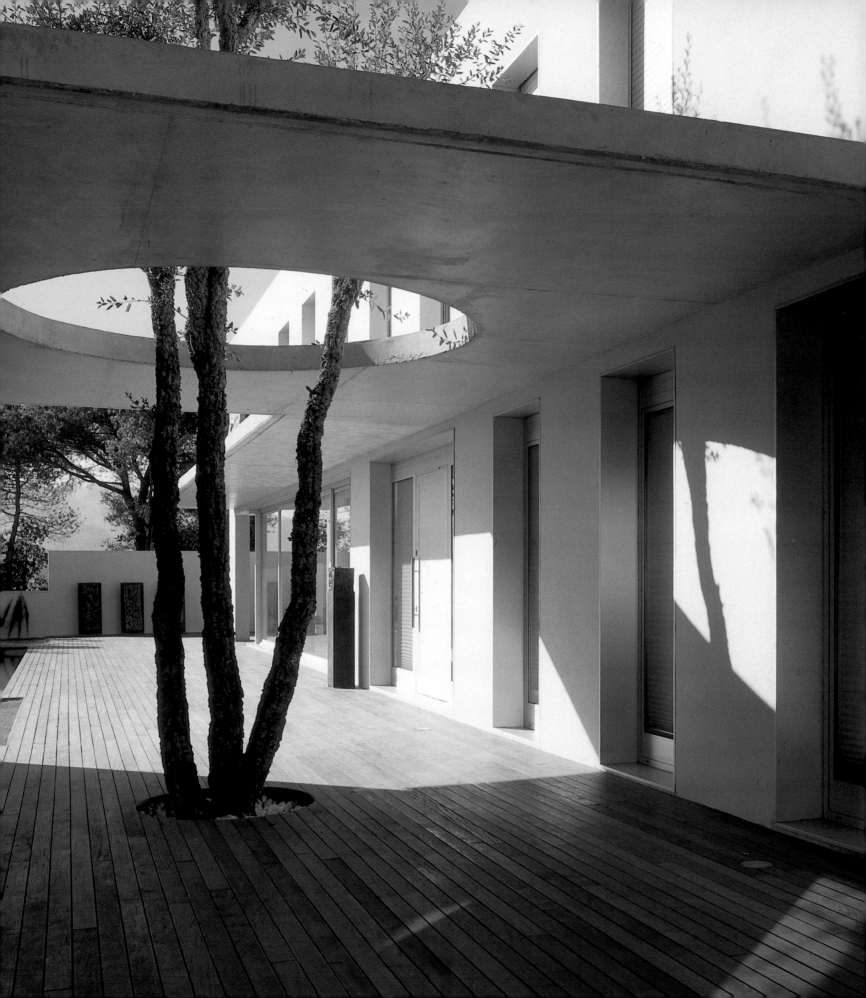

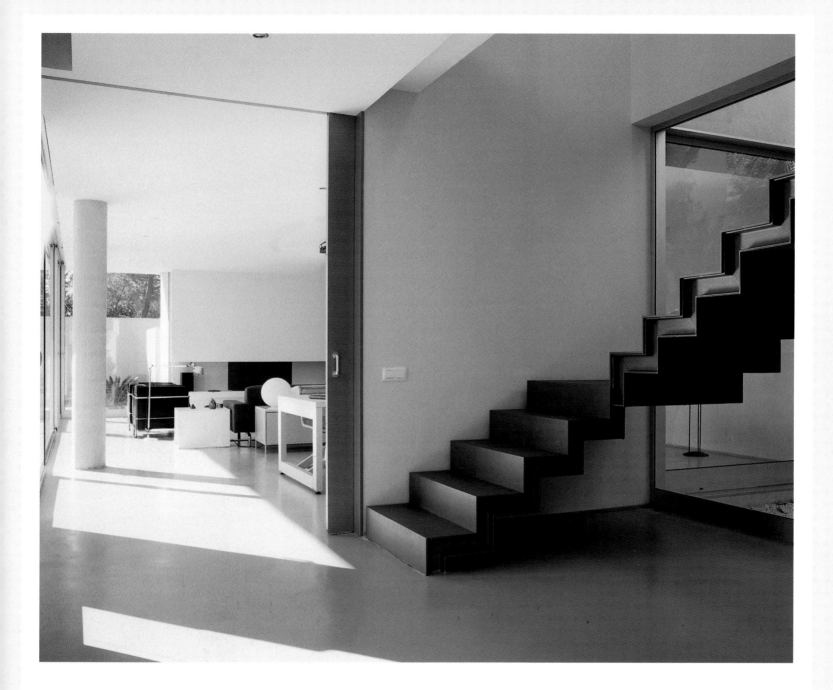

At the point where the main building meets the office annex, an extension serves to unify the two structures. A tree rises and is framed between the two like a work of art.

Yamano Guesthouse and Residence

Architects: Edward Suzuki and Associates| **Location:** Tokyo, Japan. 2001| **Photos:** Furutate Katsuaki

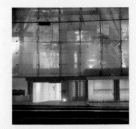

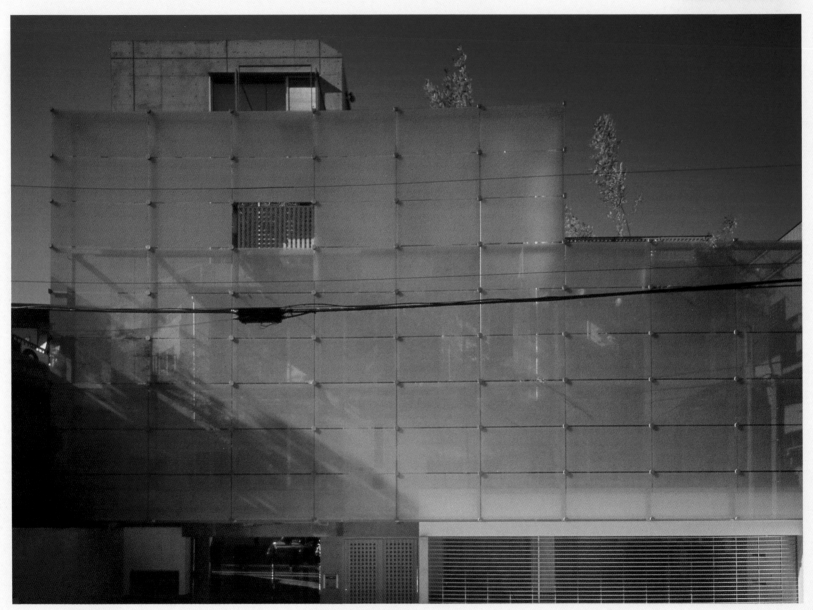

ecuring intimacy is always a principal virtue in the design of a single-family home. It's not surprising that designs of this sort explore different ways of keeping private spaces protected. The need for intimacy has a direct bearing on the design, and must be taken into account from the outset. In many cases, this search ends up being reflected not only in the volumetric character of the home, but in the formal result of the complex as well. In the case of this Tokyo home, both the treatment of volume and functionality reflect the

necessity of maintaining privacy. The home consists of five floors. The first two are reserved for guests, while the upper three are for the family. The guest space is independent from the rest of the house by virtue of its easily street-accessed location and its functional treatment. The spatial design of the complex involves terraces for each level of the home. The terraces do more than simply organize the different areas of each floor. They also serve to insulate the complex from sur-rounding buildings. Volume treatment also seeks to create insulating elements. A sieve in the form of a crystal membrane before the main façade is set between the volume and its context, mediating between the street and the house. In addition to being a transitional element, the glass membrane gives rise to a play of light and shadow inside and outside the house. By subtlety disclosing nighttime interior activity, the membrane converts the house into a glass lantern.

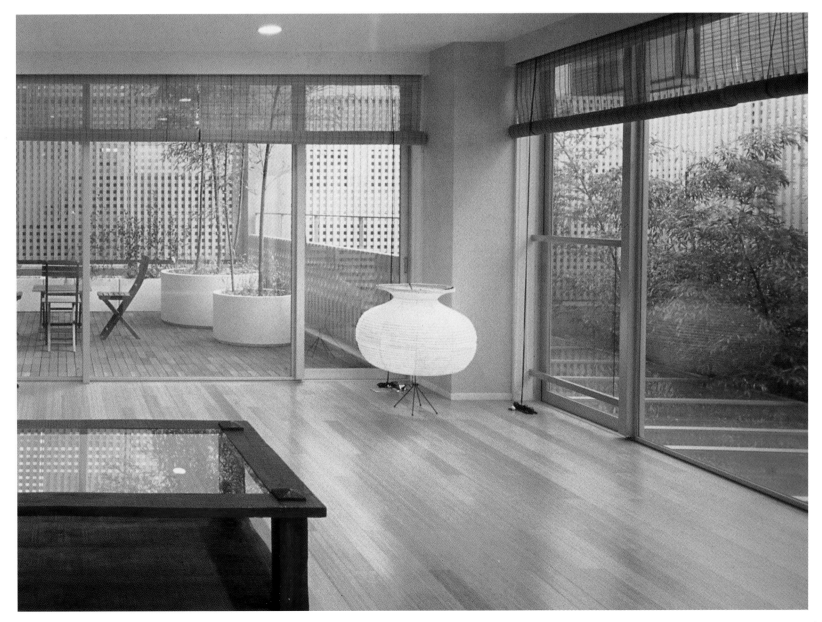

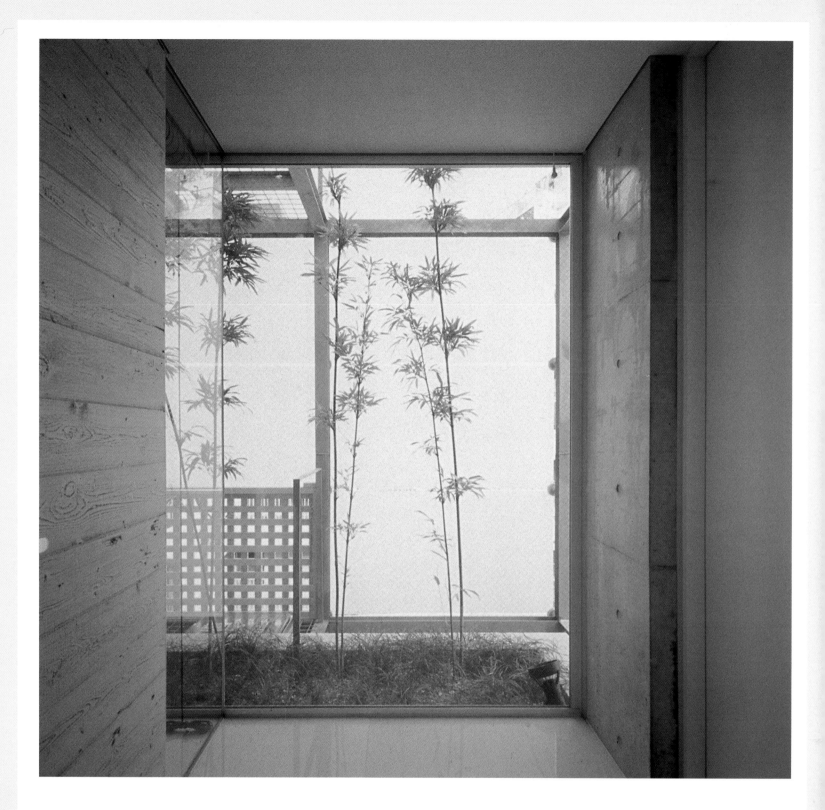

The first two floors of the home are reserved for guest use. In this way, guest activity is kept independent from the rest of the house. The nucleus of vertical circulation is distinct from that of the main house, as the guests utilize a spiral stairway.

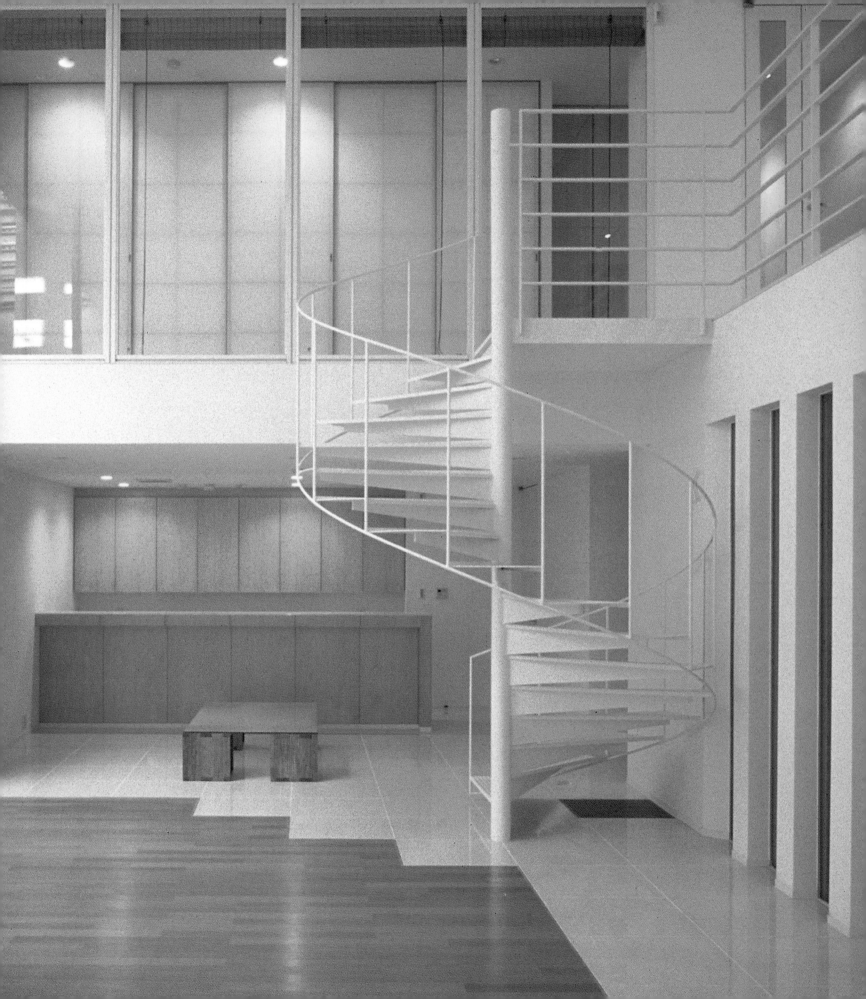

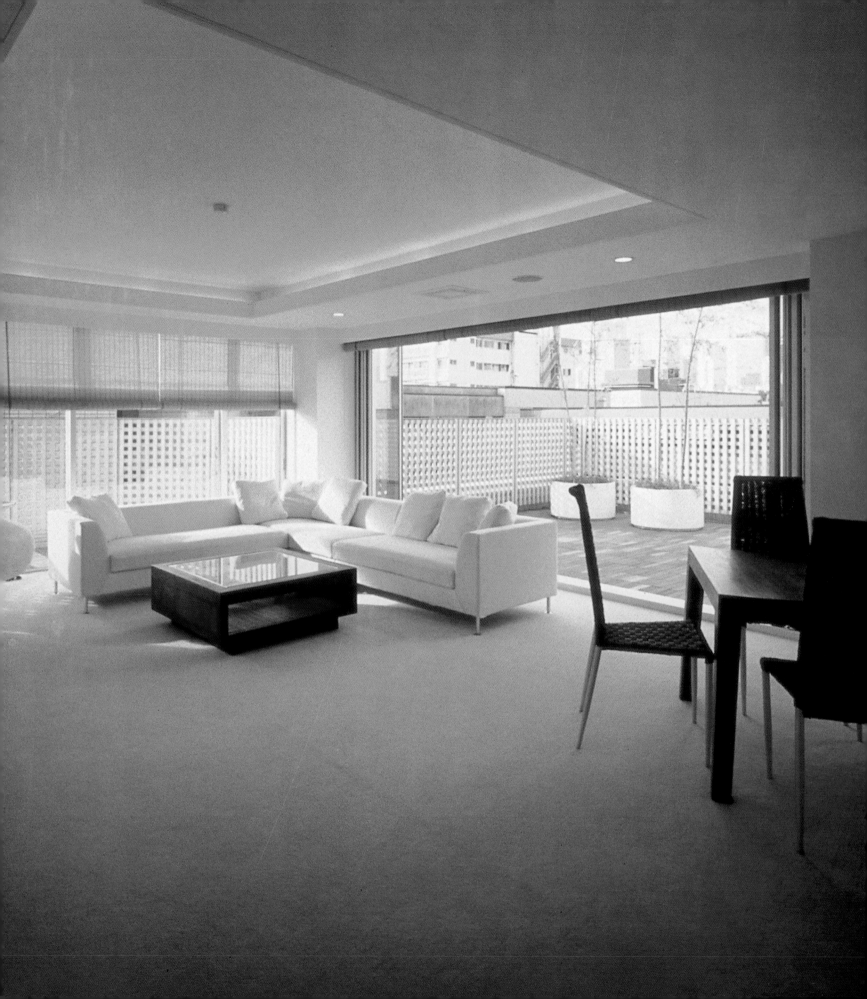

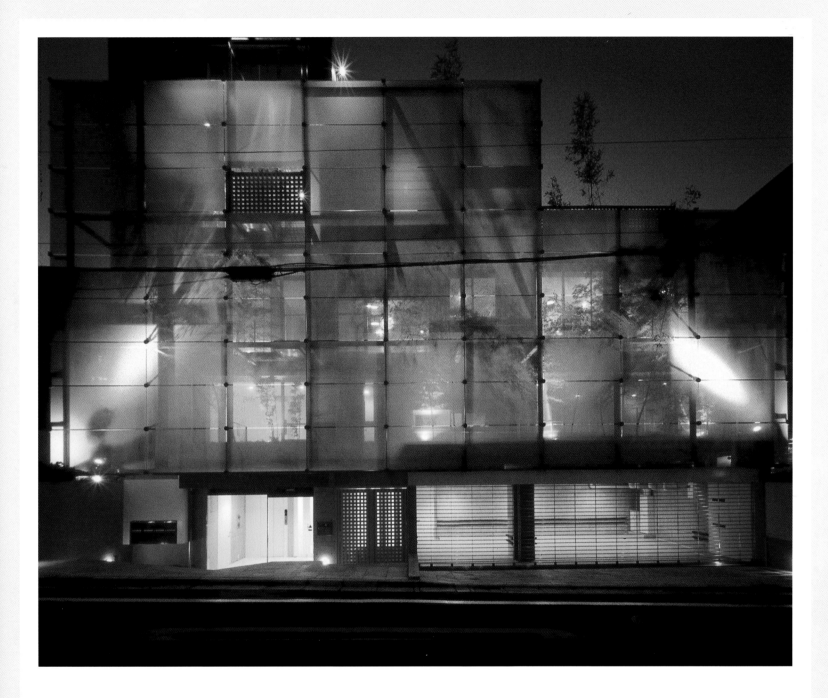

A glass membrane before the main façade mediates between the volume of the building and the street. In addition to surrounding and protecting the volume, the membrane also creates an interior and exterior play of light and shadow.

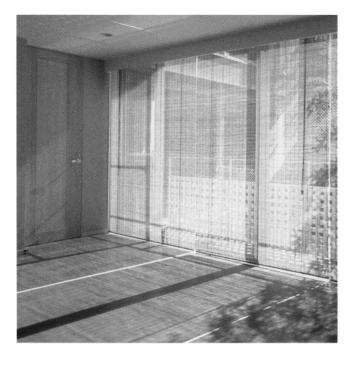

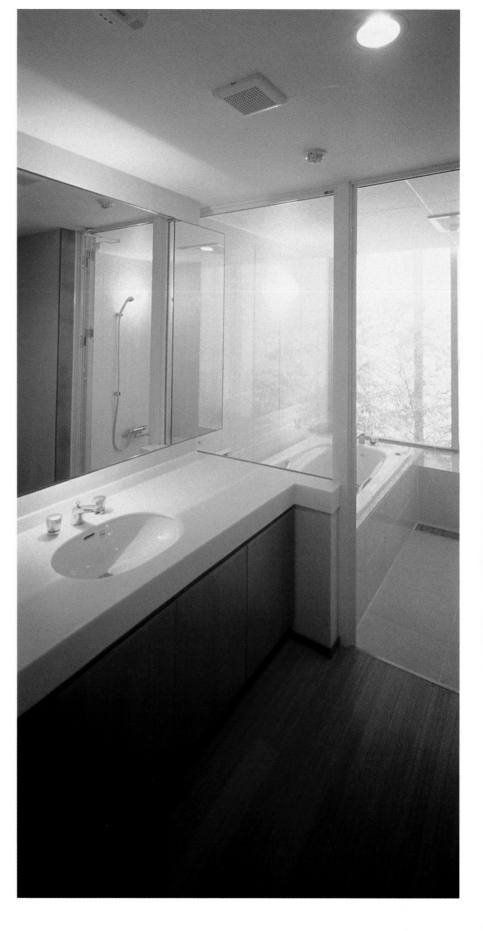

The placement of terraces on each floor of the home creates intimate spaces, completely shielded from the buildings that surround the complex. Landscaped zones complete the isolation of an environment that conserves residential privacy.

House on the Mediterranean coast

Architect: Josep Lluis Mateo. MAP Architects | **Location:** Mallorca, Spain. 1997 /2000-2001 | **Photos:** Duccio Malagamba

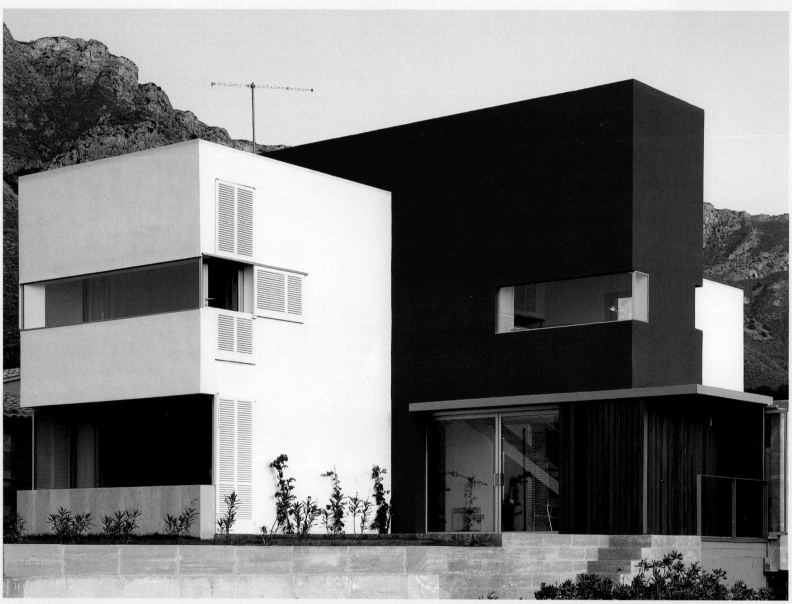

Development in the zone where the house is located is recent. This is due to physical and climatic characteristics. Frequent winds, extreme heat and remoteness of the inhabited areas are the main geographic features of the community of St. Pere (Arta), situated on the island of Mallorca. Nevertheless, this situation, which until now has limited development in the region, is taken advantage of here to create attractive conditions within the design. In this single-family home, protection from the wind and

heat is essential. The architect thus explores the possibilities and virtues of natural ventilation in the design. The volume, which consists of straight and pure lines, gives the complex a forceful image. Two elements characterized by a strong chromatic contrast arrange the principle spaces of the home. Beyond the formal solidity of the complex, the façades present a delicate handling of textures and planes with large glass openings. Consequently, volumes become attractive elements of transparency, reflection and shadow. From certain perspectives, the glass surfaces on the ground floor make the two main elements seem as if they were floating. This gives rise to an interesting play of contrast between the solidity of volumes and the light manner in which they are supported. In response to climatic conditions, the spatial design entails a patio with a microclimate, allowing for interior temperature control during the hotter months of the year. With interior temperatures under control, the design emphasis moves to the enjoyment of views from all the spaces of the home. Glass strips in the façades generate panoramic views from the interiors.

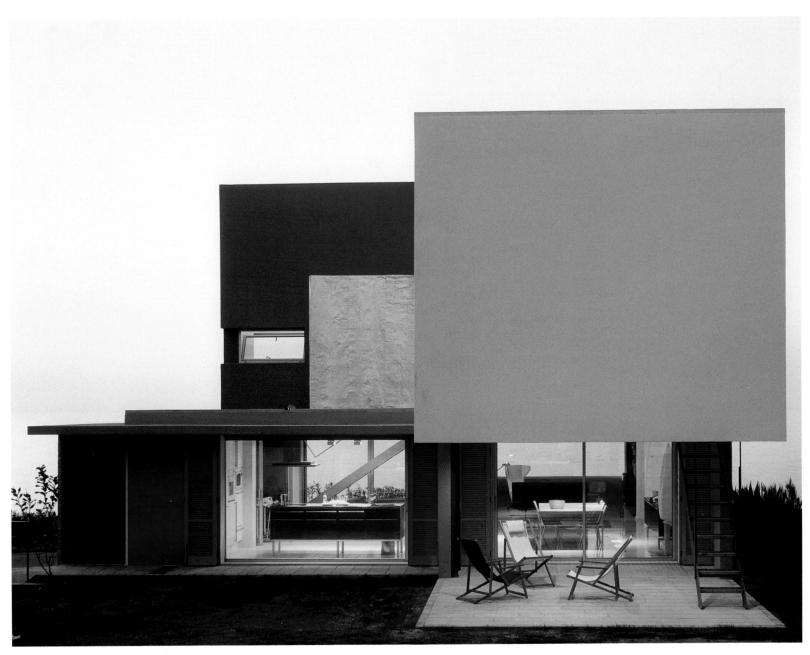

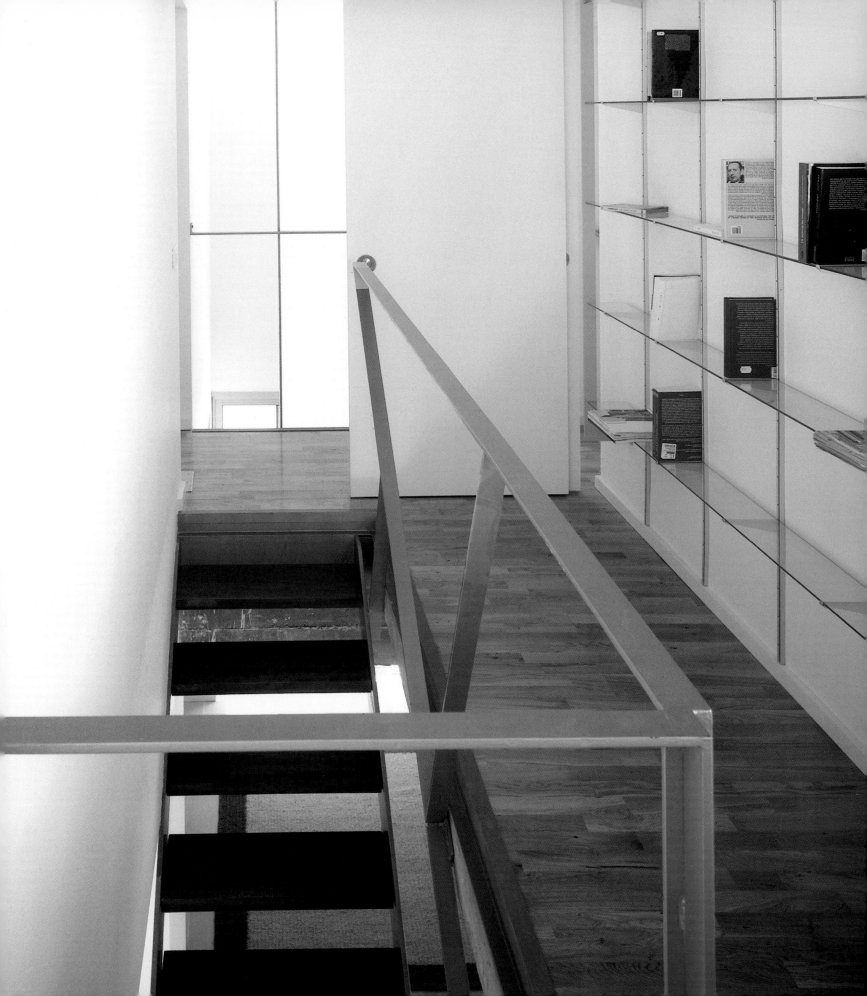

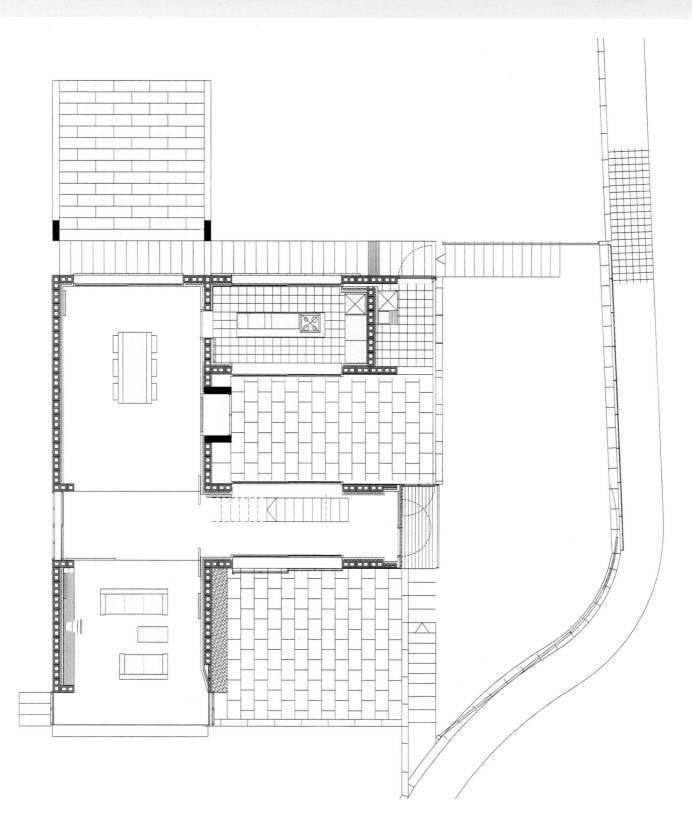

Glass surfaces on the ground floor support the volumes. From certain views, the volumes appear suspended in place. This duality of volumetric solidity and the light manner in which volumes are supported reinforces the play of contrasts typical of the entire design.

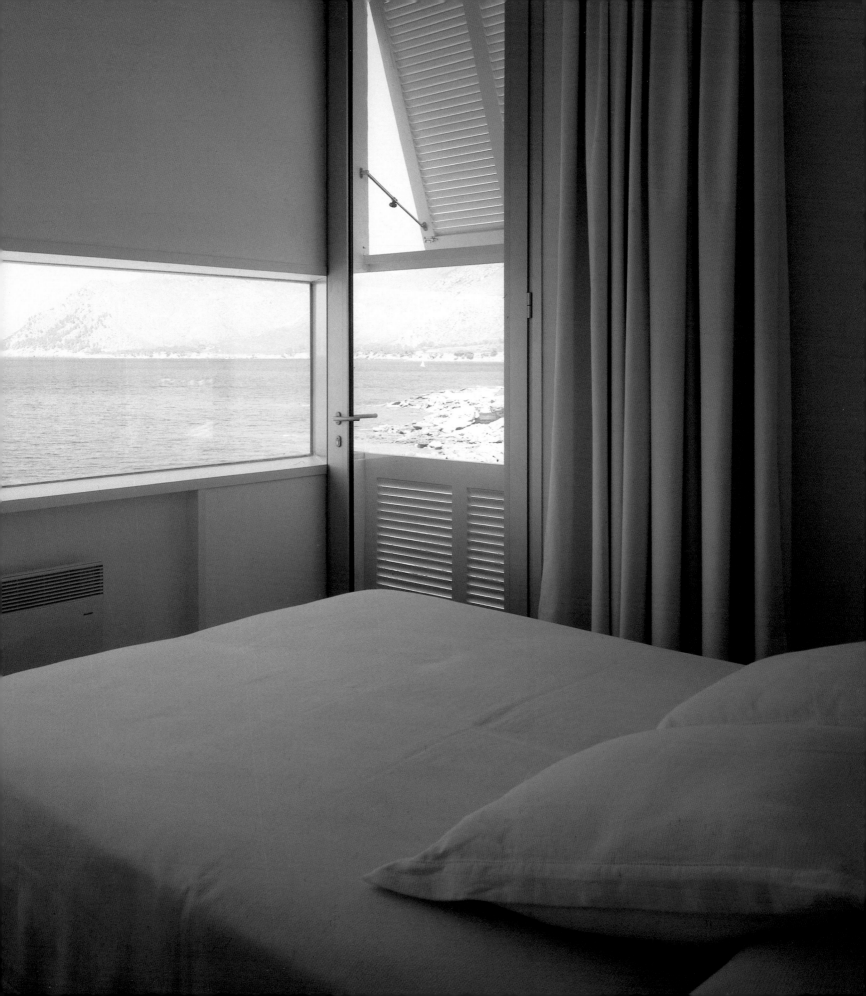

Vos House

Architect: Koen Van Velsen | **Location:** Amsterdam, The Netherlands. 1999 | **Photos:** Duccio Malagamba

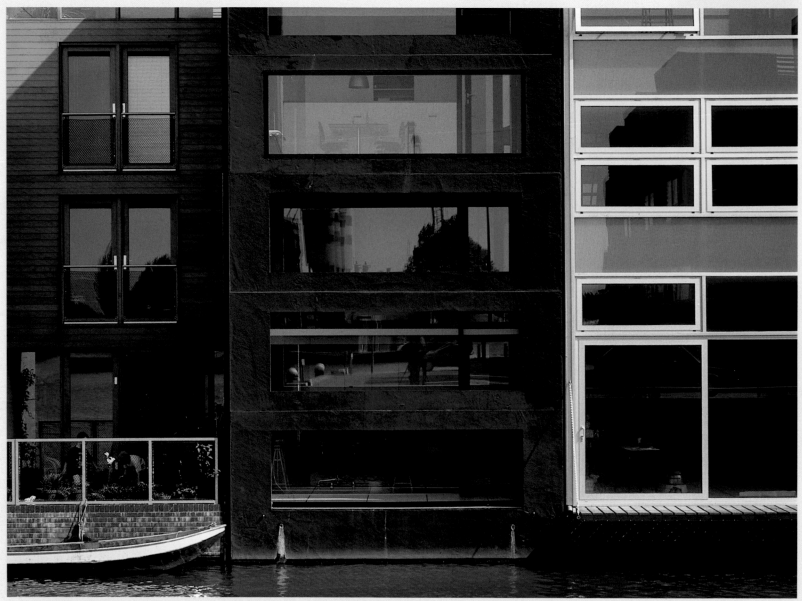

Neither the small nor the large-scale work of this Dutch architect reflect preconceived ideas easily associated with a specific architectural style. Still, studious attention to each and every design detail may be considered the signature Van Velsen sign of authorship. This single-family home on the island of Borneo reflects a refined study of the design and its necessities. Due to its placement between party walls, the house presents only two façades: one facing the street, the other the canal. This positioning is used

as a springboard to create a "wrap" that gives rise to the box-like character of the house. A concrete "skin" with a sequence of large rectangular openings doubles as both façade and roof. This concrete façade –and roof– also "hides" a second glass skin. The second skin tucks in the interior spaces between the principal façades.

This makes possible the three-level patio on one side and exterior terraces on the other. The patio and a tree create an intermediate level between the façades, giving the home a personal atmosphere. The proportion of the patio to the house demonstrates the importance of the former to the design. The design proposes four levels that contain the study, the bedroom, the dining room and the living room, respectfully. Like the exteriors, the interiors –also designed by Van Velsen– maintain strict control in the use of materials. In this way, the complex (only 140 m² or 459 sq. ft) benefits from close attention to detail and formal austerity.

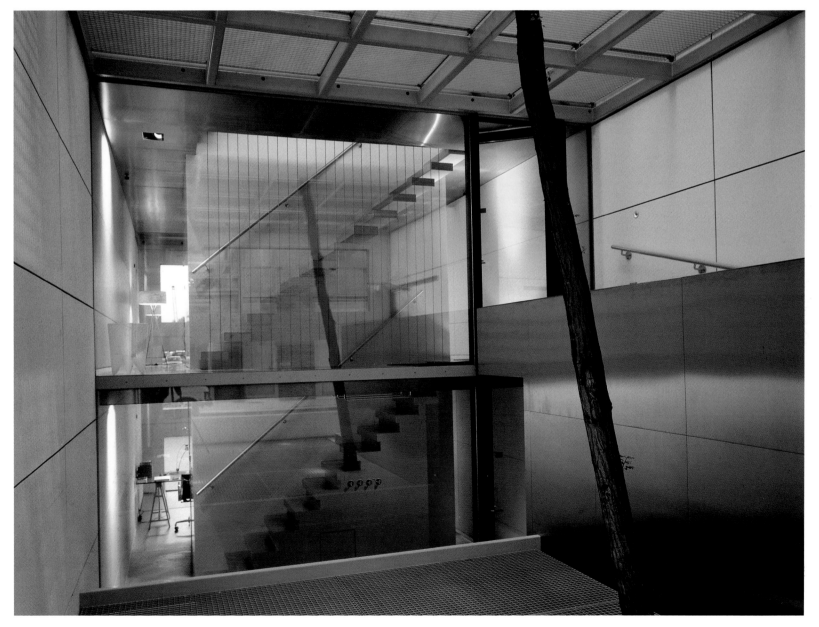

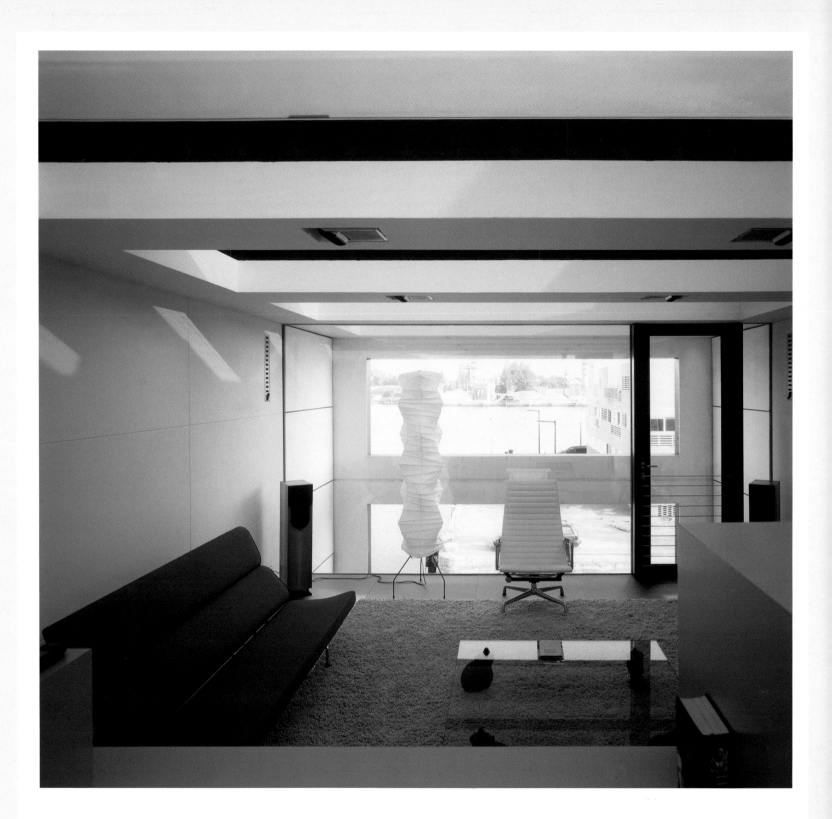

The formal design of the house is based on different façade layers. The first layer is made of concrete and functions as a kind of façade and roof "wrap" to the house. The second layer is glass, permitting more liberty in the design of interior spaces.

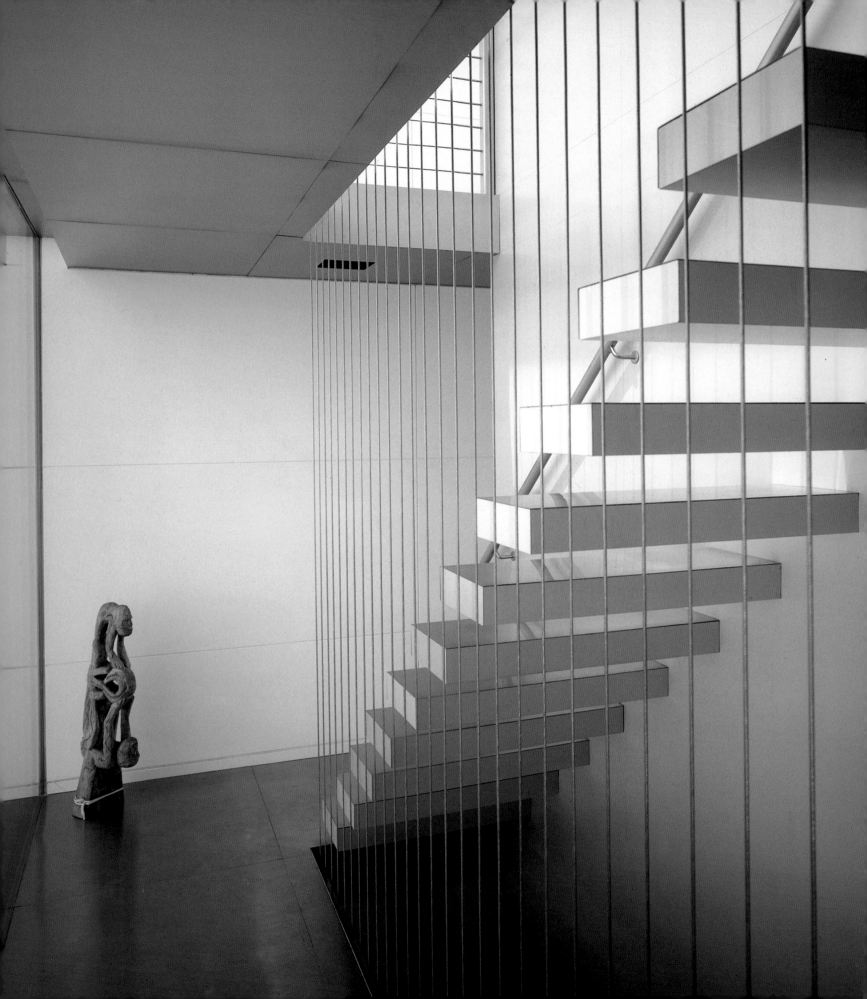

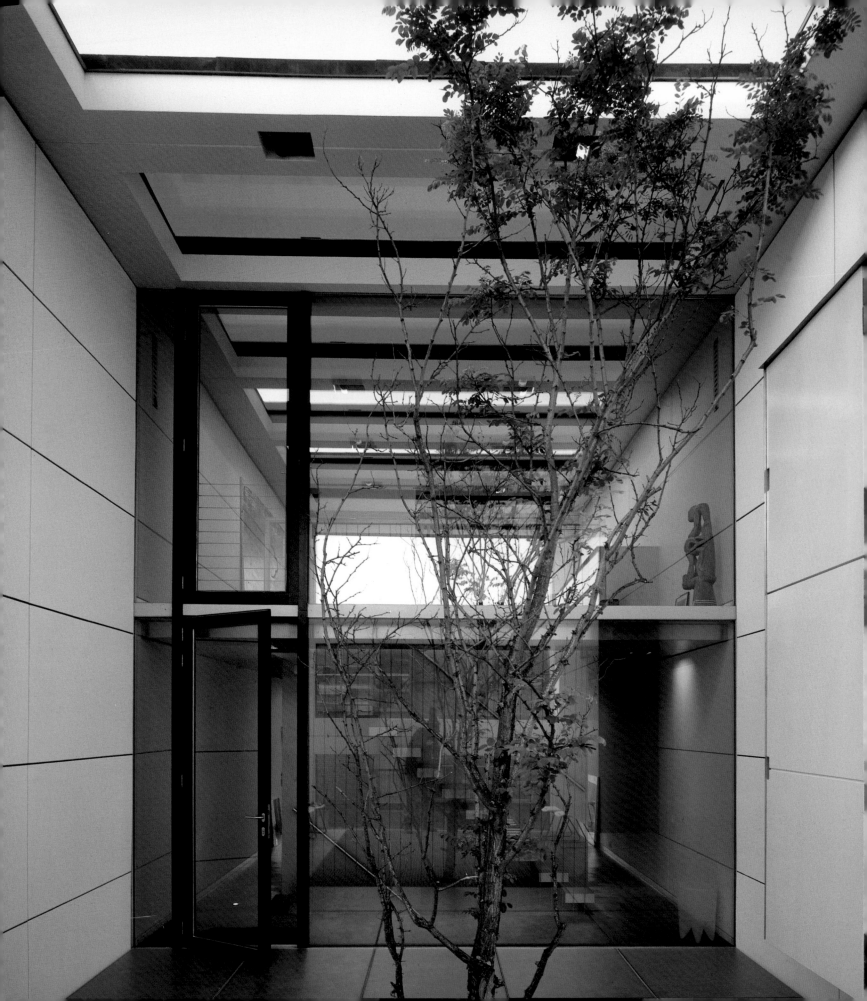

The concrete "wrap" contains a sequence of rectangular openings. In addition to being a façade, this "skin" acts as a structure that frames interior activity. The use of different façade layers permits the tucking in of interior spaces. This gives rise to intermediate spaces such as a large patio or exterior terraces.

House in Santa Margarita

Architect: Angel Sánchez-Cantalejo/Vicente Tomas | **Location:** Sta. Margarita, Mallorca, Spain. 1997/1999-2001 | **Photos:** Alejo Bagué

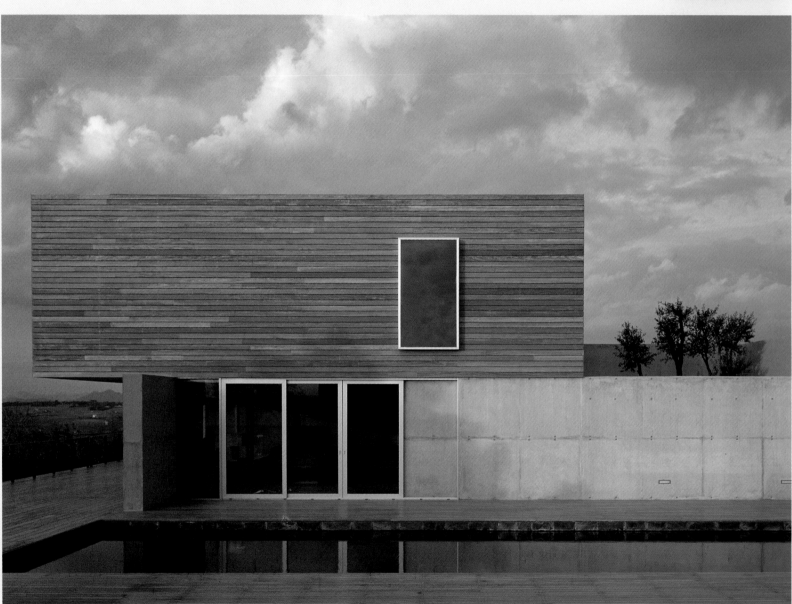

Based in Mallorca, architects Ángel Sánchez-Catalejo and Vicente Tomas began their professional careers together in 1995. Participants in numerous contests, their work has been awarded on various occasions. Such is the case of this one-family home, a finalist both in the category of architecture and interior design in the "Architecture of Mallorca 1997-2001" awards. The house sits atop a hill, at the urban limit of the town of Santa Margarita. This gives the home a markedly borderline quality, blending urban and rural

characteristics. A large concrete wall opens solely to provide access to the home, clearly demarcating rural and urban limits and reinforcing the frontier quality. Beyond the wall, a "true" entrance more freely gives way to the home by virtue of a patio. The house is situated at the one of the extremes of the property. This makes for an interesting sequence of exterior spaces, of different use according to their location. Sometimes, the spaces end up being "trapped" by the house. Two elements provide the formal image of the complex: a wood-covered "box" and three concrete structural walls supporting it. The handling of these elements, which open and close, also opens up other boundaries offering even more attractive views. Spatial organization not only grows out of the functional necessities of the project. Structural and constructive rationality are also important elements of the design. Interior and exterior spaces take measure from the metallic formwork of walls and casings, reflecting the importance of dialogue between architecture and construction.

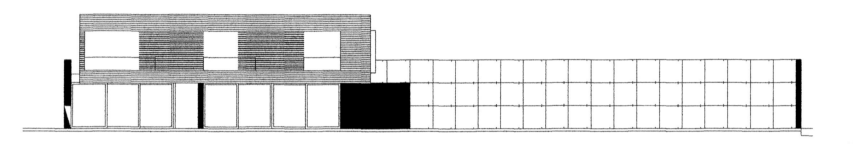

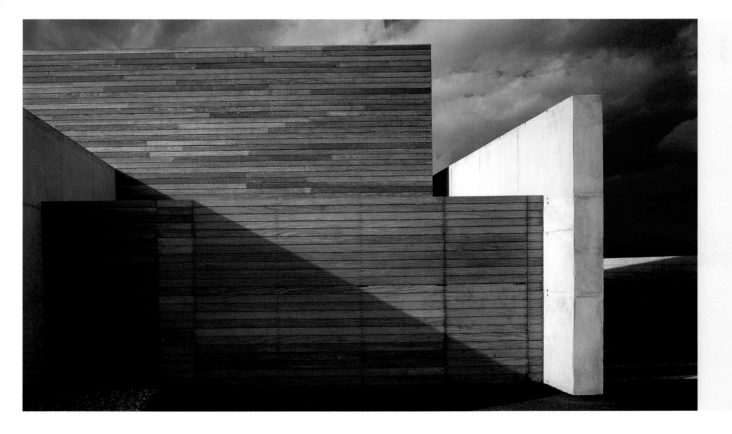

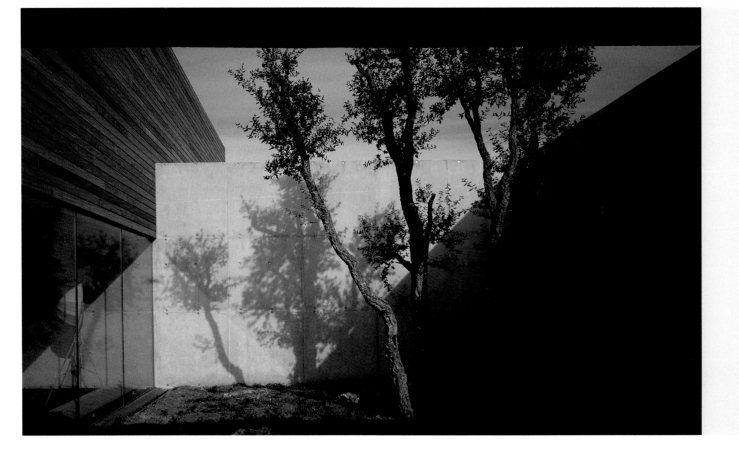

Placing the home at one of the extremes of the property creates exterior spaces of diverse character and dimension. In some cases, the result is auxiliary areas such as two interior patios. The architect Bet Figueras was responsible for the landscape architecture.

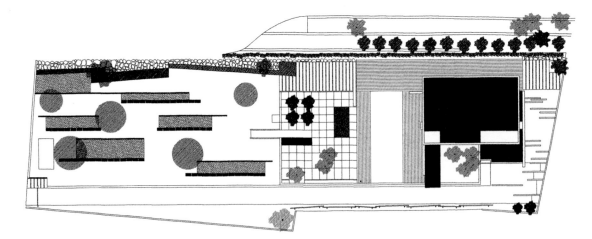

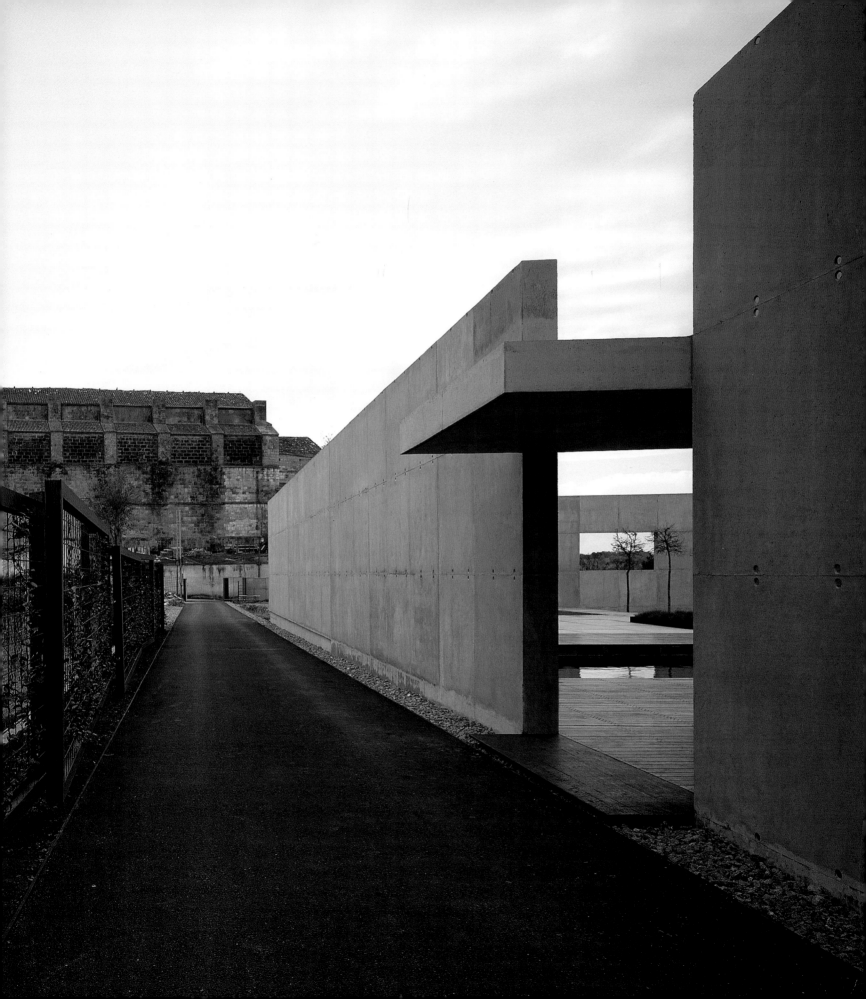

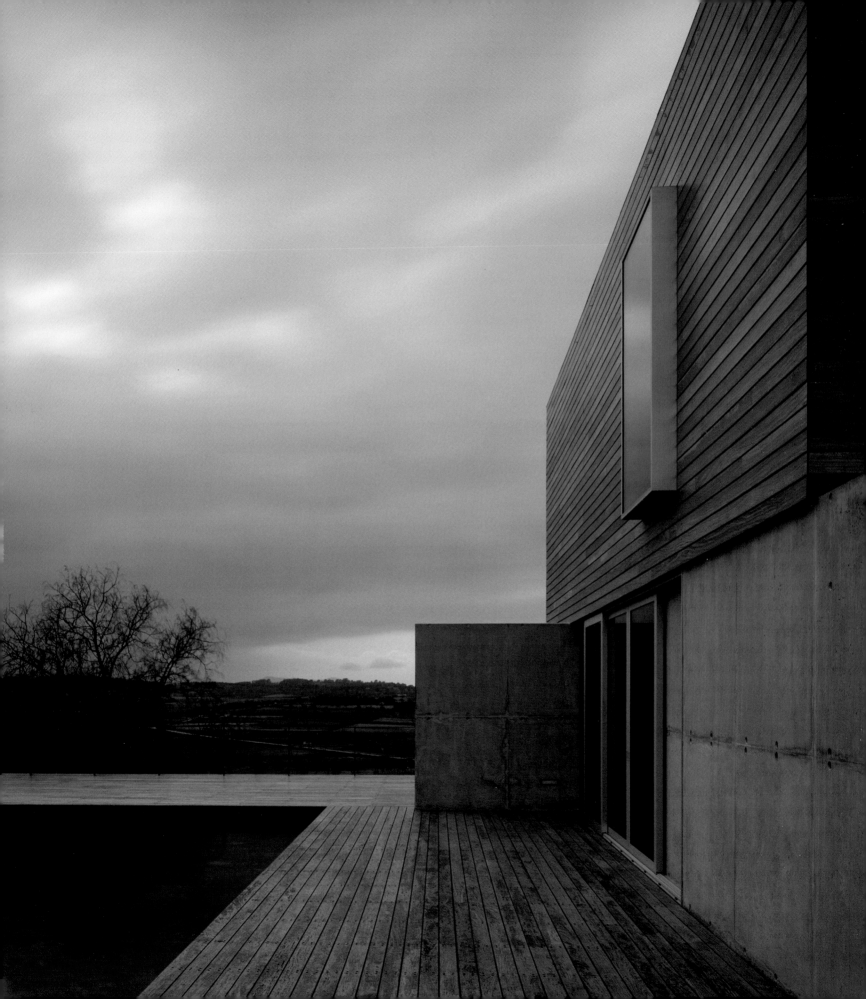

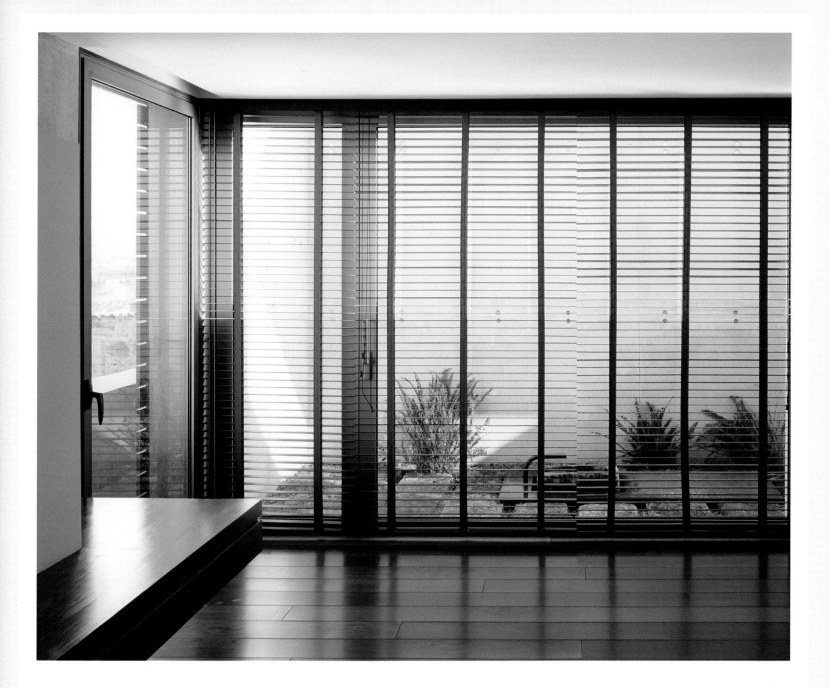

Three concrete structural walls serve as a base for a wood-covered volume. The handling of openings reflects the intention to isolate the home from the town, while at the same time opening it up to other views. The manner in which concrete, wood, and glass are used underscores the intrinsic character of each material: solidity, lightness, and fragility.

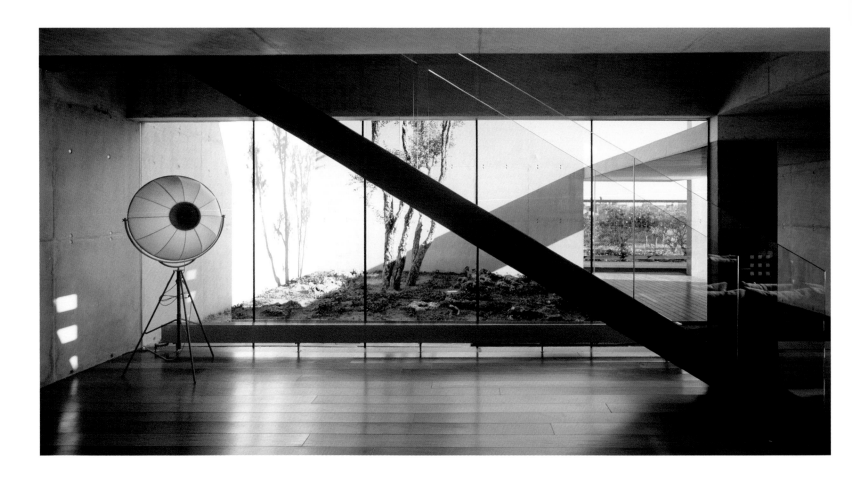

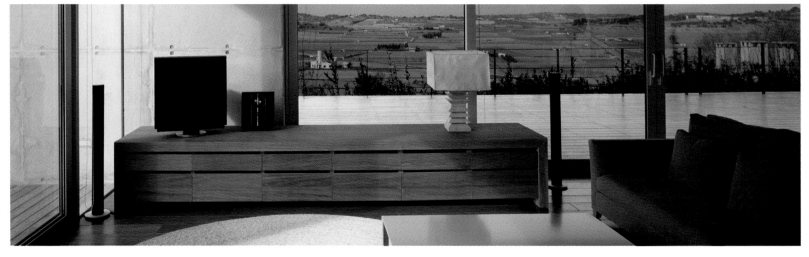

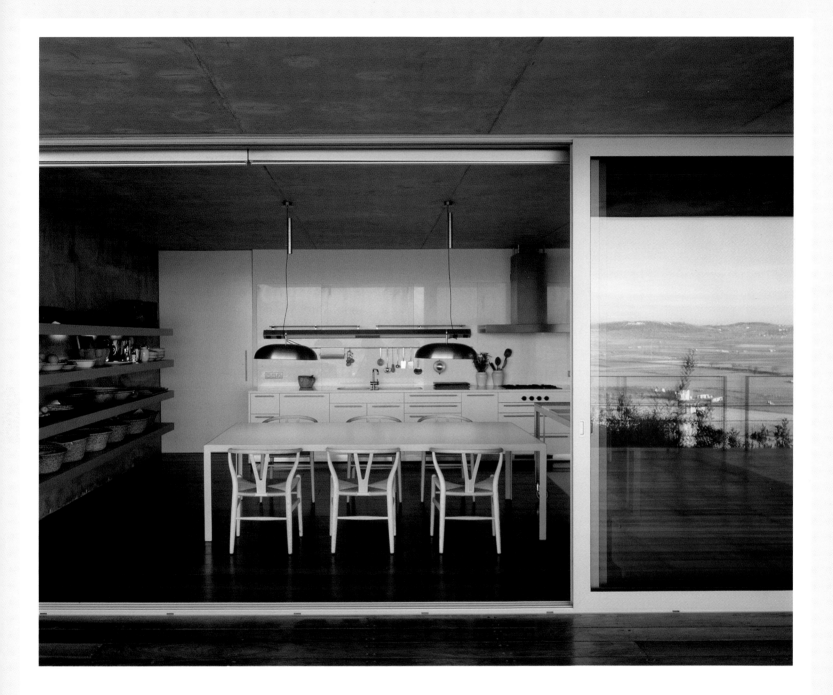

The design of interior spaces, based on a 1.35 m x 1.35 (4.43 x 4.43 ft) unit, takes maximum advantage of the attractive views. Sandra Tarruella and Isabel López were responsible for the interior design.

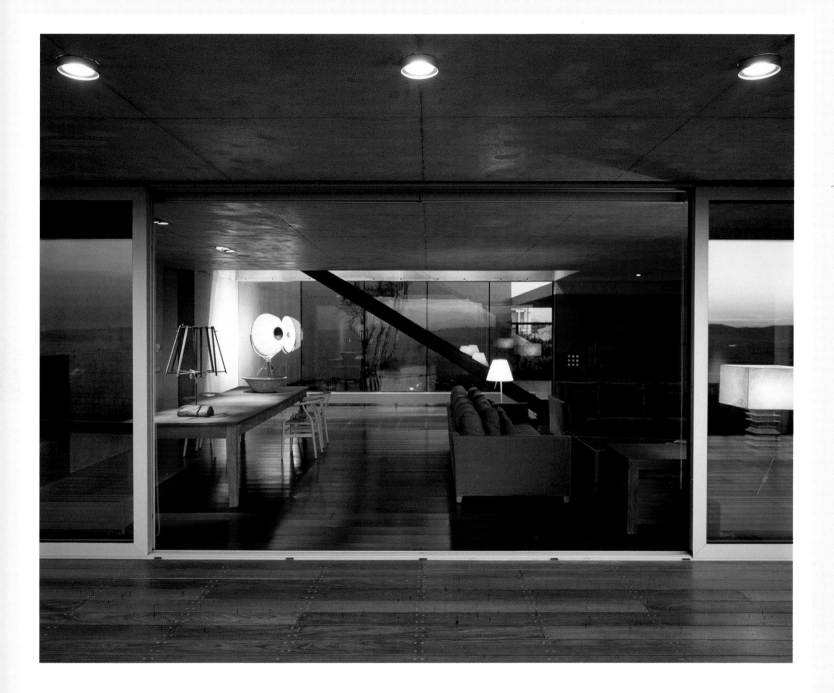

The home consists of two floors, the first of which contains communal spaces. Private spaces are located on the second floor. They are organized by a longitudinal axis that separates the rooms from the vertical nucleus of communication and the two patios joined to the house.